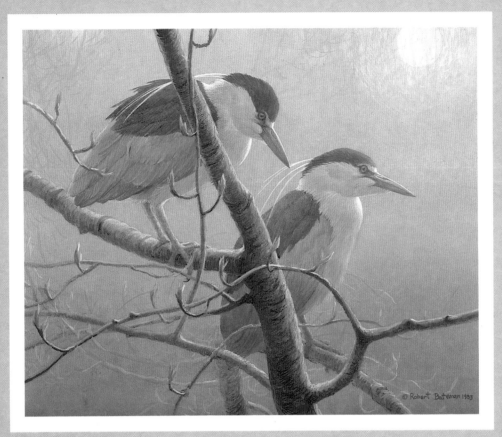

ROBERT BATEMAN
AN ARTIST IN NATURE

*Conservation is
a state of harmony
with a friend;
you cannot cherish
his right hand and
chop off his left.*

–Aldo Leopold

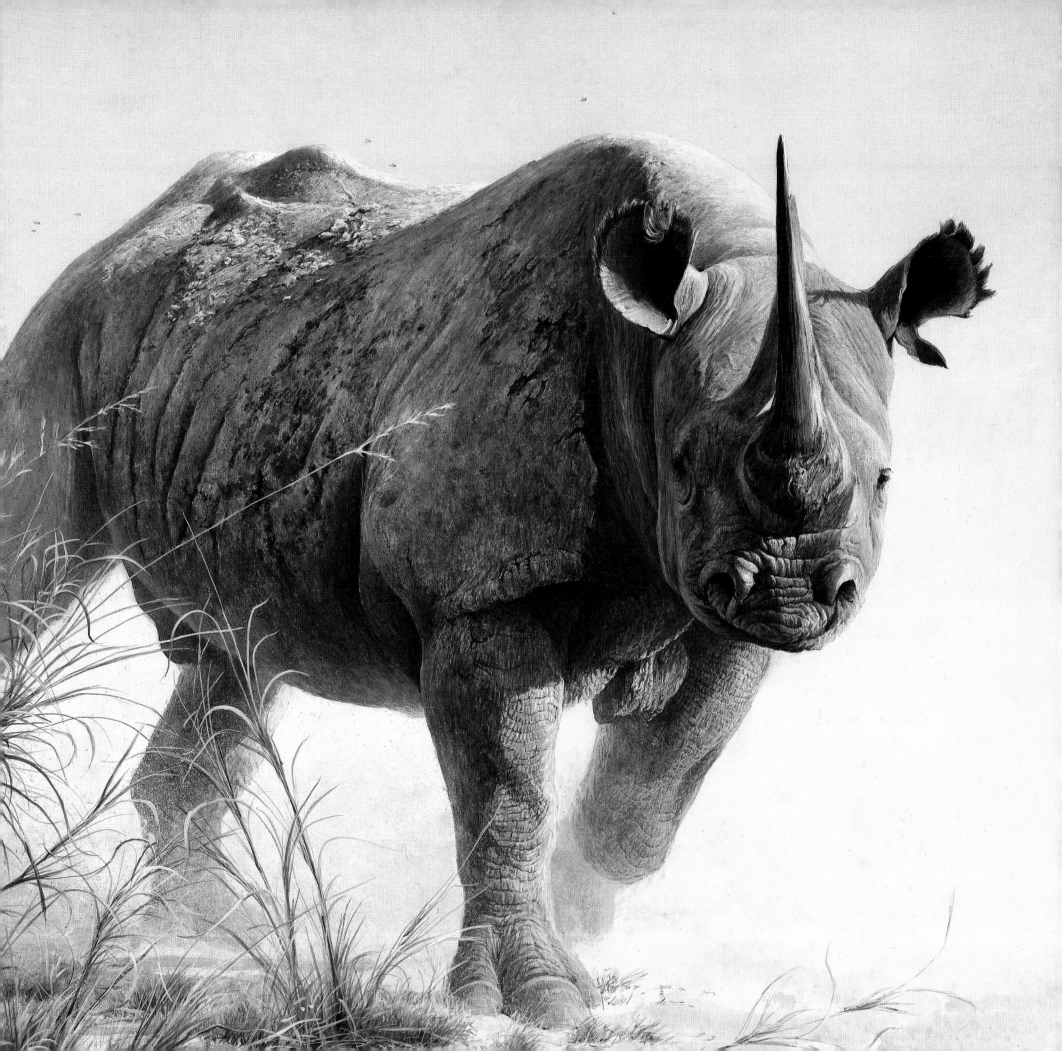

A Viking Studio/Madison Press Book

VIKING
STUDIO
BOOKS

ROBERT BATEMAN
AN ARTIST IN NATURE

Text by Rick Archbold

6 Text and compilation copyright © 1990
The Madison Press Limited.

Artwork copyright © 1990 Boshkung Inc.

First published in Canada by
Viking, Penguin Books Canada Limited,
2801 John St., Markham, Ontario L3R 1B4.

First published in the United States of
America by Random House Inc.,
201 East 50th Street,
New York, N.Y. 10022.

First published in Great Britain by
Swan Hill Press,
an imprint of Airlife Publishing,
101 Longden Road, Shrewsbury SY3 9EB,
England

British Library Cataloguing in Publication
Data available.
ISBN 1-85310-182-6
First edition 1990.

Canadian Cataloguing in Publication Data
 Archbold, Rick, 1950-
 Robert Bateman: an artist in nature

ISBN 0-670-83426-2

1. Bateman, Robert, 1930-
2. Animals in art.
3. Painters – Canada – Biography.
4. Naturalists – Canada – Biography.
I. Bateman, Robert, 1930-
II. Title.

QH31.B24A72 1990 759.11 C90-093623-1

Library of Congress Cataloging in
Publication Data.

Bateman, Robert, 1930 –
 Robert Bateman : an artist in nature /
by Robert Bateman and Rick Archbold.
 p. cm.
 ISBN 0-394-58700-6 : $60.00
 1. Bateman, Robert, 1930 – .
 2. Nature (Aesthetics)
I. Archbold, Rick, 1950 – . II. Title.
N6549,B38A4 1990
759.11 — dc20 90-52611
 CIP

The publisher is grateful to the following
people for permission to use their
photographs:

*Patricia Corsini: front jacket flap, 17, 18, 39,
42, 54, 56; Birgit Freybe Bateman: 19, 29, 35,
44, 45 (bottom); Robert Bateman: 23, 32, 50;
Pat and Rosemarie Keough: 53; Laura
Middleton Downing: 24; Terry Moser: 45 (top);
The Osborne Collection of Early Children's
Books, Toronto Public Library: 23; James
Wilkinson: 47.*

Produced by:
Madison Press Books
40 Madison Avenue
Toronto, Ontario
Canada M5R 2S1

Printed in Italy

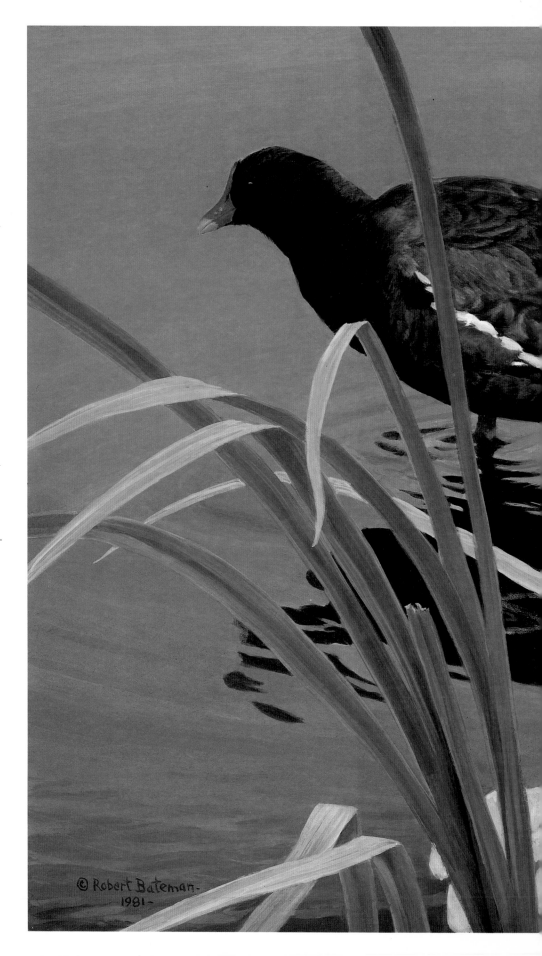

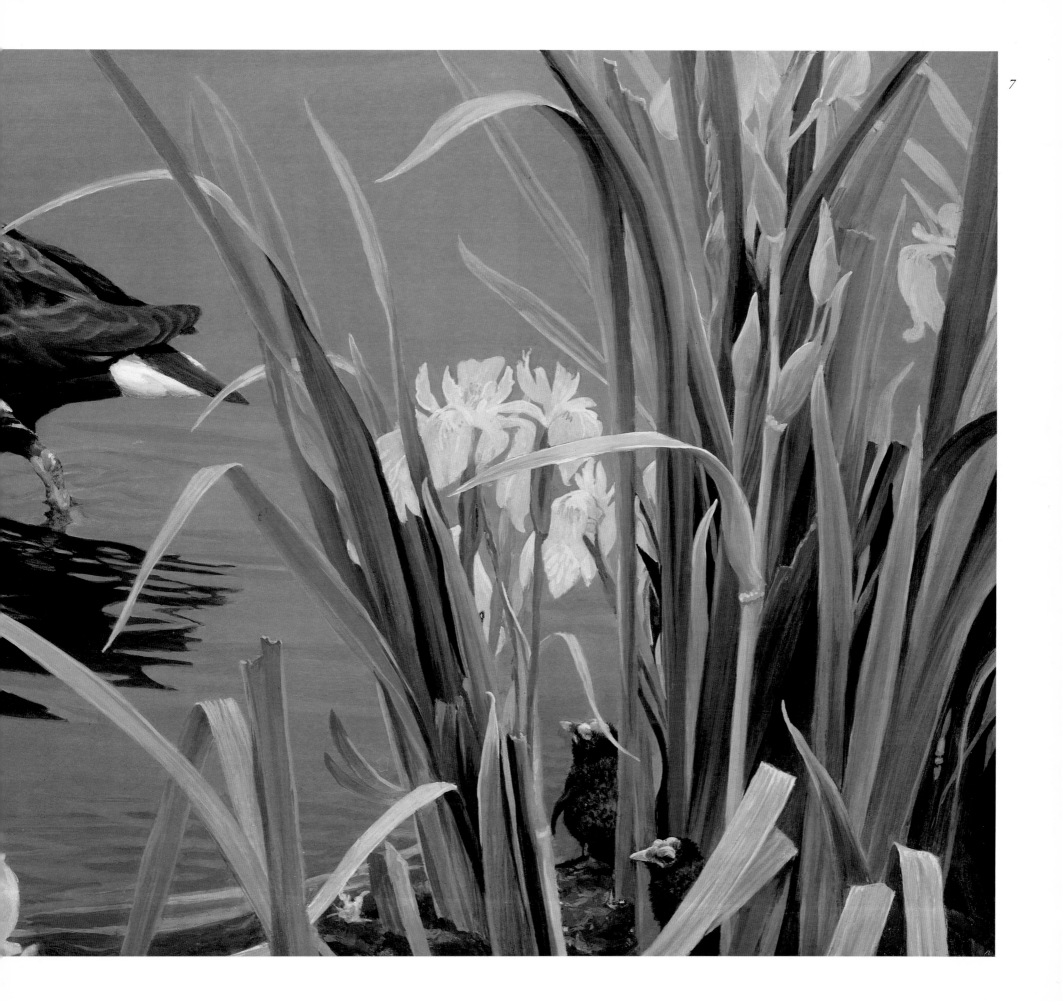

This book is dedicated to all those who are working to save our planet from destruction.

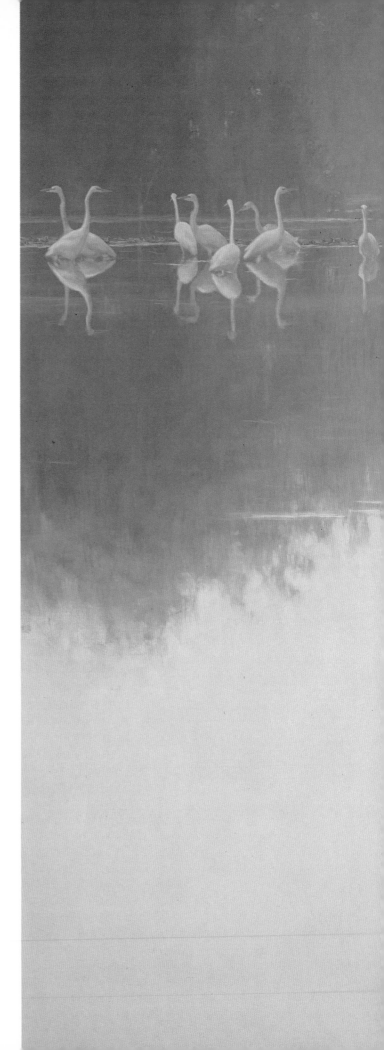

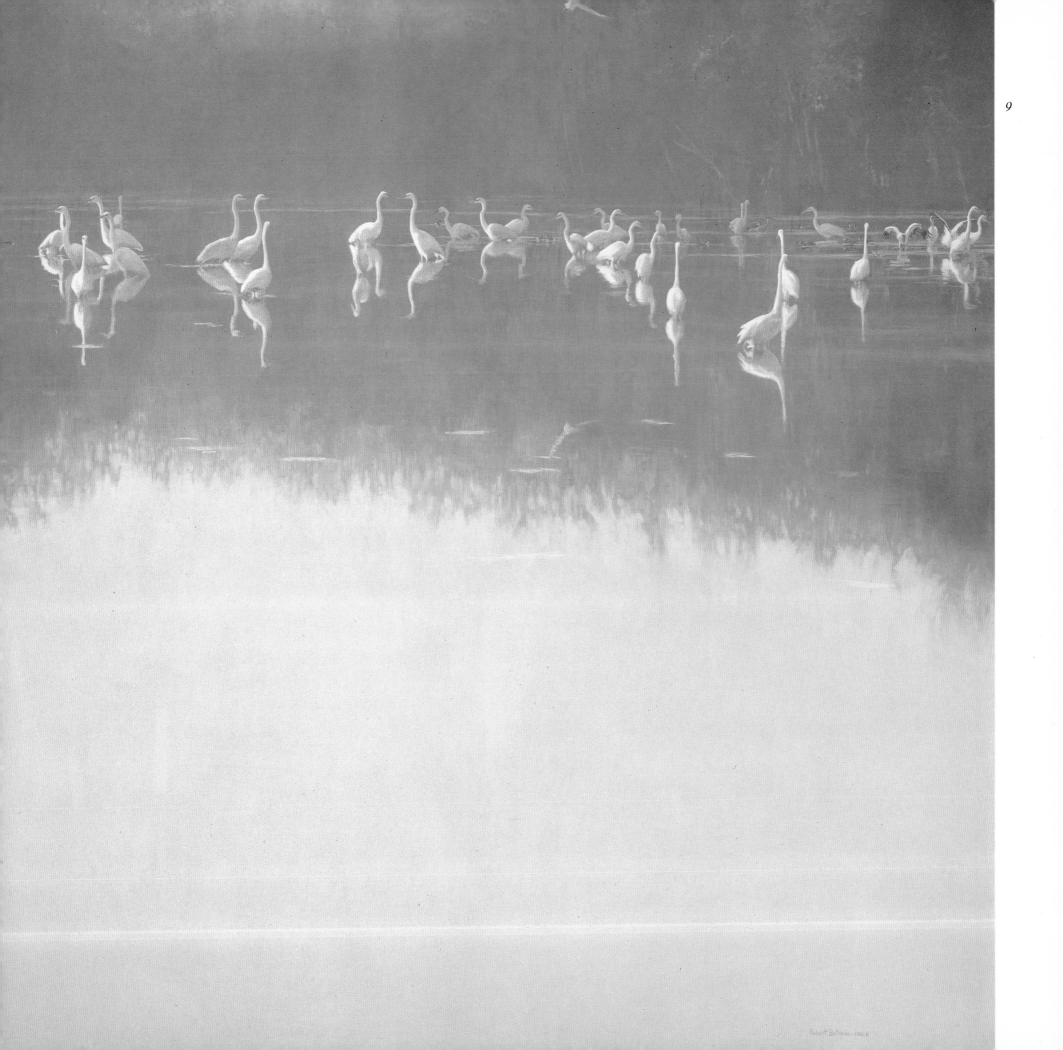

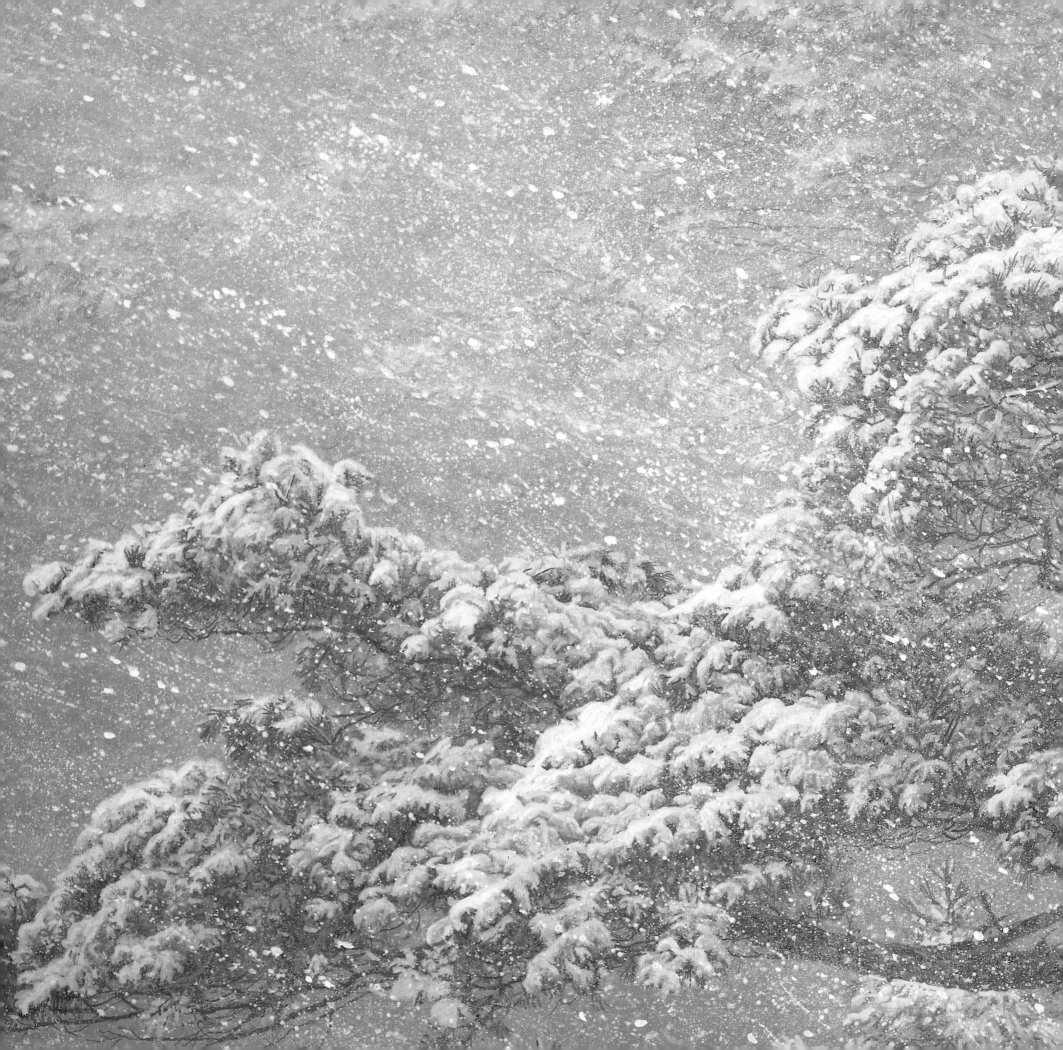

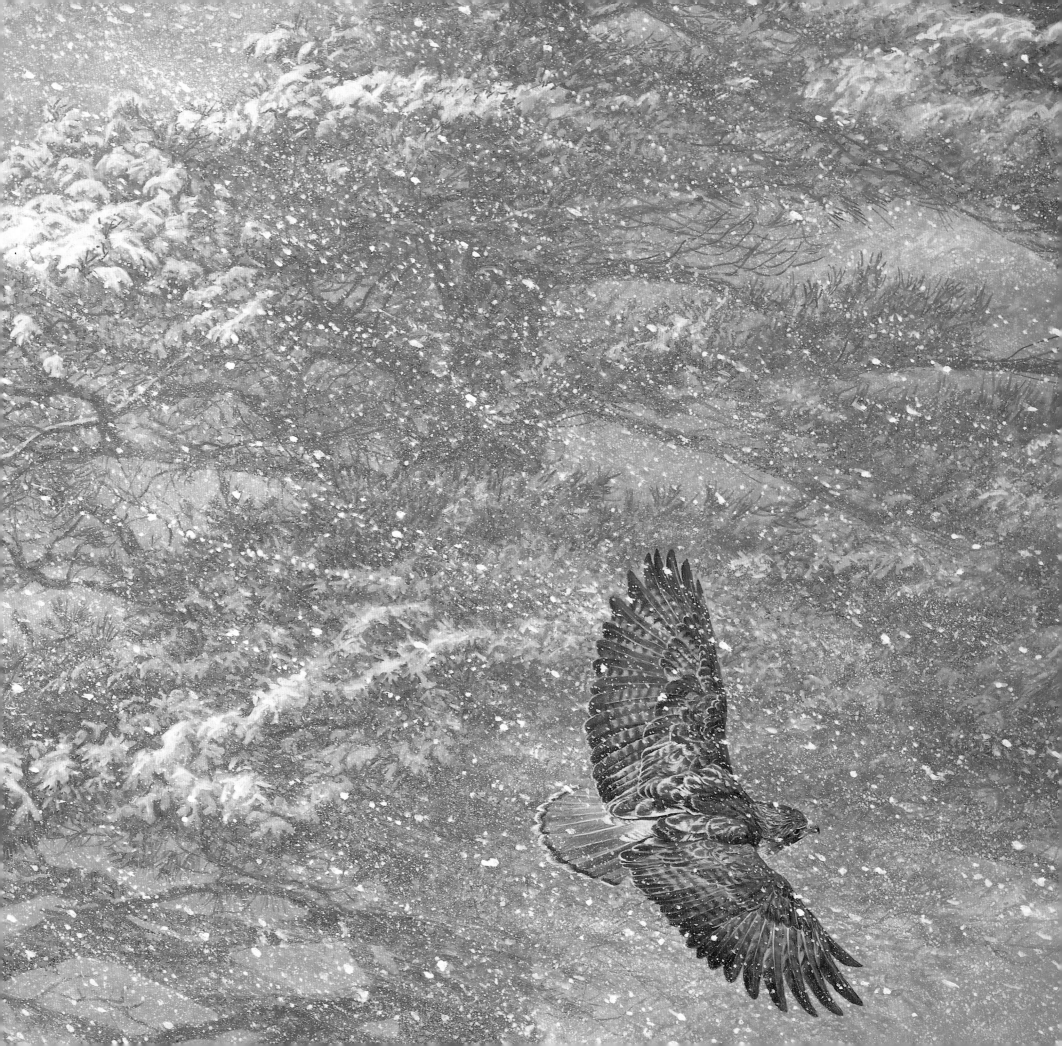

12 The publisher would like to thank the following people whose encouragement, support and cooperation helped make this book possible.

Birgit Freybe Bateman, Tom Beckett and the staff of the Beckett Gallery, Michael Bloomfield and the Harmony Foundation, Jack Coles and the staff of Nature's Scene Ltd., Dr. Bruce Falls, Dr. Bristol Foster, Arne Hansen and Mark Hobson of the Western Canada Wilderness Committee, Betty Henderson of the Elsa Wild Animal Appeal, Monte Hummel of World Wildlife Fund Canada, Pat and Rosemarie Keough, Ian Kirkham and the Federation of Ontario Naturalists, Michael Levine, Robert Lewin and the staff of Mill Pond Press, John Livingston, Kay McKeever of the Owl Rehabilitation Centre, David Neave of Wildlife Habitat Canada, Dr. Roger Tory Peterson, Ron Ridout, Doug Robertson and the Bruce Trail Association.

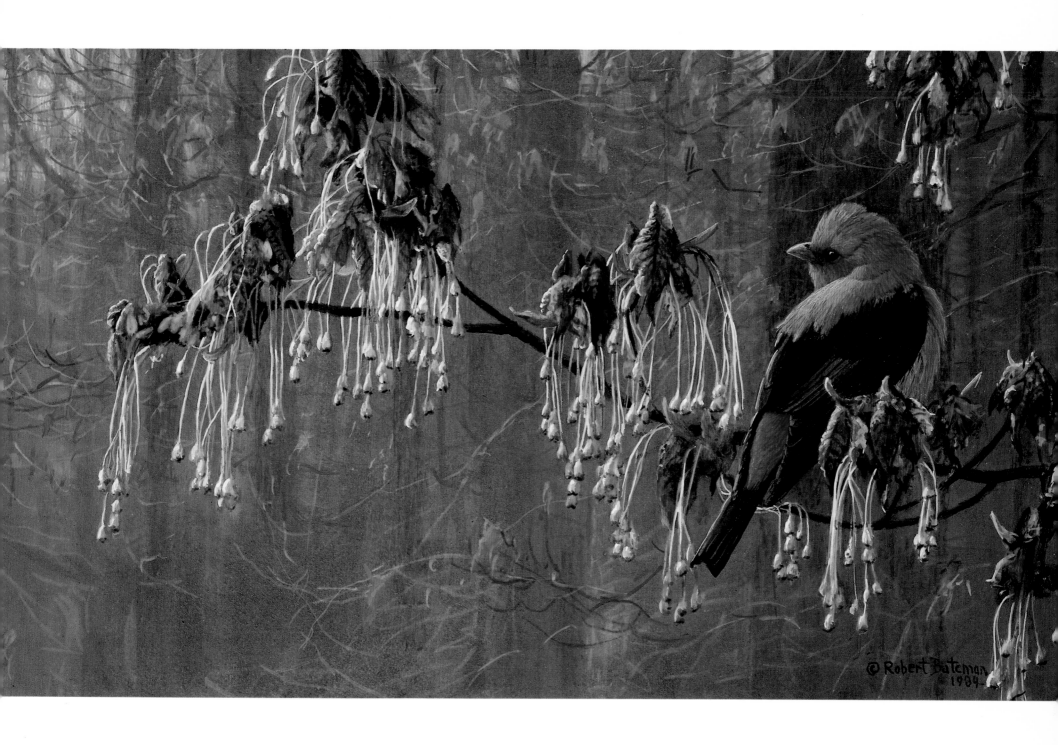

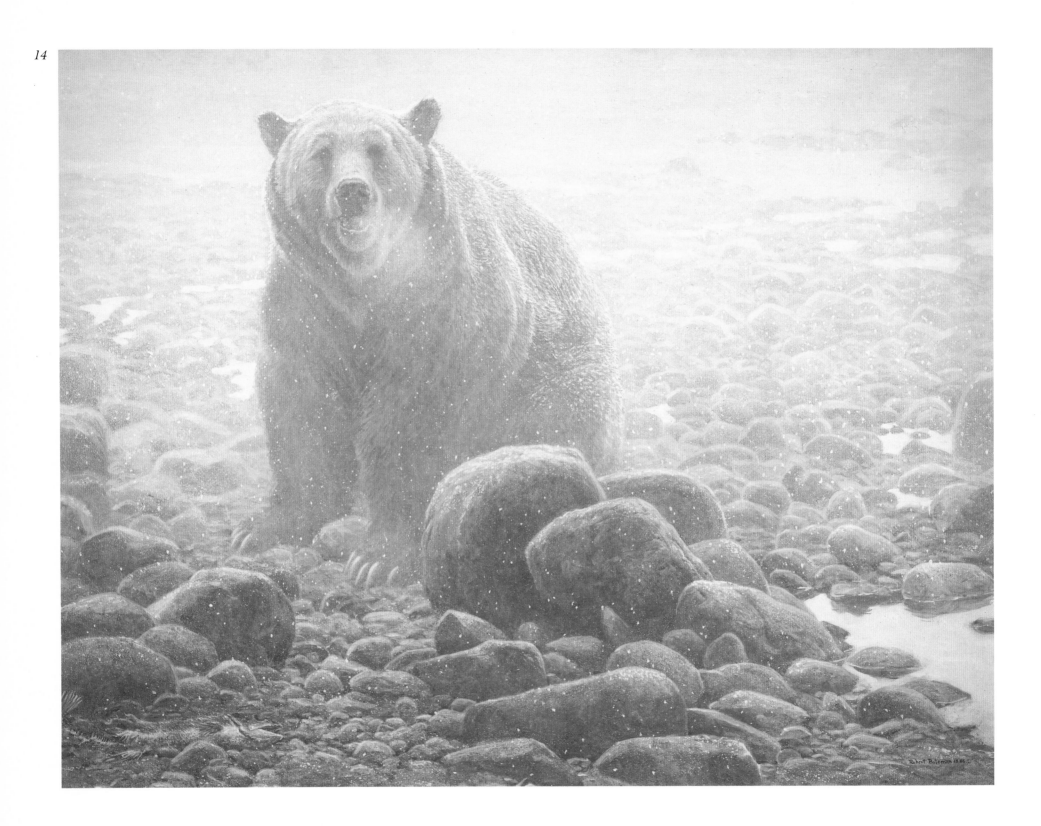

Contents

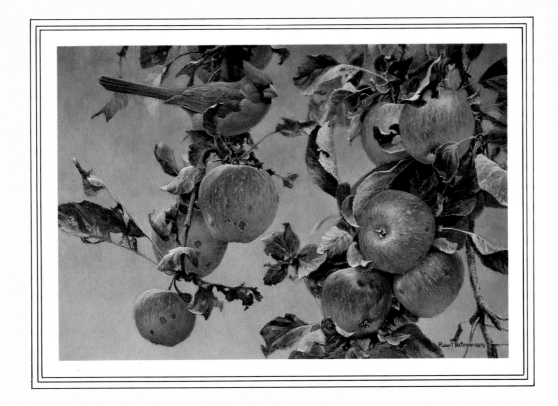

AN ARTIST IN NATURE

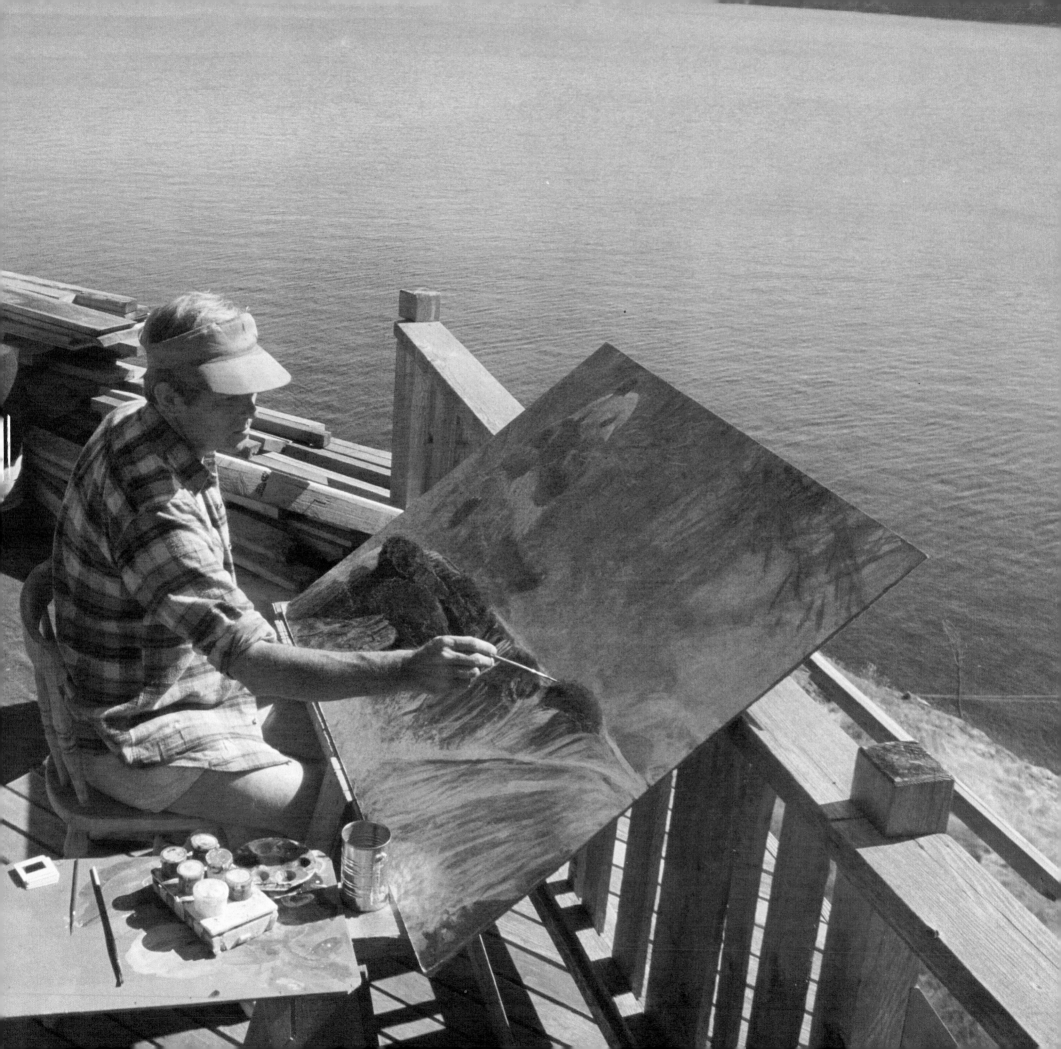

I Prologue

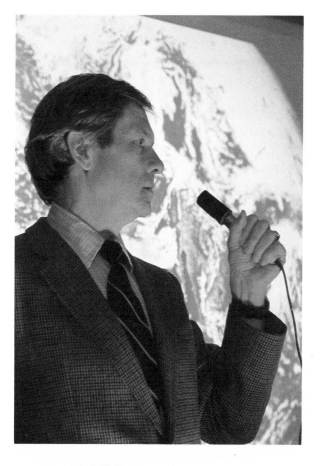

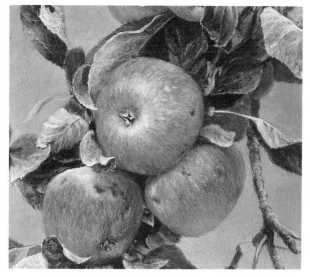

THE AUDITORIUM is dark and crowded. Several hundred people are staring at a still image on a projection screen while listening to the disembodied voice of Robert Bateman. He is low-key, self-deprecating, occasionally cracking a joke – he might be sitting in a living room chatting over a beer, rather than lecturing to a packed house. Some members of the audience shuffle uncomfortably in their chairs. Bateman has been showing slides and talking for an hour and a half; the room is warm and stuffy. Besides, what he's telling them isn't exactly what they've come to hear – amusing anecdotes about the life and art of a successful painter of nature (although his talk has certainly included some of these as well). No, he's talking in his quiet, earnest way about the image they're staring at, which is an astronaut's view of the earth.

"The biosphere of the earth can be compared to the skin of an apple. And that's where everything is that counts, in that thin layer that goes around the planet earth. And there is now quite a bit of evidence that this little skin is being pushed beyond its capacity, that we cannot keep using it the way we are currently doing. For our children and

our grandchildren we have to start acting differently now."

There is more of the schoolteacher – indeed Bateman was a high-school teacher for twenty years – than the environmental evangelist in these slide talks. He is always eager to pass on what he has learned during his extensive travels – this time it is his observations from a year in southern Germany. Still, he isn't afraid to confront his listeners with grim truths or exhort them to action. And his words now carry considerably more weight and reach many more people than when he taught art and geography for a living and painted pictures in his spare time. He has become probably the world's most successful wildlife artist – his major

paintings now sell for well over $100,000 – and this success has made him into a public figure, a powerful spokesman for our threatened planet whose opinions are sought and whose speaking engagements draw big crowds. But his worldly success is only part of the explanation for his impact on the environmental movement. He has also been extremely generous to conservation causes with both his time and his money. His widely reproduced art has raised the awareness of people who previously took their natural inheritance for granted. Most immediately, he has a direct and personal way of communicating with his audiences. Although he is about to turn sixty, the young boy who fell passionately in love with nature is still very much a part of him.

Opposite: On the deck of his home in Saltspring Island, British Columbia, Bateman works on the 1985 painting, *Giant Panda.*

Top center: During a slide talk, Bateman makes a point about the astronaut's-eye view of the earth.

Top right: A detail from *Cardinal and Wild Apples,* 1987.

II The Education of an Environmentalist

BOB BATEMAN grew up in Toronto, Ontario, but in the thirties and forties that city was a very different place from the sprawling metropolis it is today. Then it was really an oversized small town in which wild nature was never very far away, thanks to the city's network of ravines – small river valleys that had been left relatively untouched by civilization. One of these ravines ran behind the North Toronto house where Bateman lived as a young boy.

"I would climb down over a low bank that my father had reinforced with cedar posts," he remembers. "Then I would find myself at the edge of a stream. The water was clear in those days and probably was still clear for another ten years or so after that – but it was a real stream, a tributary of the Don [River] that flooded in spring and produced a wonderful variety of creatures that I would capture, learn about, and let go free again – minnows and polliwogs and even painted turtles. Today this stream is a storm sewer, buried and underground. . . .

"Our woods were a remnant of the beautiful mixed deciduous and coniferous forests of maple, beech, ash, pine and hemlock that covered the whole area in pioneer times; but because of the water level, the dominant tree was the willow. Some of the largest willows that I have ever seen anywhere grew in our ravine. To a young lad they seemed like Amazonian giants. This jungly illusion was enhanced by a rampant growth of

fox grapes and Virginia creeper that provided me with natural forts and castles."

From an early age Bob Bateman was hooked on nature the way some kids today are hooked on computer games. It's not easy to explain why, except that nature was close at hand. Neither of his parents was a naturalist by avocation, although both of them loved the country, and the family spent weekends and vacations at the cottage they had purchased on a lake in Haliburton in northern Ontario. But Bob seems to have discovered the delights of nature on his own and to have become part of an enthusiastic group of neighborhood naturalists, several of whom went on to become professional biologists.

Bateman's early passion was for birds, an interest he retains to this day. Many nature lovers start with birds, perhaps because, in the words of nature writer Charlton Ogburn, they "represent for us an escape from confinement and abridgement," an escape that seems ever more difficult in our technological age. Birds are an ideal subject for the fledgling naturalist. The most common North American birds are relatively easy to see, and many of them are quite colorful. And, once you've had a taste of discovering and identifying them at a basic level, you are enticed into increasing levels of complexity and sophistication. It's easy enough, for example, for a beginner to spot a male red-winged blackbird with his vivid red and cream epaulets, but identifying the

dowdy brown female, which looks disconcertingly like a large, striped sparrow, takes practice. And some wood warblers in their fall plumages can only be distinguished by their voices.

Learning to identify birds develops all the basic skills a naturalist must have. You need to use all of your senses as well as your brain – above all, your eyes. "What really makes a naturalist?" asks Gerald Durrell in his book *The Amateur Naturalist*. "Well, I think that a naturalist first of all has to have a very enquiring mind. He seeks to observe every little variation in nature and to try to discover its origin and function." From about the age of eleven, when Bateman first discovered birding, he seems to have exemplified Durrell's description. No living thing was too small to escape his eye or too insignificant to be recorded in his sketchbook. He was soon delighting his parents and his friends with his drawings and paintings of the natural world – especially his birds.

Opposite center: A common loon sketched in the early 1940s.

Opposite right: A self-portrait of the artist at age sixteen.

Above: Sketches of a raccoon that was a teenage pet.

Right: A page from one of Bob's 1943 sketchbooks.

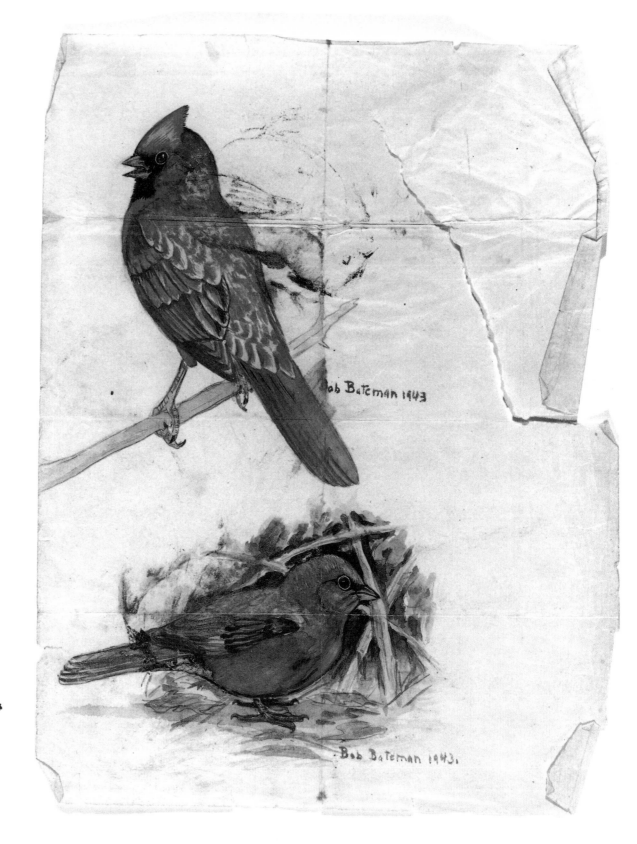

Bateman himself can't remember when he started making pictures of nature, but it must have been very young. Not long ago his Sunday school kindergarten teacher turned up at a book signing, informing him that while the other kids just splashed paint around, he was drawing rather precise and careful flowers. No examples of these very early works survive, but later childhood efforts do attest to how early Bateman's talent blossomed. For suitable subject matter he needed look no farther than his own backyard.

"I remember one day," Bateman has written, "sitting in a brilliant, fragrant bower of wild plum blossoms waiting to see what birds would come to me." The day in question was a May morning in the early 1940s – when he was perhaps eleven or twelve – during the annual invasion of migrating wood warblers, a warbler "wave." He had gone into his backyard ravine wilderness armed with field glasses, his copy of Roger Tory Peterson's *Field Guide to the Birds* and sketch pad to observe the show. Another budding Toronto naturalist, John Livingston, vividly recalled such a morning in a similar ravine a few years earlier: "That day there was an unusual number and variety of warblers … I hid motionless in my retreat and watched the parade. I was surrounded by birds – darting, fidgeting, flashing, shimmering – a magnolia warbler, a black-throated blue, a black-throated green, a myrtle! And I could now *identify* the birds, which brought me infinitely closer to

them." Such scenes, endlessly repeated in different seasons and varying habitats over the next few years, formed the basis of Bob Bateman's education as a naturalist.

Bateman has compared the process of learning about nature to the one children go through as they learn language. First there is the simple act of naming things, then comes a rudimentary grammar: "As you progress, you learn to read whole paragraphs – brief wilderness essays. Their subject is invariably the relationships between things – what scientists refer to as ecology. A marsh stops being just a place to observe waterfowl or listen to frogs croaking. It becomes a place of complex interaction between plants and animals, prey and predator species, all existing in an elegant balance. The naturalist is fascinated by both individuality and interrelationship, and that's what ecology is all about." In those days, of course, *ecology* was not a word in common use.

Bateman the young birder soon became adept at identifying species and subspecies, often with only the sound of a bird's voice as a clue. But simultaneously he was developing a philosophical attitude toward the natural world – and by extension the human world as well. At some point in this educational process, Bateman came to a conclusion that has become a central part of his credo. This new perception was about the infinite particularity and variety of nature. Every living thing, he came to believe, is a unique individual.

He now refers to this point of view as part of his personal "religion." It crops up frequently in his speeches when he is talking about an individual animal he has used as a subject. "I know some lions so well," he says, "that when I see them on TV I recognize them. Every bald eagle's face I've seen has its own individuality. It only stands to reason. Every zebra stripe is different, every human fingerprint, every snowflake is different, unique. Maybe every cricket has a different face, maybe every aphid. If we started thinking about the planet earth this way and paying attention to the particularity of the different species and the different races, we would probably have a different attitude toward wiping things out."

This passion for the particular is evident throughout Bateman's work. Specific, identifiable individuals appear in many of his paintings, albeit sometimes disguised for artistic reasons. His 1979 painting *Bluffing Bull – African Elephant* is a portrait of an old elephant with one tusk who lived in Amboseli Park. Although Bob had painted the animal with a second tusk, it was still immediately recognizable to a woman who knew the elephant well. Many of his early owl paintings used subjects he sketched and photographed at Ontario's Owl Rehabilitation Centre run by Kay McKeever, who could name the individual as soon as she saw the painting.

Of course, as a boy in his early teens, Bateman hadn't yet worked out his

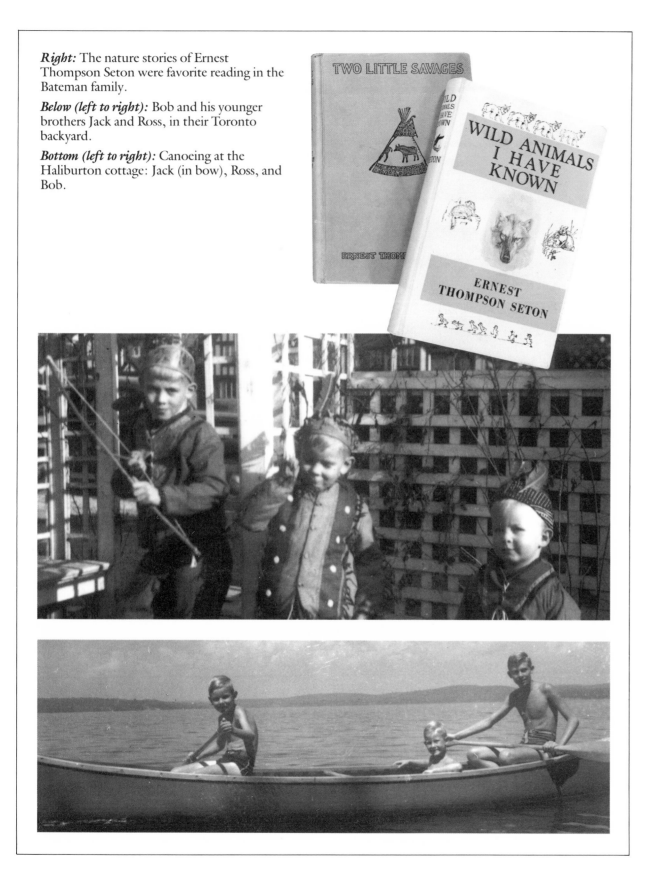

Right: The nature stories of Ernest Thompson Seton were favorite reading in the Bateman family.

Below (left to right): Bob and his younger brothers Jack and Ross, in their Toronto backyard.

Bottom (left to right): Canoeing at the Haliburton cottage: Jack (in bow), Ross, and Bob.

adult philosophy. Nor could he be said to have acquired a consciousness of environmental issues. It takes a while for the connoisseur of plants and animals to realize that they are disappearing and may some day be gone for good; longer to figure out what needs to be done about the problem. Yet when he looks back at these years he is aware of strong formative influences. Primary among these were the books of the artist and naturalist Ernest Thompson Seton, *Two Little Savages* and *Wild Animals I Have Known.* Long before it was fashionable, Seton wrote in ecological terms and questioned the prevalent notion that nature's value was measured by its usefulness to man. Bateman particularly recalls a Seton cartoon entitled "The Wildlife of the Future," which consisted of nothing more than a collection of bleached skulls.

When he was older one of Bateman's favorite books was *Driftwood Valley,* by Theodora Stanwell-Fletcher, a first-person account by a young American woman who had spent several years in a remote wilderness area of northern British Columbia. This book became "almost like a Bible" to Bateman. His mother would read aloud from it to him and his two younger brothers. And what he remembers about it now is "the feeling of spirituality of the wild, the wilderness, and also the vulnerability of it."

It was by influences such as these, combined with his own deepening knowledge of natural history, that

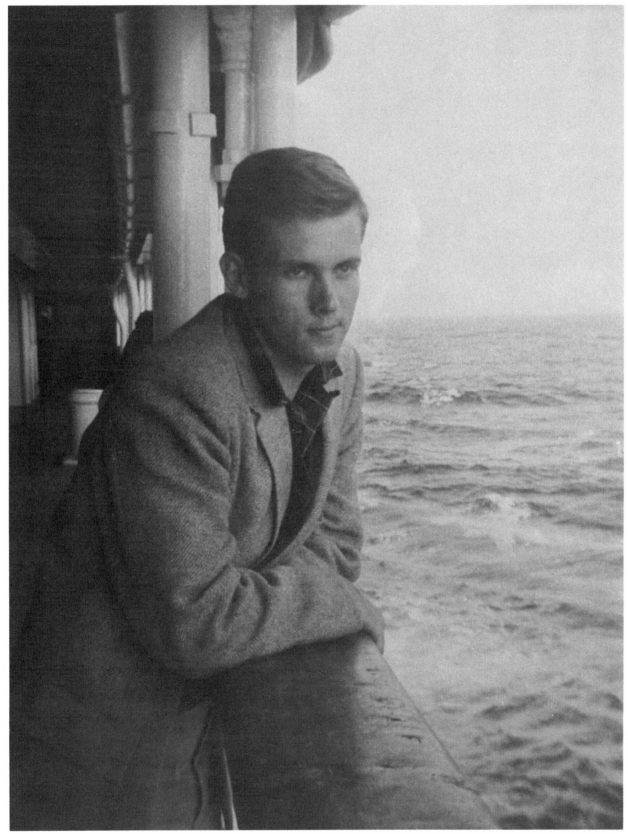

Bateman's reverence for the natural world was shaped. Inevitably this led to his first questioning of the values of the "civilized" world he had been born into. Bateman remembers one turning point – when he was in his early teens – when it first dawned on him that what he loved so much was being threatened. "Here I was, a kid in the forties living near the corner of Eglinton and Spadina [two major streets in Toronto]. A friend of mine kept a pony just northwest of there, where it was endless pasture. You could stand up in the hills and look west as far as the eye could see and it was rolling grasslands with little willow pot-holes full of birds nesting. In February and March we'd go there to see the first spring migrants of a particular species. Then we began finding bulldozers oper-ating in our favorite spots, and we'd find the potholes being filled in and the pas-tures being paved over. And it got so that we had to go farther and farther." Bob Bateman had come face to face with something called "progress."

During his teenage years Bateman began pursuing his love of nature and drawing in more formal settings. First there was the Junior Field Naturalists Club at the Royal Ontario Museum where he spent Saturday mornings in his early teens. It was here that he first came under the spell of the dean of Canadian wildlife artists, Terence Shortt. Then came the Intermediate Naturalists, a club he and some friends started when they had outgrown the museum's introduction to nature art and wildlife

biology. In 1947, when he was seventeen, he spent the first of three summers at a wildlife research camp in Algonquin Provincial Park in northern Ontario. He recalls now that while the biologists at the camp were concerned about the increasing acidity of Algonquin's lakes, they hadn't yet made the connection with air pollution. Acid rain was falling, but these scientists didn't know it.

Bateman was attracted not only to nature, but to naturalists, epitomized for him by Terence Shortt, who knew more about wildlife than anyone he had met. According to Bateman, "there's a wild and rugged outdoor adventurist aspect to most of these people; they are intrepid and willing to put up with a lot of discomfort. At the same time there's an intellectual component, a sensitivity and an aesthetic sensibility. Naturalists tend to be gentle people; they almost always have a sense of humor. They exude a sense of peace and energy at the same time." Gerald Durrell would agree: "The majority of great naturalists have been enormously modest, seeing themselves as very privileged to live in this magnificent and complex world and to be given the opportunity of unravelling some of its secrets." One of the most important things that characterized these people was their joy in the small and the unspectacular. They retained a sense of wonder that Bateman suspects is fast disappearing from Western culture, where we seem to need to have our excitement manufactured for

us – the bigger the jolt the better we like it.

In the early fifties, while he was earning his degree in geography at the University of Toronto and then his high-school teaching certificate, Bateman also became addicted to travel. Summer jobs on geological field parties took him as far afield as Quebec's subarctic Ungava Peninsula and the remote reaches of Newfoundland. In the summer of 1950 he and his friend Erik Thorn went by bus to British Columbia. In 1953, with his brother Ross and two college friends, Bob traveled to Mexico, including the Yucatan, which was the first time he encountered a real tropical rain forest. The next year, with Erik Thorn, he explored England, France and northern Europe.

This traveling bug culminated in 1958 when he and another friend from ROM days, Bristol Foster, set out on a trip around the world in a Land Rover. They had saved up enough money to get started; the rest they would earn along the way doing odd jobs including any work they could pick up at biological research stations or natural history museums. As they traveled they collected specimens for the ROM; as always Bob painted and sketched everything. Bristol Foster, who became a wildlife biologist and was until recently in charge of British Columbia's ecological reserves, soon got to know his friend's style of absorbing each new place. "Some people can be really intensive," he says. "Bob doesn't appear that way.

He is almost invariably easygoing and yet he's obviously soaking things up like a blotter. He's very rarely in a panic but he's always steadily using his binoculars, or his ears, or his pencil, or something."

Their trip took them to Africa, Nepal, India, Southeast Asia, Malaysia and Australia and introduced Bateman to a natural world of wonders. Above all he fell in love with the infinitely rich ecosystems of the rain forests and the great mammals of East Africa. Since that first trip, he has returned to East Africa many times – it was his paintings of East African wildlife that launched his art career – and he often refers to it as the Garden of Eden, one of the last places on earth where man and nature have lived in complete harmony.

After the trip, Bateman returned to his teaching career, taking a job at a high-school in Burlington, Ontario, then still a small satellite town of Toronto. Although he'd returned to home turf, he'd come a long way from the imaginary jungle of his backyard ravine. He had acquired a global perspective.

x1

July 4 1952
South Brook
beside a river
ht. 20"

Opposite: A twenty-seven-year-old Bob Bateman sets out on his year-long trip around the world.

Right: Sketch of a wild blue-flag iris done during a visit to Newfoundland.

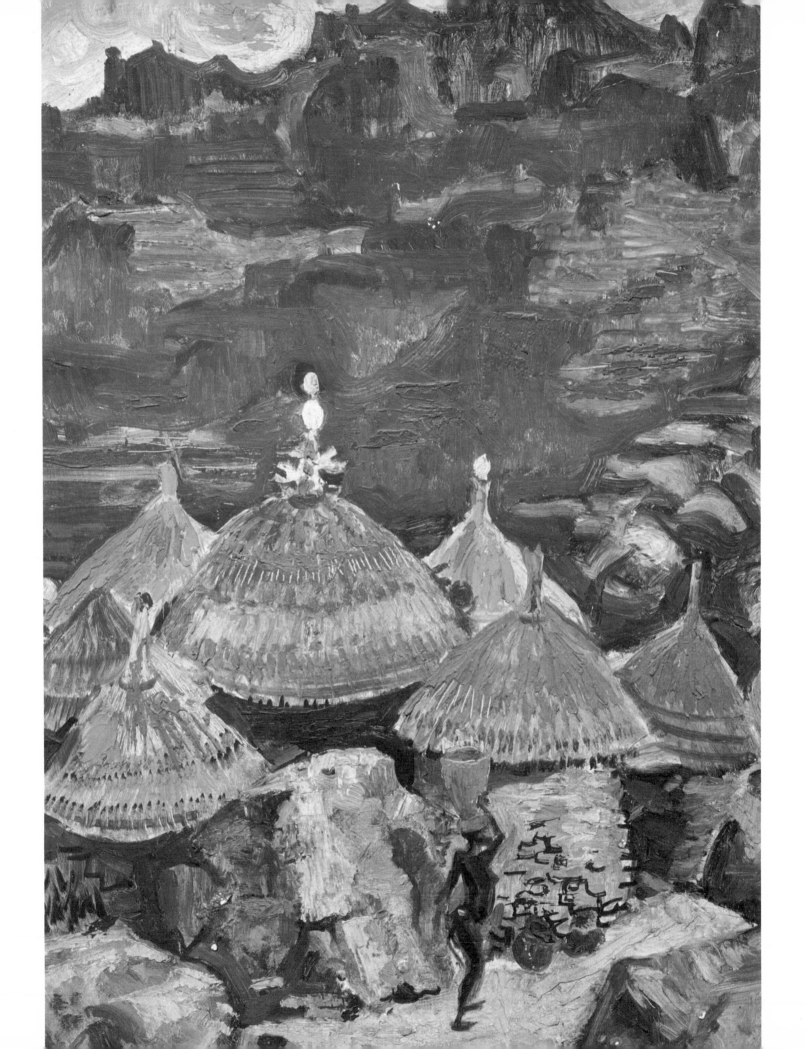

III Teacher and Activist

THE YEAR IS 1965; the place, Government College Umuahia, Nigeria. A boyish-looking Bob Bateman, now thirty-five, stands on a slightly raised platform in front of the blackboard and surveys the neat rows of wooden-topped desks with cast-iron sides, each one occupied by a lanky black teenage boy in the khaki school uniform. This is the geography classroom where Bateman has taught most of his classes for the previous two years. The cracked, green-painted cement-block walls are adorned with moldering maps and framed photographs of school patrons. Although a breeze is blowing through the open windows along both sides of the room, the air is hot and muggy, carrying a pleasant blend of the smells of mildew, lush vegetation and cement floor polish. Outside the sunbirds and whydahs are twittering and chattering. When Bateman speaks it is in the crisp accents of Nigerian English, the lingua franca of this former British colony.

The subject of today's lesson, as it has been for all of this final semester of senior geography, is old exam papers. Bateman has had to make more adjustments to his teaching than learning a Nigerian accent. The Socratic method that worked well with his Canadian pupils has been replaced by straight lectures. Everything is geared to passing the final exams that are set and marked in Oxford and Cambridge. Success at these exams is the ticket out of a backward village to a good job and some of the conveniences of modern life. Ironically, the Nigeria that fascinates Bateman – a world of teeming nature, tribal cultures and a primitive but dignified way of life – is being actively rejected by his students.

Bateman's two years in Nigeria were the most difficult of his teaching career. Back in Burlington his relaxed style would continue to go over well until he stopped teaching for good in 1976. He still traveled whenever he could and brought his experiences of exotic places into his art and geography classes as illustrations of the points he was trying to make. The slide talks people now pay to attend began with his high-school students – they were a way of making his lessons personal, entertaining and accessible. Bateman has always been a prolific photographer as well as sketcher (he uses both sources for his paintings), and the slides frequently came from his own growing photo archive. Although nature wasn't specifically on the curriculum, he brought it into his classes wherever possible. If he were talking about the geology of the Grand Canyon, he would describe his own difficult trek down and back and supplement his comments about the geology of the place with observations about plant succession and the wildlife he had seen.

He also insisted that his students learn the basic nature vocabulary of the place they were living – southern Ontario. He expected them to be able to identify the twenty most common birds, trees and herbaceous plants; and he would pop the occasional surprise slide quiz to see if they had been paying attention. Bateman feels that this sort of thing should be part of the school curriculum. He now sees education as a key to creating the changed awareness necessary before we'll start to respect what we've been given. You can't respect something you can't even name, he would argue. If you can conjugate French verbs you ought to be able to name common garden birds: "If we can identify the various species in the nature that's around us, we are much more likely to treasure it than if we have this attitude, 'if you've seen one bird, you've seen them all.' With this attitude if a whole species goes missing, we won't notice. If we are able to identify things, we are more likely to be responsible citizens of the planet."

In addition to bringing nature into the classroom, Bateman took every opportunity to get both his art and geography students out of the classroom and into nature. On these field trips he would draw his pupils into the complexity of their surroundings by turning the outdoors into a puzzle for them to solve. This is the same method he uses whenever he leads a nature walk, something he has done many times. On these guided tours through a particular patch of nature, he pointed things out, but mainly he asked a lot of questions.

Opposite: An African village painted during the two years Bateman taught in Nigeria.

For example, he might have had his students stand in one place, then said to them, "This is like a detective story. I want you to tell me what this place was like a hundred years ago and what you think this place will be like in another hundred years." Then he might have given them a few clues, perhaps the information that the trees in this part of southern Ontario grow at the rate of about a foot a year. After that it was up to the students to solve the mystery by observing and asking questions. Through this process he hoped they would learn more than the facts about a particular place. He wanted them to understand that "everything is significant and everything is related to other things."

His art classes were also given a large helping of nature appreciation. One of his favorite exercises was to get his students to make a picture of every aspect of a particular place outdoors – he was teaching them to soak up their surroundings the way he had learned to do: "Each person found a secluded spot and described everything his senses detected – in both words and pictures. I would encourage the students to close their eyes and just listen to the sounds around them, then attempt to write down every one. This is a wonderful way of heightening awareness, a sort of focused meditation on nature."

Soon after he started teaching in Burlington, Bateman joined the Federation of Ontario Naturalists. Founded in 1931, the FON had been started as a means of bringing together the local naturalists' clubs that were springing up around the province, to promote an appreciation of natural history, and to protect natural areas. Still a relatively small organization when Bateman signed on in the early 1960s, with roughly 3,000 individual members, the FON was then quite close to its roots in the early North American conservation movement that had begun in the late nineteenth century with the establishment of Yellowstone, the continent's first national park. According to former FON president John Livingston, the organization was comprised of birders, naturalists and botanists – "people who just loved to be outdoors and wanted to share their experience." Not long after Bateman joined, he found himself serving on the executive.

The 1960s saw a change in attitudes to conservation and the birth of a new, much more broadly based and less unified environmental movement. This was the decade that saw the publication of such books as Rachel Carson's *Silent Spring* (1962), which documented the shocking ecological and health side-effects of the widespread use of chemical pesticides and herbicides. (Thanks to this sort of publicity the pesticide DDT was finally banned and many species threatened by its use started to make a comeback.) The world was shrinking and the population exploding; predictions of environmental catastrophe filled the air. Inevitably, the FON, like other naturalists' organizations, became more political, and its membership expanded rapidly. By 1971 it was up to 15,000. And in 1972 the FON launched its can campaign, an attempt to persuade the Ontario government to ban disposable containers. Stickers were distributed urging citizens to "Mail a Can to John" (John Robarts, then premier of Ontario). This created lots of publicity for the organization and attracted still more members, although it had little or no effect on public policy. Nevertheless, Bateman remembers the campaign with pride; it was one of the first really activist efforts he became involved in.

The real and lasting work of the FON has been in conservation and preservation. It has been instrumental in lobbying for provincial parks and conservation areas, and it founded the Nature Conservancy of Canada, which acquires and manages land requiring protection. There remains a great deal to do. In most ways Canada has lagged behind the United States in wildlife conservation. This is in large part due to more rapid development and population growth south of the border, where the problem of the disappearance of wildlife was more obvious sooner.

Around the time Bateman joined the FON, conservationists and naturalists decided it was time to take action to preserve what remained of the region's most impressive geographical feature, the Niagara Escarpment. Formed by the upturned and exposed strata of an ancient lake bottom, the escarpment is both a classroom of geological history

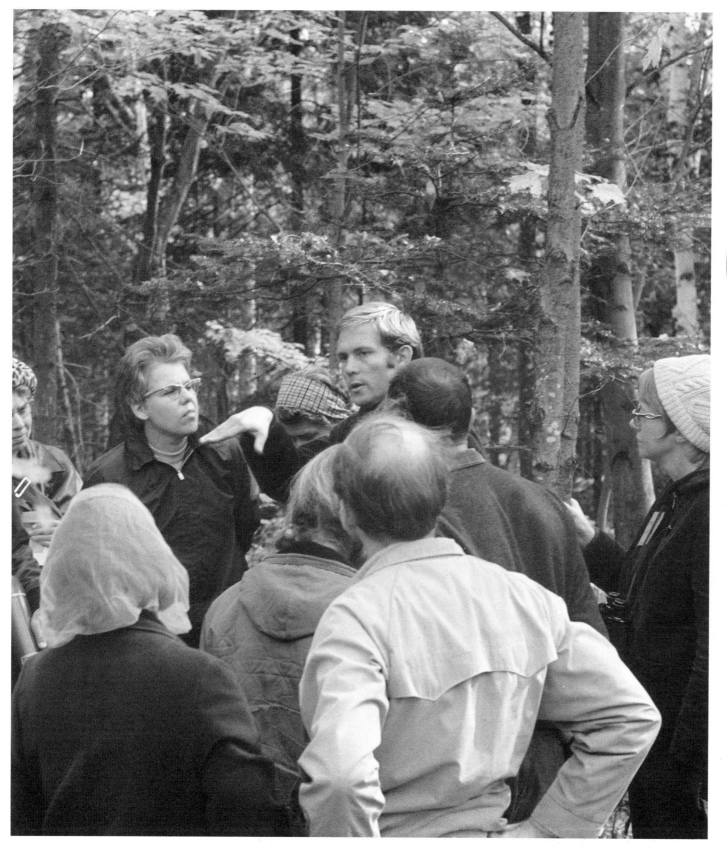

Left: Bateman leads a nature walk in the woods of southern Ontario.

Below: A detail from *Daisies and Viper's Bugloss,* 1970.

and home to a precious variety of habitats.

The piece of the escarpment that lies in Ontario runs roughly four hundred miles from Niagara Falls to Tobermory at the tip of the Bruce Peninsula. In the late fifties, a member of the Hamilton Naturalists Club named Ray Lowes had the idea of building a continuous hiking trail, similar to the Appalachian Trail, that would follow the escarpment. The members of the Federation of Ontario Naturalists, Bateman included, soon became enthusiastic proponents of the scheme and took an active part in promoting the idea and helping to build the trail. In the words of FON historian J. David Taylor, "They envisaged not simply a hiking trail, but a comprehensive plan to control land use and development so that the jewel of southern Ontario would not be gradually destroyed."

In late April 1962, with the trail partially complete, Bateman took part in a 117-mile trek from Waterdown to Craigleith that was part publicity stunt and part scouting expedition for possible trail routes. The hike was the idea of Toronto *Telegram* reporter Harvey Currell, who published a report of the expedition in the Toronto daily. Along with Ray Lowes, Currell and four others, Bateman spent six days walking and camping along the escarpment. He still recalls the event with great fondness: "It was one of the most pleasurable experiences I've had. Of course, it was difficult – everybody got blisters on their feet and

so on – but it was really wonderful, partly because of the fellowship, hiking for twenty miles or so every day and just chatting with all these interesting people and camping every night."

Once the trail was completed in 1967, Bateman became one of the dedicated army of volunteers who helped maintain it. (In 1966 he designed and built a house on escarpment land in Halton County near Burlington; the trail cut through a corner of his property.) He also became one of the most vocal advocates for its improvement. Much of the trail passed over private land, and its course kept shifting as ownership changed or existing owners lost patience with inconsiderate hikers. By the early eighties it looked as though Lowes' dream was in danger of crumbling as more and more of the trail route was forced off private property and onto public roadways. Since 1985, however, this trend has been reversed thanks to the Ontario government's Niagara Escarpment Land Acquisition Program. According to Bruce Trail Association director Doug Robertson, by 1995 eighty-five percent of the trail will be secure, a 440-mile footpath that links 105 provincial parks and conservation areas "like pearls on a string." Although Bateman now lives on Canada's west coast, he is still a member of the Bruce Trail Association and donates artwork for the annual calendar.

In 1963, as he was preparing for his stint teaching school in Nigeria, Bateman had the first glimmerings of an idea

that was to become a major theme in his thinking. He was pondering what he would tell his Nigerian students about Canada – "ordinary things like having a picnic, which they don't do in Africa." He went around Burlington and the local area taking photographs of everything from the high-school parking lot to old farmhouses, fields and orchards. As he recorded these images he began to realize that many of the things he was photographing were fleeting. A seed, planted when the teenage birder watched some of his favorite habitats being paved over to make way for progress, began to germinate.

After he returned from those two years in Africa – where his paintings of East African wildlife began to enjoy major success – he started to prepare for his first one-man show in Ontario. Since this would occur in 1967, Canada's centennial year, he decided to make the show his personal centennial project. As subjects he chose only things that had existed in Halton County in 1867 and still existed in 1967. These paintings combined his love of our human heritage with what he felt for nature. As he worked he became more and more aware that his man-made subjects were about to disappear as the Toronto building boom of the fifties and sixties spread in his direction. "I began to realize that this historic heritage that I cherished was disappearing."

Other experiences helped bring this idea into focus. Not long after his successful centennial show, Bateman was

invited to give a talk to a big convention of crafts teachers. This was a natural forum for him, since he has long been fascinated with aboriginal and folk culture. On his trips abroad he is as interested in the old ways that haven't yet been eradicated by technology and progress as he is in the flora and fauna. He is also a great appreciator of traditional crafts and of indigenous architecture that uses natural, local materials. He loves the weathered old pineboard barns of southern Ontario, for example, and the stump fences left by the pioneers who first cleared the land.

In his various trips around the world Bateman had gathered quite a collection of crafts from many lands, and he planned to show the teachers slides of these to illustrate his talk. While he was preparing the slide talk, he suddenly began to wonder what he would do if his collection of artifacts was destroyed: "The thought occurred to me, 'What if I came back from a trip and found that my house had burned down?' Then I said, 'That would be too bad, but I could build the house again.' Then I asked myself, 'What about all the things that I've collected on my various trips, and all the slides?' And I said, 'Well, I would just go around the world and collect them all again and take the slides again.' But then I said to myself, 'No, I couldn't do this, because these things have disappeared.' I started to think of the many places that I used to go as a kid where I walked or looked at birds, and they'd disappeared, too. So I started to

realize that we are living in a disappearing world, that we are wiping out the natural and human diversity of our planet."

This idea became the basis for a slide talk he would give many times over the next few years – and he is still giving a version of his disappearing world speech twenty years later. In these public appearances he would talk about the accelerating pace at which species are being wiped out, particularly in the tropical regions where rain forests were already being cleared at an alarming rate, threatening the planetary gene pool and increasing the chance of environmental catastrophe: "It seems likely that before much longer we will reach a kind of biological dead end. Everything that can disappear will have already disappeared, and everything else will be managed or programmed." (Indeed, biologists estimate that we are currently exterminating one species of plant and animal every hour, and that by the year 2000 the rate will be one species every fifteen minutes.) A few years after Bateman began giving this speech he was able to point to the paintings he'd done in 1967 and say that none of the man-made artifacts he'd painted then were still standing.

Bateman was pitching a much broader message than the simple preservation of species or heritage homes, however. What was being lost were not just things that he and a few other lovers of nature, crafts or architecture would miss. The variety that makes the world interesting and life worth living was

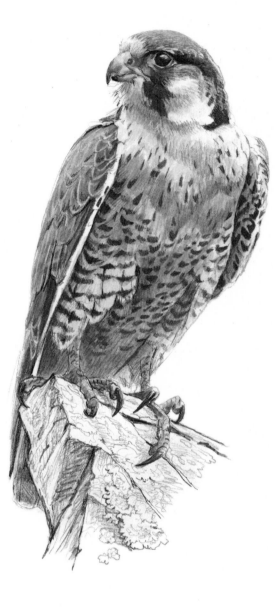

Above: A peregrine falcon sketch done in 1988.

Right: *Ireland House*, 1977, depicts a fine example of southern Ontario Loyalist architecture of the early nineteenth century.

Bottom left and right: The old Fisher house in Burlington, Ontario, before and after demolition.

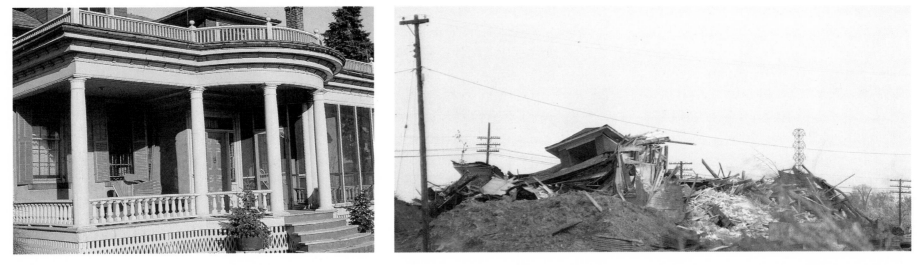

being replaced by an "instant-pudding" culture: "Like instant pudding, the world we live in has become increasingly bland and smooth and sweet. It comes in a small range of flavors, all artificial, and we have no control over any aspect of it apart from choosing between artificial Swiss mocha or artificial English Tudor. We don't even know what the contents will do to our systems. We are simply consumers of a commodity. In this instant-pudding world there is no place for the random or the unexpected, the happy or unhappy accident."

Almost all the slides Bateman showed in his disappearing world talk were of man-made things, man-created environments. It was as if he were asking his audiences, "If we don't value and care for our own culture, what is the point in trying to halt the rapid march toward biological extinction?"

One of the most compelling transitions in the talk was a series of slides that began with an Ontario heritage home, the old Fisher house in Burlington. He had photographed this charming nineteenth-century structure only a week before it was torn down to make way for the new Burlington Mall, and he had framed the shot tightly so that his audience couldn't see the already devastated surroundings. The next picture was the scene a week later – the house a total wreck in a bulldozed wasteland. The shopping mall itself was next, the ultimate in instant pudding. Now he would ask his audiences, "Can you feel anything deep in your heart about your local shopping plaza? Can your kids who hang out there?"

With this rhetorical question left hanging, the scene on the projection screen changed to a poor but well-kept Nigerian village – a winding dirt road, thatched roofs and palm trees. The people who live here, he would say, still have some control over their own destiny and thus a much stronger sense of belonging to their place and of their place in the world.

The final picture in the sequence was of the central plaza of the same Nigerian village. Two leaves lying on the carefully swept dirt were the only visible blot on the otherwise immaculate scene. The next time somebody walked through that village square, Bateman would inform his listeners, those leaves would be cleaned up: "When was the last time you were in your local shopping mall and you saw someone bend over to pick up a chocolate bar wrapper or a pop can?"

In the early seventies Bateman continued to give this talk to anyone who would listen while looking for other ways to make a difference in the disappearing world. In 1972 he became the "token naturalist" on the Niagara Escarpment Commission, a government-appointed body set up to devise a plan to preserve the escarpment as a continuous natural area, the same vision held by those who conceived the Bruce Trail. If he had harbored any lingering love for the North American obsession with "progress," this was dispelled during his tenure on the commission: "Most of the commissioners were men who were in municipal politics from up and down the escarpment, and as we tried to develop our plan, I kept finding a very key attitude or assumption coming through – the assumption that you can't stop progress. Most were older than me, and they had witnessed what was happening in the towns and villages surrounding Toronto. They had seen family farms failing one after the other and the farmers pocketing half a million dollars or a million dollars and retiring to Florida. They had seen the land owners in the little towns becoming quite rich. Their brains were imprinted with the phenomenon of progress. They thought it was a perfectly natural condition that would always continue. The idea that bigger is better and more is better and that everybody is going to get rich quick is a phenomenon that's fairly recent. And I was like Horatio at the bridge trying to defend this little patch of nature we had left."

At this time Bob also got involved in several conservation organizations he supports to this day. According to his friend Kay McKeever of the Owl Rehabilitation Centre, when they got together socially during this period, conservation and the environment was all they ever talked about. "I mean, it was almost our whole discussion, the degradation of the environment," she says. One of the lasting associations Bateman made at this time was with the Elsa Wild Animal Appeal, the international conservation

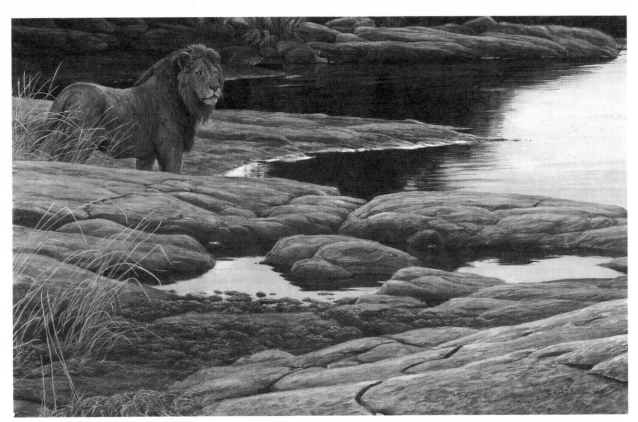

whole. It will reduce alienation and things like vandalism and give people more of a sense of identity and belonging."

At the same time as he was developing his ideas about the disappearing world and the economics of aesthetics, Bateman's artistic career was finally taking off. For most of his adult life, painting was something he did in his spare time. Every afternoon after school he would come home, take a brief nap and then work at his easel until ten or eleven o'clock. By the mid-seventies he was finally experiencing some solid commercial success, and painting full time became a real possibility.

organization founded by artist, naturalist and filmmaker Joy Adamson after the huge success of her film *Born Free*. When Toronto high-school teacher Betty Henderson was launching the Canadian chapter in 1971, she phoned Bob and asked him if he would join the founding board. He soon found himself doing cable television interviews and giving his disappearing world talk to auditoriums full of high-school students as a way of raising Elsa's profile. Henderson remembers how good he was at reaching those teenage audiences: "He went over very well wherever he spoke because he's got a marvelous gift. He would make the audience aware of what was happening to our own environment. It was never a depressing story. He is, as

you know, a very positive person." Bateman himself says that as he has given the speech over the years, he has changed it to end on a more positive note. He now talks more about the progress that is being made and the concrete things individuals can do.

As an artist, Bateman is very tuned in to aesthetics, and he has increasingly come to believe that "good aesthetics makes for good economics" and decreases individual alienation. He is almost certainly on to something. A recent study of crime in the Toronto subway system discovered that the most attractive stations were also the safest. "If something has a pleasing appearance, and also has a particularity to it," he says, "it will be good for society as a

Left: A detail from *Lion at Tsavo,* 1979.

Below: A Nigerian woman, 1965.

Right: The Bateman family on safari in East Africa in 1987. Left to right: Birgit, Robbie, Sarah, Bob, John, Christopher.

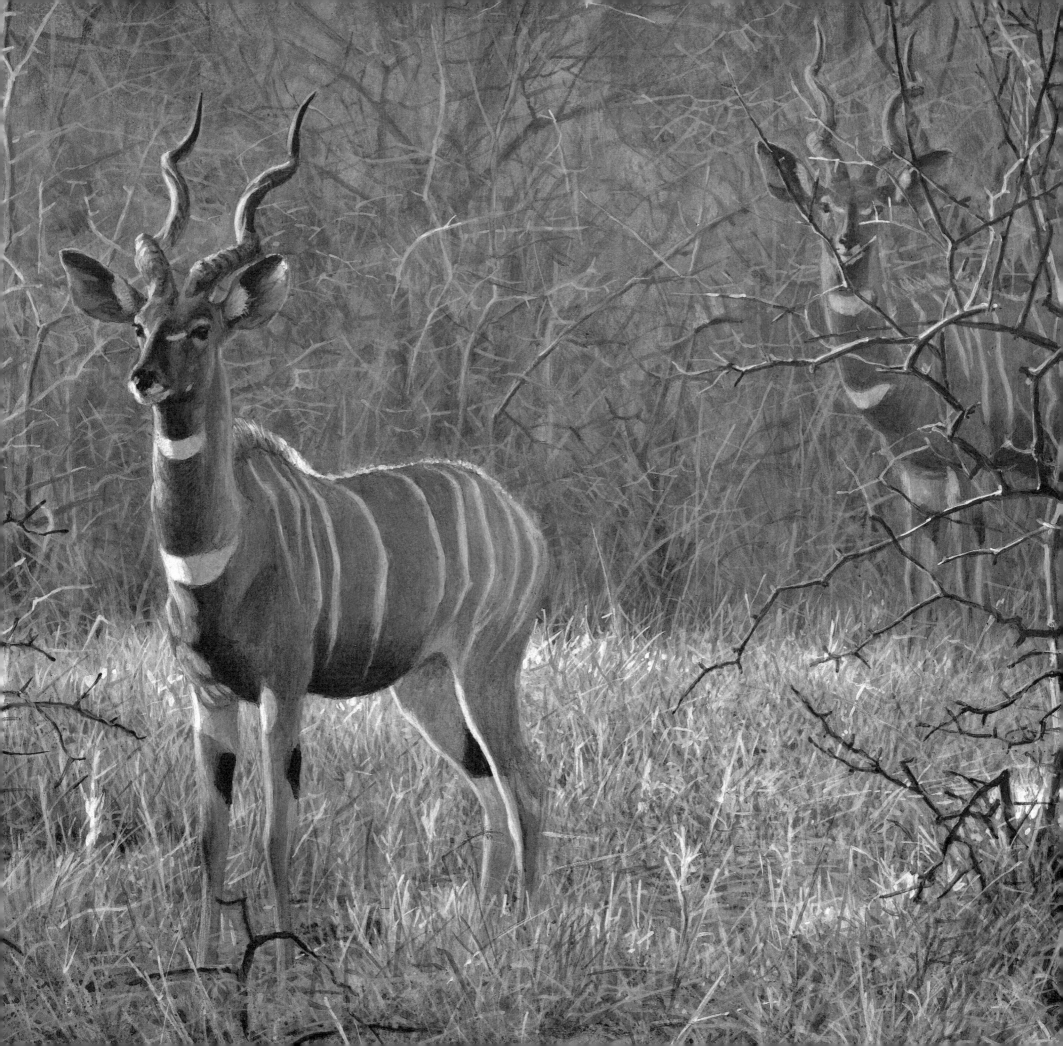

IV An Ecological Artist

IT IS ABOUT AN HOUR before dusk on a dusty back road on a brushy ridge in Meru Park, Kenya. Riding in the back of a Land Rover are Bob Bateman, his wife Birgit and son John, who are peering intently into the acacia trees and scrub bushes. This is the last of their three days in the park, and they are hoping to sight the lesser kudu, one of the most noble of African antelopes, but usually skittish and difficult to see because of its thicketed habitat. As the vehicle slowly rounds a bend there is a collective intake of breath. Only a few yards away, etched in late afternoon sunlight, is a magnificent male kudu. Their driver, an African guide, brings the jeep gently to a stop while the antelope continues to quietly nibble leaves. Then another male emerges from the trees nearby. Awe gives way to action as photographs are snapped and Bateman sketches furiously. It is one of those beautiful golden moments that keep bringing him back to the great game reserves of East Africa: "I have seldom seen such a lovely sight. The whole scene had a translucent quality because the kudus were all soft browns and grays and beiges and so were all the twigs of the background and everything was caught in this lovely slanting light."

This trip in August 1988 is the seventh time Bateman has been to East Africa since his first visit with his friends Bristol Foster and Erik Thorn in the late fifties. He says he will keep going back as long as he can. The great game reserves, originally established by farsighted British colonizers, have become lodestones in his life and in his art. He speaks of them now with almost religious reverence, in particular of his favorite area, the Masai Mara Game Reserve in southwestern Kenya: "It's a thrilling encounter with primordial nature. It's the world as God made it." And he can wax lyrical about its pleasures: "At daybreak you're on the road – which is no road but the one you choose. The darkness gives way to a golden, living light, and you watch and wait to see what the land will reveal. Perhaps the morning will find you driving across a dusty plain, surrounded by an enormous herd of murmuring, shifting wildebeests. The afternoon may bring the sight of a lioness at play with her cubs, or a glimpse of a cheetah as it flashes through a sunny glade. At day's end your path may take you through a field filled with the scent of acacia blossoms."

It may seem ironic that this aficionado of the intimate and the close to home – the artist for whom not even a blade of grass is insignificant – should have found his artistic voice painting the grand animals and landscapes of East Africa. But this is exactly what happened. From roughly the age of eighteen, when he started to pursue the path of the "serious" artist, until he was in his early thirties, Bateman was an artist in search of a style. Although he continued to fill his sketchbooks with realistic renderings of the plants and animals he observed in the field, he pigeonholed these images in his mind as scientific illustrations. Meanwhile, his serious art ranged the stylistic gamut from impressionism to cubism. At one stage he adopted the bold expressionistic style of Canada's Group of Seven. But even as he experimented with abstract expressionism or imitated Chinese paintings of the Sung Dynasty, his love of nature shone through. "During this whole period, though I painted in many different styles, I generally chose subjects in nature, as opposed to, say, wine bottles or the interiors of rooms."

Then in 1963, a few months before he was to leave for his teaching job in Nigeria, he went to see a major exhibition of Andrew Wyeth works at the Albright-Knox Gallery in Buffalo – an hour's drive from his Burlington home. He was bowled over. For the first time he encountered the work of a serious contemporary artist who was also a realist. It was the pivotal point in his artistic development, an experience that set him on his present course: "Here was an artist involved with the real world, who wasn't concerned with only the surface of the paint, as I was then. When I saw the Wyeth show it all came together, and I realized that of course I was interested in the distinctions between trees as well as the mass of form and color. I went back to naturalism, but kept the

Opposite: Detail from *Lesser Kudus*, 1989.

impressionism and cubism as underlying concepts for picture ideas."

Bateman arrived in Africa with images of Wyeth's painterly realism dancing in his head. But the Nigerian landscape did not fire his creative impulses. It wasn't until a school vacation allowed him to journey again to Kenya that he found the subjects he was looking for. Back at Government College Umuahia, after a day struggling to communicate with his Nigerian geography classes, he went home and painted images of East African wildlife – elephants, antelopes, buffalo – in the realistic style he quickly became known for. The naturalists and biologists to whom he showed his work were impressed with his attention to scientific detail and his ability to capture the essence of an animal and its movement. So were the people who passed through the Fonville Gallery in Nairobi and bought these early works. And so was Roger Tory Peterson, author of the famous field guides and one of the world's great naturalists, who saw a Bateman painting hanging in a friend's house in Nairobi during this same period – a wildebeest in full gallop. Peterson later wrote, "The wildebeest on the wall was handled simply and impressionistically, reminding me not a little of the wall paintings of game animals by Stone Age men in the caves of southern Europe, except that it was obviously more sophisticated." Although Peterson didn't meet Bateman until ten years later at the 1975 Animals in Art exhibition at the Royal Ontario Museum in Toronto, he knew from this one painting that Bob had found his voice: "It was very understandable then that he was going to go places because he had that observational skill, and he had got the essence of a movement."

Peterson, who is classically trained and a fine wildlife artist in his own right, notes that while Bob was inspired by Wyeth, and his technique of building a painting from bold abstract patterns is similar, the end result is very different: "There is an immediacy in the paintings of both Bateman and Wyeth but there is also a profound difference between them. Wyeth nostalgically freezes the moment, holds on to it, whether he portrays the boy in the coonskin hat, the farmhouse of yesteryear, or the nubile young girl brushed by light from an open window. It is a moment suspended forever. In contrast, Bateman's subjects are ready to go somewhere else, to fly away. His creatures are invariably off-centered. They enter from off the canvas or are heading out toward the edge. A pheasant hurtles beyond the limits of the painting rather than flying toward the center. This apparent imbalance gives Bateman's compositions a marvelous sense of action; a split second later the bird would be gone." Wyeth makes time stand still; Bateman highlights its fleeting quality.

When Bateman returned from Nigeria to southern Ontario, he began to paint more familiar creatures and landscapes, honing his technique and experimenting with compositions that drew on all his stylistic experiments. One of the first paintings he did at this time, *Rough-Legged Hawk in Elm* (1966), was actually the reworking of a painting he'd done in 1962 in an abstract impressionist style influenced by Franz Kline and Oriental calligraphy. The result still has a powerful abstract quality, the dark "negative spaces" of the tree trunk playing off against the "positive spaces" of the light background, but is very much the Bateman we know today – right down to the loving and dexterous recreation of the texture of the elm bark.

Although the locales of his paintings have wandered as far from home as Antarctica, Alaska and the Galapagos, the great body of Bateman's work is set in North America. And until his 1985 move to Canada's west coast, Ontario subjects predominated. It is not exotic settings or rare beasts that have ultimately established his reputation, but his particular approach to familiar subjects. Many of his most impressive paintings are of tiny patches of nature – a baby cottontail almost invisible among a carpet of fallen leaves, a meadow vole peering out from under the carnage of a mowed meadow, a winter wren at the foot of a snowy trunk, its mottled plumage almost an extension of the bark.

Today, twenty-five years after those first African canvases began to capture the attention of critics and nature lovers, Bateman has secured his place as one of

the world's foremost practitioners of wildlife art, a field that has grown astonishingly in recent years. Bateman was a leader in the modern movement away from wildlife painting as primarily animal portraiture (most often commissioned expressly as book or magazine illustration) and toward the portrayal of animals within a fully realized natural environment. While he freely acknowledges his admiration for and debt to such early masters of bird portraiture as John James Audubon and Louis Agassiz Fuertes, among wildlife artists his inspiration has come from the likes of Canada's Major Allan Brooks and Terence Shortt, and Bruno Liljefors of Sweden, whom he describes as his favorite artist: "He was able to capture the whole feeling for a subject with flair and economy." If anything, Bateman's most recent major works are moving more in Liljefors' direction, toward a looser and more impressionistic use of paint.

Despite his commercial success – or perhaps in part because of it – Bateman is not taken seriously by the art establishment, a fact that still rankles. None of his paintings hang in a major art gallery, and his biggest show to date was held at the Smithsonian Institution's Museum of Natural History in Washington, D.C. – emphatically not an art museum. A frequently leveled charge is that Bateman and other wildlife painters do "mere illustration." These critics admit that the animals look like real animals and the landscapes look like real

Above: Bateman works on a corner of one of his biggest canvases, *The Wise One,* 1986. In the background hangs a print by one of his favorite artists, Robert Motherwell.

Left: Working directly from nature, a broken branch serves as a model for part of a painting.

places, but say it isn't fine art. "Wildlife art can only be elevated above the level of scientific illustration if it has a moral and spiritual dimension," wrote Hubert de Santana in a scathing assessment of Bateman's work that appeared in the magazine *Canadian Art*. Bateman's response to such comments is simple. He points out that some of the greatest art of all time, such as Leonardo da Vinci's *Last Supper,* is illustration. All he asks is that his art be judged on its artistic merits, not dismissed because of its subject matter.

A criticism he takes more seriously is that his art is too nice, that he avoids the savage or unpretty aspects of nature. *Washington Post* art critic Paul Richard, reviewing Bateman's big Smithsonian show in January 1987, put it this way: "His lions are grand, regal beasts, they don't claw at sweet gazelles; his eagles soar majestically, they do not stink of fish. Behind the sigh of breezes and the twitterings of birdsong, one tends to hear within his paintings stirring hymns and rousing anthems." Bateman admits that he hasn't very often painted scenes of a predator killing a prey or shown many dead animals in his pictures, but he isn't defensive about this. However, he laments the fact that none of his harsher pictures were included in the Smithsonian show. He paints what interests him, he says. But he takes umbrage at the implication that his art is primarily comfortable or reassuring. Many of his paintings are deliberately intended to make the viewer feel uncomfortable, he points out, citing such works as *Dead Gull* (1968) or the more recent *Carmanah Contrasts*: "I want them to be a little disquieting, a little bit disturbing."

Whatever the art establishment thinks of Bateman's work, he represents a phenomenon that is not about to go away. Wildlife art is booming, and he is but one of a rapidly growing number of naturalist-artists working in a wide variety of styles, but all painting pictures of the natural world.

Where does Bateman fit into this contemporary scene? Stylistically, the answer seems to be somewhere in the middle, between the abstract impressionism of painters such as Sweden's Lars Jonsson and the hyper-realism of New Zealand's Raymond Ching. Although Bateman's art is realistic, it retains strong abstract and impressionist elements. Like the original impressionists he is fascinated by the effects of light. In a Bateman painting you can often tell where the light is coming from. Many of his subjects are backlit or lit from unusual angles, as is the case when sunlight reflects off water or snow, and he loves to play with light and shadow.

Bateman has exerted a major influence on a whole generation of artists – not just in terms of the style he has perfected, but in terms of his overall approach. He was one of the first to put his animal subjects into an environment, to create a painting that is an ecological whole. According to Christopher Hume in *From the Wild,*

Detail from *Vulture and Wildebeest,* 1975.

"Bateman's major artistic insight has been to place the depicted bird or animal back into a natural context, into a total landscape which includes many other elements. His artistic skill lies in making us see things which are not actually there. Some people are convinced for example, that in the interests of realism, Bateman paints every blade of grass. Far from it. Visually, as well as in emotional terms, he gives us just enough to let us believe in the reality, but leaves plenty of room for the imagination." Bateman now

forms; he is more interested in "the vermiculations of the feathers of a grouse and how they overlap each other" than in telling the viewer about the role of that grouse in its ecosystem. When he conceptualizes a painting he is thinking above all about abstract patterns and artistic sources ranging from Claude Monet to Mark Rothko.

But he freely admits that for him the process of painting draws on much more than his artistic resources. Almost every painting becomes an exploration of nature as well as a carefully worked out pattern of color and form. Many of his pictures require natural history research. To help him, he has a wide network of people whose expertise he draws on, from his boyhood birdwatching friend Al Gordon (now a PhD in forestry) to Roger Tory Peterson. He borrows specimens from museums and consults his vast collection of slides. Given this intense and intimate process, his environmental concerns can't help but surface in his work, however subtly. One of his most quoted utterances seems to sum up the situation well: "For me the preservation and celebration of the natural world is a continual concern, and it is the underlying motive for virtually all of my art."

Bateman has always showed as much interest in an animal's habitat as in the animal itself, and he has painted many pictures in which the animal is peripheral to the composition or almost invisible. But this is only part of the reason his work has been singled out

among his contemporaries as having an environmental sensibility. It is also related to the fact that he approaches his subjects without sentimentality; he does not anthropomorphize. Wildlife art critic David Lank has said that Bateman "presents the animal from its own point of view." And many observers comment on his work's immediacy, the sense that you are peering into an actual place and time, not some idealized hunter's-eye view of romantic wild nature. Bateman says, "I try to portray an animal living its own life independent of man." Says Roger Tory Peterson, "He has looked at his subject so long that he can almost think like a deer or antelope or whatever the species may be."

But the key seems to be Bateman's respect for the "total environment" in his paintings, including the barns and farmhouses and other man-made objects he depicts. His attraction to the Taoist-inspired art of the Sung Dynasty is relevant here. "In this art," he says, "you see people and animals and trees and mountains and even air as being parts of one whole. Each element has a small part to play, and man is just a tiny part of a great cosmos." Elsewhere he has said, "What I'm trying for in nature art is to show a piece of the world." Stanwyn Shetler, the curator of the Smithsonian's 1987 Bateman retrospective, "Portraits of Nature," writes in the exhibition catalog that every Bateman painting "tells an ecological story" and that his paintings "convey powerful

has many followers and many imitators.

This ecological aspect of his art, combined with its scientific accuracy, has prompted some critics to look for environmental messages in his paintings. Bateman, however, does not think of himself first as an artist with a message. He says, "The primary motivating factor for doing the art is the art itself." He may be a naturalist by self-training and avocation, but he paints because he is an artist. His paintings take nature as their subject because he is attracted to organic

conservation messages." Roger Tory Peterson agrees: "I think what Bob represents best is the environmental approach. By painting whole environments he is raising environmental consciousness in the public."

The immediacy of these conservation messages arises out of Bateman's ability to fix a fleeting moment in time. In each painting, he preserves a piece of the world that he fears is vanishing. And he does this in a way that communicates the fragility, the evanescence, of what we are seeing. This effect can be heightened by the fact that he is drawn to all seasons except summer (he doesn't particularly like the color green is his disingenuous explanation), that he loves to paint variations of gray or black or brown, and that he delights in the murky images caused by mist or dust or falling snow.

However Bateman's paintings will be regarded a century hence, they are very much expressions of the late twentieth century and its troubled relationship with the natural world. As Christopher Hume points out, part of the appeal of wildlife art is "the fact that the natural world is being destroyed at an unprecedented rate." He adds, "Against this backdrop, wildlife art takes on an added poignancy. It harkens back to a distant, mythical age when the world was a Garden of Eden and animals roamed at will. The fact that wildlife art has gained momentum at roughly the same time as the conservation movement is no coincidence. Awareness of

one leads inevitably to appreciation of the other. Some artists, notably Robert Bateman and Roger Tory Peterson, are closely identified with the conservation movement, while virtually all the artists contribute paintings and sketches to fund-raising efforts, or participate somehow in environmental causes."

Robert Bateman is not the only modern wildlife painter whose art is an expression of his deeply felt concern about the fate of the world environment, but he is one of the most eloquent. And his international success has put him in a unique position to bring his environmental message to a wide audience.

V Ambassador for Conservation

THERE ARE ONLY two sounds audible in the large, plain, fluorescent-lit, air-conditioned room: the faint scratching of a pencil on paper and the sound of a TV documentary. Bob Bateman is signing prints at the headquarters of Mill Pond Press in Venice, Florida. The only other person present – Denise Muscato from the Mill Pond staff – deftly removes each print as soon as Bob has signed it and puts a fresh one in its place. He's been signing for almost a week, and the end is finally in sight. The print in question is a reproduction of a new painting, *Midnight – Black Wolf.* Dealers across North America have ordered 25,000 of them in a time-limited offer (usually Bateman's prints are offered in editions of less than one thousand copies). Royalties from this new print will be divided among several worthy conservation causes, the main ones being World Wildlife Fund Canada and The Wolf Sanctuary in St. Louis, Missouri, founded by the late Marlin Perkins.

Some dealers and artists argue that these reproductions are not true prints at all. They further maintain that such works damage the status and market value of "original" prints, the term

applied to more traditional forms such as copper plate etchings, wood block cuts and stone lithographs, where the artist works directly on the plate, and the prints themselves are the only originals. Bateman, whose financial success is in large part due to the limited-edition reproductions of his paintings, counters that the value of a limited print, be it an original work of art or a carefully controlled photomechanical reproduction, is determined by demand. He points out that any artist who signs and numbers a print – whether in an edition of 500 or 50,000 – does so for reasons of market. He does worry, however, that the public may confuse the two types of print and has also, perhaps in part to silence his critics, recently done a number of original prints, mostly stone lithographs.

The sound of a pencil scratching continues, hour after hour. Although it may seem surprising, Bateman enjoys this mindless, repetitive task. It's a welcome break from the demands of painting – and the many other demands on his time. He doesn't find it boring – he can watch television or listen to the radio or chat with Mill Pond staff. In fact Bateman is almost always talking to someone about something as he signs. Bob Lewin, Mill Pond's co-chairman, wants to discuss future painting ideas and a planned Bateman traveling museum show for 1991 and 1992. Mary Nygaard, Lewin's executive assistant, wants to review the flights she has arranged to get him back home to

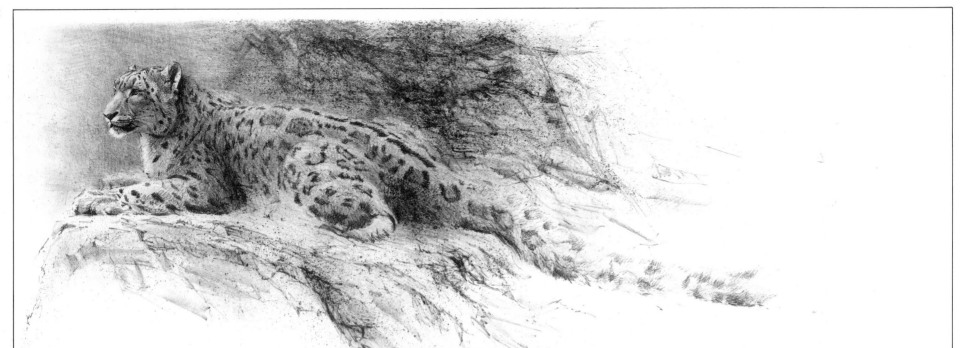

Above: A detail from *Snow Leopard*, 1989, a hand-pulled, two-color lithograph.

Right: Using cliffs near the shore outside his Saltspring Island home for reference, Bateman works on the rocky setting of *Snow Leopard*.

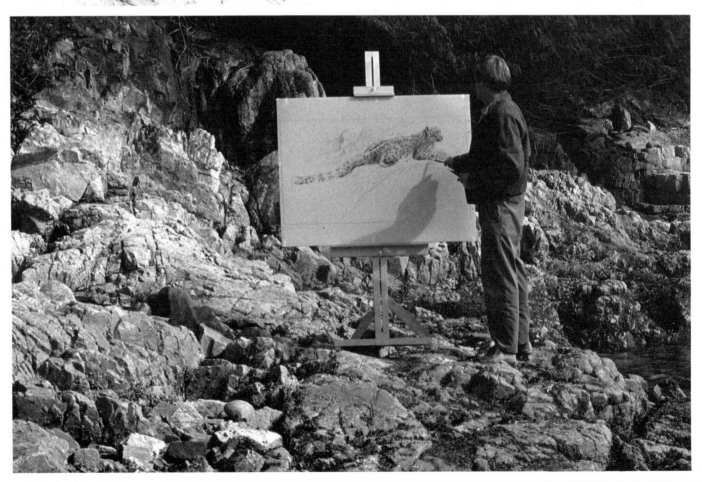

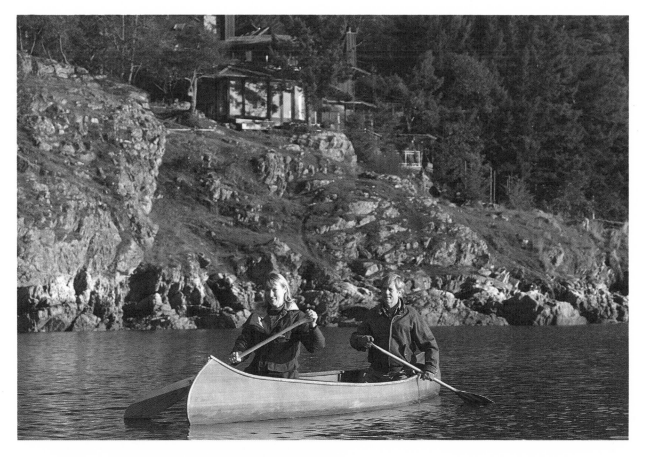

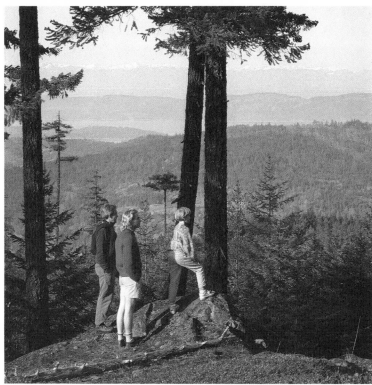

Above: Bob and Birgit go for a late-afternoon paddle near their Saltspring Island home.

Left: A hike on Saltspring's Mount Tuan with sons Alan and Robbie.

British Columbia after a stop in San Francisco to give a speech. Bateman's lawyer, Michael Levine, calls from Toronto to discuss details of his latest book contract. Nancy Taylor, director of special projects at Mill Pond, drops by to talk about an upcoming duck stamp program. And his wife, Birgit, calls from Toronto, where she is attending a World Wildlife Fund board meeting, to talk about plans for their three-week canoe vacation in Nahanni National Park in the Northwest Territories.

After a week at Mill Pond Press, the entire edition of the black wolf print has been signed, and Bateman leaves Florida for Ontario, where a round of public appearances is scheduled. Sandwiched into his crowded itinerary is a meeting with his Toronto publisher and a few days' respite at his Haliburton cottage. Then it's back to the studio in his house on Saltspring Island off the British Columbia coast. On his easel is an original stone lithograph of a snow leopard that he is working on with a litho crayon. There have been technical problems with the printing, and this is his third attempt. He's working standing, walking up and down as he builds up the rock textures in the background (earlier he was outside using the cliffs near the shore by his house as reference). Frequently he glances in the mirror tacked to a post behind him; this gives him a reverse image of what he's working on and helps him gauge how the overall composition is falling into place. Birgit has just come home from

shopping, and Bob asks her what she thinks. Bateman's wife is an accomplished artist herself; he invariably consults her when he is planning a new painting and seeks her input at every stage of a work in progress.

Nearby, a new painting of a mute swan, dramatically backlit, its face in shadow, has just been varnished and sits drying. Later today it will be dispatched by courier to Mill Pond for photographing. (Ultimately it will be raffled to raise money for the Kidney Foundation of Canada.) Behind Bob is a painting just underway. Although in its current state it's very loose, with big bold strokes, the subject is evident – a clear-cut mountainside once the loggers have left.

Although the long, high-ceilinged, irregularly shaped room is bright and airy – all wood and glass with white-painted walls and ceiling but bare beams and rafters of Douglas fir – it is actually quite cluttered. Bob occupies one crowded corner by a plate-glass window that affords him a splendid view of rocks, sun sparkling on water and forested slopes across the bay. In the center of the room, at a U-shaped desk, sits his secretary, surrounded by the high-tech paraphernalia of a modern office. She's typing at a Macintosh computer while the nearby fax machine prints out a message. At the far end of the room, Birgit works in her office area under a big skylight.

The doors and windows are open – "It's a perfect day for *homo sapiens,*" Bob comments – temperature in the mid-seventies, dry and clear. The breeze wafts in the deliciously spicy bouquet born of sun shining on the new growth of Douglas fir. Baby violet-green swallows are chirping in the birdhouse just outside the window.

Suddenly, out of the corner of his eye, Bob catches movement over the bay. He grabs his binoculars to take a better look. It's two bald eagles playing – perhaps one of them has a catch. The phone rings. The secretary answers and calls out that it's Monte Hummel of the World Wildlife Fund, returning Bob's call. Bob returns the binoculars to their shelf and picks up the phone. As he talks he cradles the receiver with his shoulder and goes back to his lithograph. Bob tells Monte that the wolf print program has been much more successful than expected and seeks his advice about other worthy wolf preservation groups to which some of the proceeds might be donated.

At some point during a typical long day in the studio, Bob likes to get away for a walk in the woods behind his house or for a quiet canoe along the shore. But lately, there often just hasn't been time. Everybody, it seems, wants a piece of Bob Bateman. The requests range from an invitation to judge the Miss Teen Canada beauty pageant to cutting the ribbon at the Olympics for the Disabled. Above all, wildlife conservation organizations and others want him to donate a painting for a fund-raising event. He describes his life as a juggling act – painting, public appearances, charitable work, family, etc. – and while he enjoys seeing how many balls he can keep in the air at once and seldom loses his cool under pressure, he recognizes that his success is becoming a problem.

The problem is compounded by the fact that Bateman has difficulty saying no to a worthy cause, and there are so many. He is besieged by requests to donate paintings for charity auctions, and until recently accepted a large percentage of them. Since such pictures have to be popular, in order to raise the most money possible for the organization, the range of subjects is somewhat limited. There is nothing wrong with these paintings – some of them are very fine indeed – but they seldom test his creative limits. They also leave him less time to concentrate on the major works that continue to place him at the top of his class. Bateman has become increasingly concerned about this trend, realizing his creativity is in danger of becoming a prisoner of his willingness to paint for charity.

Bateman's art may occasionally have suffered, but the movement to save the earth's environment has benefited enormously because of his generosity. The list of groups he has helped reads like an environmentalist's Who's Who. One of his latest enthusiasms is the Harmony Foundation, a new Canadian organization "trying to bring together all the elements in society, government, business, the education system and to use positive reinforcement instead of confrontation." As Harmony's founder

Opposite: While Birgit and Bateman's assistant Terry Moser look on, Bob works on a new lion painting.

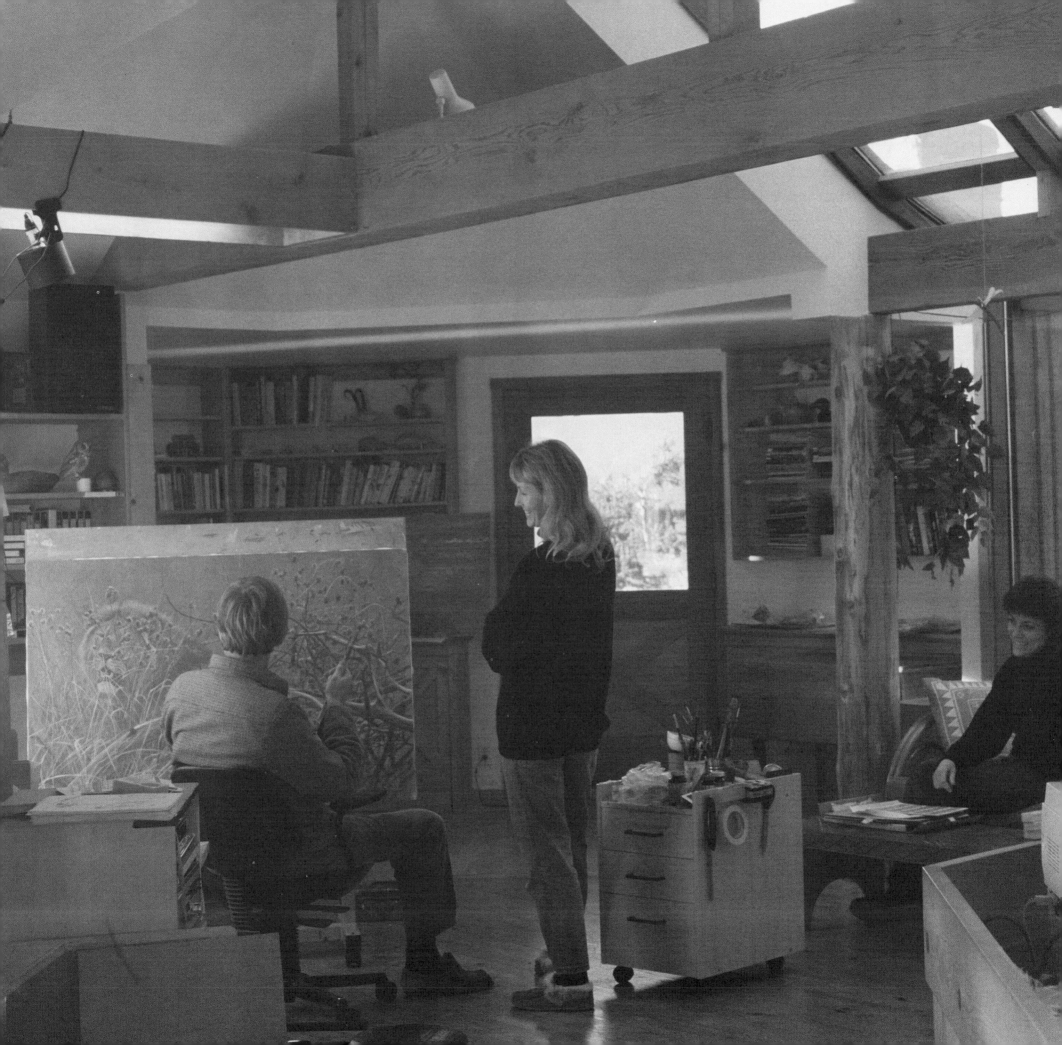

and director Michael Bloomfield puts it, "If we're going to make progress on environmental problems, two things have to happen. Business, government and community groups have to work together. Even if they're not in agreement they have to agree on the same agenda and start tackling the issues. But over the long term the real change is going to come from a very active program of public education at every level." The targets of this ambitious educational process range from the chief executives of major corporations to kids sitting in classrooms. For Bateman, the former schoolteacher, the appeal of this approach is obvious.

Of all the organizations Bateman supports, however, the one that seems closest to his heart is the World Wildlife Fund. WWF is doing the sort of thing he might be doing now if he weren't an artist. It is on the front line of the war to preserve endangered species and protect their habitats around the world. Bob's direct involvement is with WWF Canada, but through this organization he is able to help projects in many parts of the globe. WWF was, for instance, the first private organization to negotiate a conservation agreement with the government of mainland China – to protect the habitat of the endangered giant panda. Another international project that Bateman took a special interest in was the purchase of 20,000 acres of threatened Costa Rican rain forest at Monteverde on the continental divide. The fund now has twenty-seven affiliate organizations and since its founding in 1961 has raised more than $500 million for 5,000 projects in 130 countries. Ten percent of that sum has been raised by WWF Canada, which must be one of the most effective and efficient conservation organizations anywhere.

Recent Canadian-backed projects range from Operation Burrowing Owl (which has persuaded ranchers and farmers to voluntarily protect 20,000 acres for this threatened prairie species) to playing a leading role in the successful lobbying to establish six new national parks in Canada. In 1987, thanks to WWF conservation efforts, the white pelican had increased enough in numbers to be removed from the Canadian endangered species list; in 1988 the wood bison was also removed. Although the fund-raising focus is often on attractive animals such as these, the real emphasis is on the habitat without which these high-profile species wouldn't be able to survive.

A number of Bateman artworks have raised substantial amounts of money for the WWF. In 1985 a painting of a giant panda with its accompanying print sales brought the fund roughly $400,000, one-tenth of its total budget for that year. Since then he has contributed royalties from *End of Season – Grizzly* and *Cougar in the Snow* (1978), as well as *Midnight – Black Wolf*. Bateman and Mill Pond Press have together raised well over a million dollars for WWF projects. In 1986 Bateman became one of the very few Canadians to become a Member of Honor in the World Wildlife Fund, in recognition of his work for the organization.

But, as many of the people he's worked with point out, the financial support Bateman has provided is only part of his contribution. As his fame as an artist has spread, so has his influence. Today he has much less time for the hands-on types of activities he threw himself into when he was still a teacher, but he is always willing to speak out. He sees it as his duty: "I think everybody should be taking whatever talents they have and putting them to work for a better planet." He is often invited to speak to large groups of people, and invariably he uses the opportunity to speak out on his environmental concerns.

Birgit shares her husband's committed stance and is an active partner in shaping his thinking. They discuss everything from the difficulty of finding recycled paper for their office to the latest scientific report on acid rain. Before Bateman gives a speech, he picks Birgit's brain for ideas and bounces his thoughts off her. While his mind is often on global concerns, she is the one to bring him down to earth, to remind him of the practical day-to-day ramifications of their conserver philosophy. It was Birgit, for example, who designed their kitchen to include four big drawers next to the sink for separating material to be recycled: cans, glass, plastic and cardboard. She is also a firm believer in the power of the individual consumer to make a dif-

flying over the clear-cut desert of parts of British Columbia's Queen Charlotte Islands, Bateman described the sight as resembling the "shaved head of a concentration camp victim." "It sometimes seems," he says, "that the main factor affecting our forest plans and schemes is not sustained use, not harvesting a renewable resource, but ignorance, laziness and greed."

However, as his involvement with the Harmony Foundation suggests, Bateman's environmental message spreads far beyond his immediate concerns about specific species or vanishing ecosystems. He is always able to make the leap to the bigger picture, to connect his love of nature with his concerns about the disappearance of distinct human cultures and the immediate future of the planet earth.

ference, to demand environmentally friendly products and vote for them with his or her pocketbook. She approvingly quotes Canada's Maurice Strong at an international conference on the state of the world's environment. When asked by a delegate what one powerless citizen can do, Strong replied, "It's very simple. Everything you do is either for the environment or against it."

As we enter the last decade of the twentieth century, it often seems as if the vast majority of individual and corporate decisions are being made "against" the planet. Bateman is especially concerned about two areas – what is happening to the world's forests, and the overfishing and growing pollution of the oceans. He is particularly scathing on the subject of poor forest management practices in North America, where the concept of sustained use is given much lip service but less practical application. His current favorite example of how bad things can get is the case of the Tongass Forest Region in Alaska, where logging companies are cutting down trees and selling them to the Japanese at a huge loss to prevent the area from being turned into a national park. After

Above: A detail from *Rainforest and Swallowtail Kites,* 1987, which was painted in aid of the Monteverde Cloud Forest after Bob's first visit to this Costa Rican nature preserve.

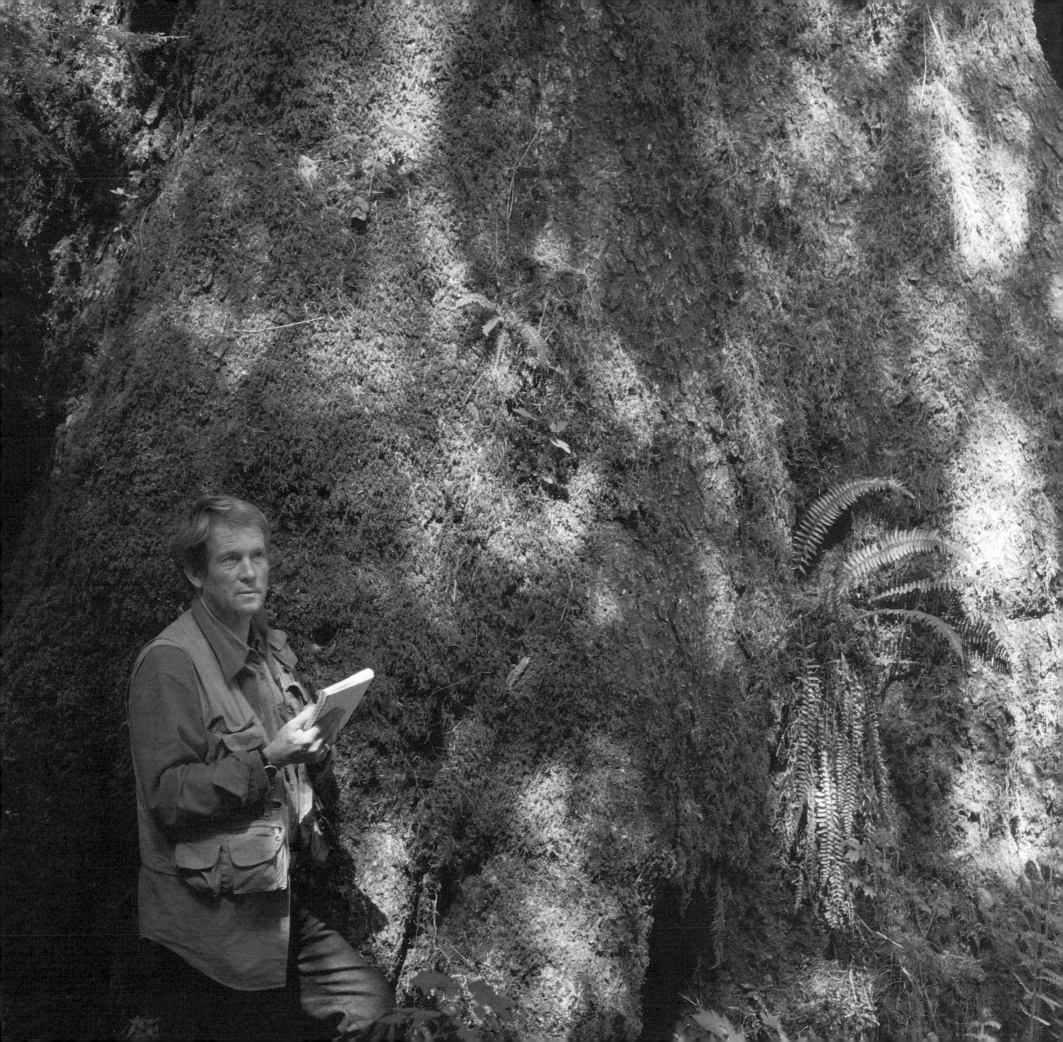

VI "Clean Air, Clean Water and the Song of a Bird"

ON A SUNLIT AFTERNOON in the remote Carmanah Valley on Vancouver Island, Robert Bateman, sketchbook in hand but for once idle, stands in silent wonder in the midst of a cathedral of towering Sitka spruce. These are old-growth trees, some over a thousand years old, including the tallest tree in Canada. Of the many rain forests he has been to around the globe, this one is in many ways the most wondrous. There is little undergrowth, just a mossy carpet, moss clinging to the trunks, and "the little filigree of huckleberry and ferns" on the forest floor. So he is able to get "a feeling of the spaces between the trees and the loftiness of the trees," as these great smooth trunks disappear into the distant canopy.

But Bateman's purpose here is only secondarily nature appreciation. He has come, with thirty fellow artists such as Toni Onley, Ron Parker and Diana Thompson, at the request of an environmental coalition called the Western Canada Wilderness Committee. The artists are here to dramatize their belief that this virgin stand of magnificent trees should be left alone by the loggers of Macmillan Bloedel, the giant lumber company. MacBlo wants to log the slopes of the valley, but the conservationists point out that this will inevitably lead to erosion, destruction of the watershed and the death of the trees in the valley itself. Protecting what's left of virgin west coast rain forest has become a major passion for Bateman, and this is his latest effort on behalf of what he sees as a priceless piece of endangered nature.

Thanks to the presence of the artists, the media are out in force. Some have come by helicopter, others have hiked in over the same route followed by the artists and conservationists. The artists are awed by the beauty of the place, and this is reflected in their comments to the press. Bateman later sums up his feelings in a letter to Macmillan Bloedel chairman, Adam Zimmerman: "I truly had a feeling of a spiritual place. I experienced the same feeling in the Haida Village on Anthony Island, in St. Peter's in Rome, and in the sacred Shinto Shrine at Ise. The combination of the clear Carmanah waters, lofty spruce and amphitheater-like slopes make this a complete entity which is integrated into this spiritual whole. ... To cut the slopes would be something like removing St. Peter's Square and the facade of the cathedral and letting people go straight to the altar from the parking lot." Such comments hit home, and there is extensive national coverage of the event that puts additional pressure on the B.C. government to save Carmanah – and as a bonus nudges it toward a full-scale inquiry into logging practices in the province.

In recent years, in keeping with the increasingly gloomy news about the state of the biosphere, Bateman's message has become more urgent. "The best things in life are not free anymore," he says. "Clean air, clean water and the song of a bird are already very expensive, and they will be beyond price in the next century if we don't start digging down in our wallets now. It hasn't dawned on us yet, but we have to pay for the best things in life." He exhorts his audiences to concrete individual action, to "do a good deed for conservation every day – write a letter, make a donation, make a phone call, congratulate or condemn a politician or a businessman." But he realizes this isn't enough, that a massive rethinking of our priorities, probably a massive restructuring of the way our economy works, will be necessary if the natural world, and by extension human culture, are to survive.

Even Bateman's paintings are becoming more overt in their conservation messages. The discarded Budweiser can almost hidden in the grasses of *Coyote in Winter Sage* (1979) has come out into the open – at least metaphorically. This is most obvious in recent works such as *Carmanah Contrasts*. Bateman's major works are never intended to please and reassure, but these recent images are designed to be positively unsettling. "I don't mind the thought of putting a message in a piece of art, as long as it doesn't mess up the art," he says. "I love teaching, and my paintings have always 'taught' something about

Opposite: Bateman stands next to a giant Sitka spruce in Vancouver Island's threatened Carmanah Valley in the summer of 1989.

ecology. But now I'm feeling the need for a little more toughness or astringency in my work."

Other Bateman paintings over the past few years have signaled this change in thinking, although more subtly. A number of them, such as *The Challenge – Bull Moose* or *The Wise One,* are impressive in scale and aggressive in presentation, the whole animal filling the frame and seeming to charge off the canvas at the viewer. And in one of his most provocative recent works, *Midnight – Black Wolf,* there is a distinct air of menace and foreboding that is missing from all of his earlier paintings of wolves, creatures he likes and admires and considers to have an undeservedly bad reputation.

Yet despite the increasing urgency of his message, Bateman remains optimistic that the necessary societal transformation is possible, indeed is in progress. He looks for and finds many hopeful signs, whether it is the latest public opinion poll showing the majority's willingness to pay a premium for environmentally safe products, or the announcement that International Nickel, a major Canadian polluter, has agreed to reduce substantially its acid gas emissions. Bob and Birgit returned from a year in southern Germany with their sons Christopher and Robbie full of admiration for the way some European countries are managing to combine both progress and preservation. They are far ahead of us in reusing and recycling and much better at protecting their landscape, he says.

One example he often mentions in his slide talks is the area around the Austrian village of Mittersill. Up on the screen he projects a slide of a picturesque valley with heavily forested slopes, farm fields down lower and a lovely village nestled in the center of the frame. Then he proceeds to parse the picture, to show how complex and modern this deceptively traditional scene really is. He explains to his audiences that those forested slopes are subject to sustained-use logging employing an ingenious combination of old and new technology. A helicopter is used to fly a cable up to the area to be logged; this becomes a log lift that transports the timber down to the valley floor. Since only the mature trees are brought out, and the cutting is in narrow swaths, replanting is unnecessary – the parent trees seed into the empty spaces. In addition to this example of self-renewing forestry, the valley supports farming, recreational skiing and hiking along many miles of trails. The streams are crystal-clear and full of trout, the woods are teeming with wildlife, and a small nearby hydro dam provides power for the area. Wildlife and landscape management is funded by auctioning local hunting rights to wealthy sportsmen – with a substantial profit left over. Bateman sums up: "If you come back in a hundred years, this valley will probably still look very much like this."

Such a paradigm of man and nature in harmony, of technology being used in ways that benefit human beings while preserving the environment, is still rare in North America, but the climate may be changing. Bateman believes that a crucial change is taking place – the disappearance of the frontier mentality. The idea of inexhaustible resources for exploitation is finally giving way to a realization that there are boundaries, and we must respect them. And he takes particular comfort from the burgeoning environmental movement and the great increase in the numbers of people who are enjoying nature – backpackers, birders, wildflower connoisseurs – the "soft" consumers who are now spending billions of dollars annually on such things as bird guides and field glasses and donating money to conservation causes. He knows that the tide has not yet turned, that tropical rain forests continue to disappear at an alarming rate, that the family farms and the old barns are vanishing, and that there are bound to be more disastrous oil spills sullying pristine coasts. But he prefers to accent the positive, to take pleasure each time a species is taken off the endangered list, at each establishment of a new national park and wilderness preserve, each increase in public awareness, every halting step toward reducing and recycling garbage or cutting down atmospheric pollution.

Birgit shares her husband's optimism, indeed is passionate on the subject. She is appalled by what she perceives as a widespread feeling of helplessness, a general feeling that the planet is already beyond saving. "I can't allow

Bateman during a family canoeing trip along the
Nahanni River in Canada's Northwest Territories in
August 1989.

my children to think they're going to
inherit a horrible world," she says. "The
hopeful thing about human beings is
that we can change." She and Bob
believe strongly that we are all going to
have to simplify our lives and live much
less wastefully, but that we can hand
over a better, cleaner, healthier world to
the next generation.

Bateman's positive position sets him
apart from many in the environmental
movement who are far more gloomy
about the prospects for planet earth. He
persists in believing that humankind will
make the necessary adjustments before
it is too late. "Mother Nature is a great
teacher," he says, while admitting that
the lesson may be a painful one involv-
ing considerable human suffering. One
reason he is hopeful is that he sees signs
of a change in our attitude toward tech-
nological progress, which has made our
lives so much more convenient but also
given us the power to destroy the
planet. According to Bateman, we have
reached a unique point in the human
story. History is like a great river, he
says, and that river has now reached the
delta: "There's a tremendous amount
of activity in any delta, but there's very
little sense of one direction."

One of the potential casualties of
this delta is the myth of progress that
has dominated our thinking since the
Industrial Revolution. "We are at the
end of progress," Bateman argues,
though we still act as if we believe that
technology will solve all our problems,
that "bigger, faster, smoother" will

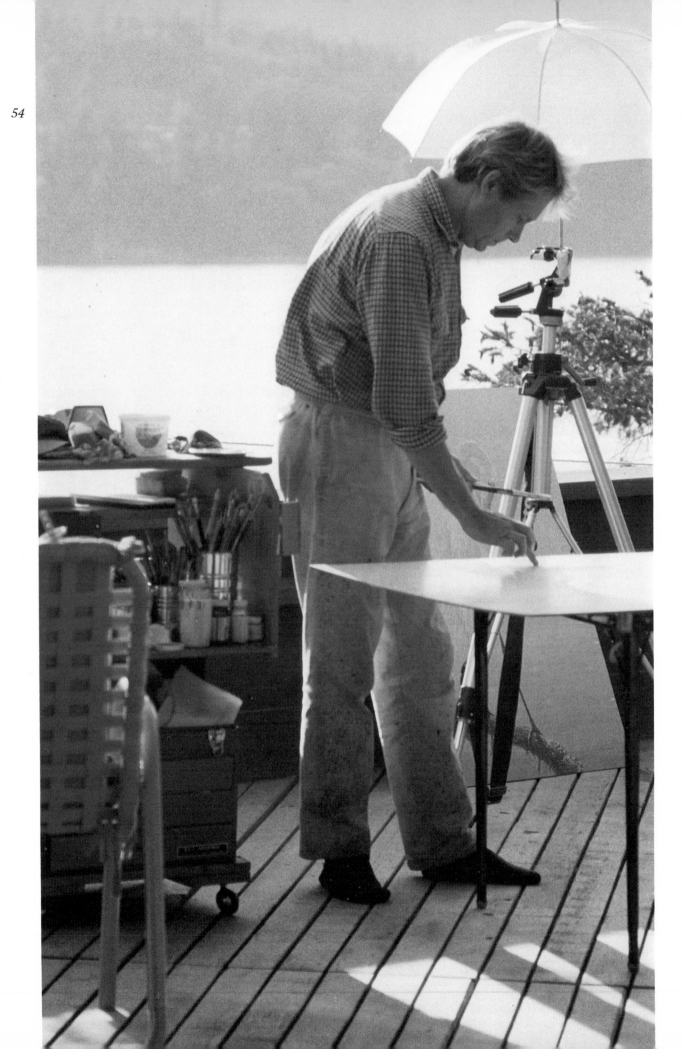

54

lead us to a point where man is in total control of a totally predictable instant-pudding world. This idea, he asserts, "is not only wrong, it's dangerous." And why anyone would want to live in such a world is beyond him.

What new ideology will take the place of the old myth of technological progress? Bateman doesn't know, although like many modern critics of our highly wasteful way of living, he feels the keys to this new way of thinking are a new respect for small-scale systems and enterprises, a resurgence of close-knit human communities, and a wiser use of technology itself. He also warns that to save the planet we may have to give up our worship of the goddess convenience. But he has no desire to turn back the clock to some pre-industrial age. He believes that a post-industrial sensibility can be combined with "twenty-first century technology" to allow for small-scale decentralized communities: "Everything would be on a much smaller scale. We would probably have more individual input from human beings. And people would live in communities where neighborhoods counted, where they knew each other and cared about each other. Status and prestige would not come from having a Porsche or a Lamborghini or a Cadillac parked in the driveway, but maybe from the fact that you spun and wove your own drapes." These may sound like hopelessly Utopian yearnings, but Bateman is not alone in believing that a different way is not only possible, but essential.

Bateman at work on the deck of his studio.

Some of Bateman's fellow optimists have already made progress in getting us to change our ways. The influential energy analyst Amory Lovins, author of *Soft Energy Paths,* has persuaded many U.S. electrical utilities to invest in conservation – electricity saved – rather than building costly new power plants that will only add to our pollution burden while encouraging us to consume still more energy. In economic jargon, Lovins and others argue that external costs must become internal to our economic system. This means that if the making of a product requires a lot of energy or produces a lot of pollution, these things should be reflected in the price the consumer pays. The minute such environmental costs were internalized in this way, the marketplace would begin to make much sounder decisions. Bateman refers to this as "a more honest system of accounting": "I have a feeling that too many things on the planet are too cheap, and that if the true price were paid we would be much better off – although maybe living a little more simply at a slightly lower standard of living. For example, the Ohio Valley has all this cheap coal which is turned into electricity. The electricity is relatively cheap because they aren't putting scrubbers on the smokestacks to take the nitrous and sulphurous dioxides out of it. But there's a very long price tag to it. The price tag stretches all the way up into Ontario where the lakes are being killed by acid rain, and the outfitters are being put out of business because the fish are dead,

and the maple syrup industry is dying because the forests are being ruined. In fact that electricity is costing millions, maybe billions of dollars."

Not long ago such talk would have placed Bateman firmly on the radical fringe and labeled him as an impractical idealist. Now similar words are being heard from the mouths of government spokespeople and corporate moguls. Phrases such as "environmental cost" and "sustainable development" are everywhere. And if there is still a great gap between all these noble words and some truly revolutionary action, the words at least sound promising.

The notion of stewardship, which is simply looking after what is yours, is central to this changed way of thinking. "We're in charge of the planet, and we're responsible for it," Bateman says. "I guess it's partly a question of adulthood, even as a species. It's a question of growing up and becoming more responsible adults as a civilization, of treating our possessions, which include the environment of the whole world, so that they will be around for future generations." But if you don't have a sense that the environment belongs to you – if it is as alien as that shopping mall Bateman often talks about – you have little or no motivation to care for it. That's why you have to start small, to begin in your own backyard, to reconstitute your neighborhood and your community.

Bateman freely admits that he is groping toward answers, that he doesn't

have a ready-made solution, and that he is using his public profile and skills as a communicator simply to get people thinking and rouse them to any kind of positive action. The force he brings to this role comes directly from the deep identification with nature that began when he was a small boy exploring his own backyard. Even those who are much more pessimistic than he is are struck by the power of his conviction. His old friend John Livingston, who is on the Faculty of Environmental Studies at Toronto's York University, says, "I would never call him naive or self-deluding, but I would characterize his optimism as childlike, not childish. And this is the way he is. He is childlike in his wonder and his love and appreciation of nature."

When all is said and done, it is Bateman's love of biological and human nature, his "religious" respect for the particularity and individuality of all life, that gives his voice such persuasiveness. He continues to come back to what is concrete, the patch of nature in his own backyard. This helps to account for his ability to move his listeners and may go a long way toward explaining the power and popularity of his paintings. His friends Pat and Rosemarie Keough, authors of *The Nahanni Portfolio* and the *Ottawa Valley Portfolio,* recall visiting him soon after he moved to his west coast home: "Bob took us on a nature walk near the house, and he told us, 'I'm making a path here.' And we said, 'Well, Bob, you've got so much

wilderness to wander through, you could follow a different path every day.' And he said, 'No, I want to follow the same path every day so that I can watch it and understand it and see how it changes – what flowers come up, what animals walk by. I want to really understand its every aspect.'" In a profound way, Bateman has retained his childlike sense of wonder; he is still a young boy discovering for the first time the delights of his backyard ravine.

Robert Bateman is not alone in hoping that humankind can learn to put a value on things that can't be bought or sold in the marketplace, in believing we can find a system that reflects the real costs of things such as air pollution, strip mining or toxic waste. Such a system would put a value on a tree that hasn't been cut down, as well as one that has. It would assign a value to good health or clean air as well as totaling the cost of caring for someone who is sick or installing catalytic converters to make car engines run more cleanly. But Bateman has a way of talking about such things that drives the essential point home, that reaches into hearts and minds.

In his art, Bateman puts a supreme value on the smallest things. In his paintings he celebrates the natural world that as an environmentalist he fights to preserve for future generations. He understands that how we look after wilderness is an index of just how civilized we really are. He believes that there are more reasons than simple preservation for protecting the wild places we have left and making more human the man-made environments we have constructed. In spirit, Bateman seems very close to American novelist and essayist Wendell Berry, who has written extensively and thoughtfully about the ways in which human society can get back in tune with nature. These words of Berry's could stand as an epigraph for Bateman's art and his personal philosophy:

"The reason to preserve wilderness is that we need it. We need wilderness of all kinds, large and small, public and private. We need to go now and again into places were our work is disallowed, where our hopes and plans have no standing. We need to come into the presence of the unqualified and mysterious formality of Creation."

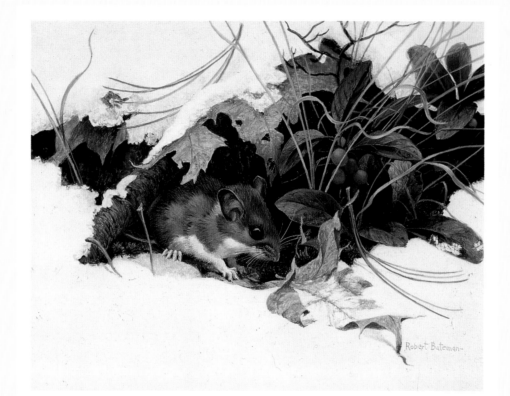

A NATURALIST'S GALLERY

Plates and Commentaries

I HAVE ALWAYS been interested in the world at my feet, and many of my paintings over the years have taken a microscope to a tiny patch of nature. To me there is nothing more satisfying to contemplate than nature writ small. Within a few square feet the entire drama of existence is played out: the cycle of the seasons, the ecological balance between predator and prey, the story of plant succession – and the interference of man. Each small patch of nature is incredibly complex and diverse. Each is unique. The habitat of the white-footed mouse (previous page) is as different from that of the meadow vole as Norway is from Italy.

In *Mowed Meadow* the hand of man is evident, but in this case the human influence is not simply destructive. The meadow vole will thrive in this chaos – the seeds, grain and grasses it eats have been harvested for it.

I consider mice to be unjustly maligned creatures. They are clean animals and only a few cause problems for farmers or homeowners. There are about eight species in the area of southern Ontario where I grew up, and dozens in North America. Lemmings and voles belong to the same family, making it one of the largest of North American mammal clans.

White-footed Mouse in Wintergreen, 1969 (previous page)

Milkweed, Chicory and Daddy-long-legs (sketch), 1971 (above)

Mowed Meadow (detail), 1971 (right)

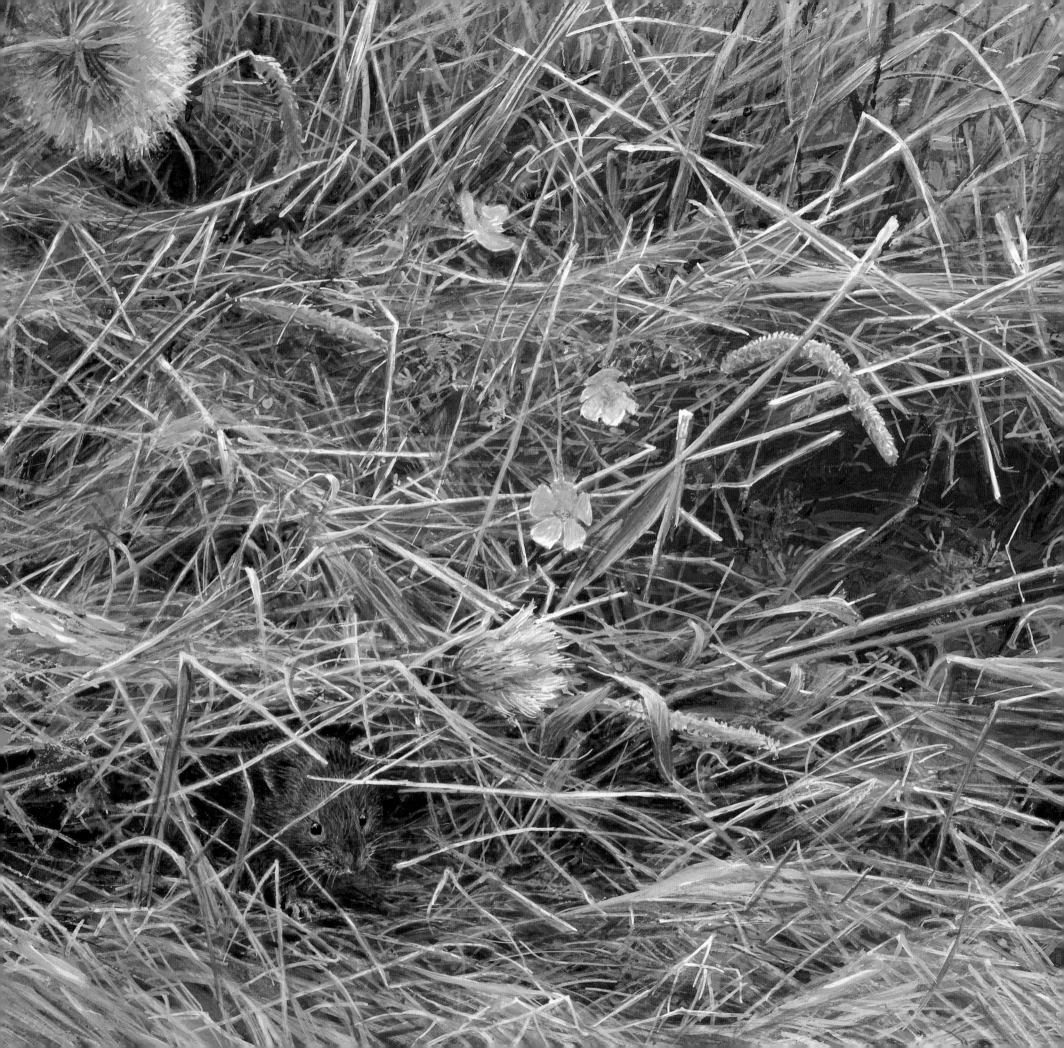

Ploughed Field, 1967

At the Roadside – Red-tailed Hawk, 1978

THE RED-TAILED HAWK on the telephone pole in *At the Roadside – Red-tailed Hawk* could very well be perched in the foreground of *Ploughed Field*, looking for a mouse for his lunch. I saw this field one spring day in the late 1960s near my home in Halton County, Ontario. Since then, the settings for both paintings have disappeared. The field is now a modern subdivision and the telephone pole, made mostly of wood with its glass insulator, has been replaced with a buried cable. (It's a sign of how fast our world is changing that older manufactured goods such as that insulator have become collectibles.)

The composition of *Ploughed Field* consists of strong horizontal bands that run across the picture. Each band is a swath of habitat. In the foreground is the ploughed field, the earth still moist from the spring rains. In the background is a willow grove along a stream edge, the branches of the willows highlighted by fresh green. I tried to capture the quality of these two habitats – their color, texture and form. I think of this painting as expressing a sense of the continuum of things moving from the past to the present and on into the future. Each actor enters, crosses the stage, and then is gone.

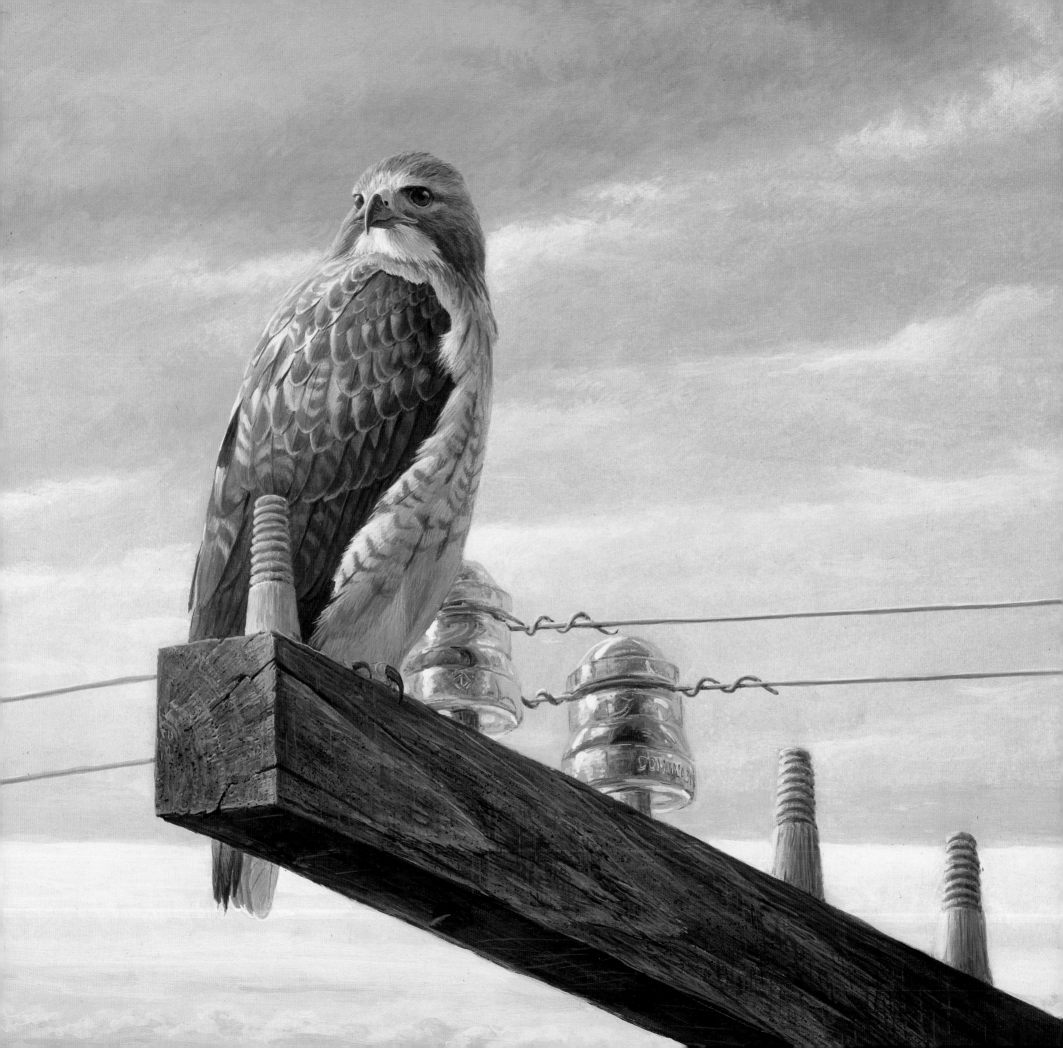

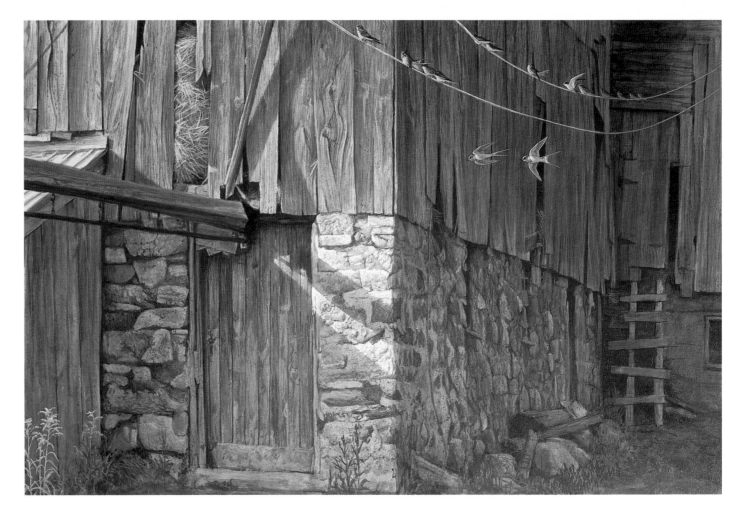

THIS PARTICULAR BARN was built by my father's father. The last time I visited the farm he cleared near Belleville, Ontario, the barn was still standing and still being used by Batemans to store hay and shelter animals. I look on my grandfather's time with great nostalgia. Although I never met him, I have warm memories of the big family picnics we had when we went to visit my grandmother and of the smell of mown hay and manure. I think of my grandfather's world as being a model of community and stability, of friendship and cooperation, of people knowing who they were and what their place was in the universe.

Like many old Ontario barns, this building is very much an extension of the natural landscape. It was built with natural materials found close by.

Then weather and organisms worked on the wood and stone so that they changed gradually with time. The barn is also a haven for insects, mice, birds – perhaps even a bat family. But the most obvious wild inhabitant is the barn swallow. Its tight, metallic shape appeals to me, as does its cheerful chitter and graceful swooping flight. It is also useful, devouring a great many insect pests. Barn swallows have adjusted well to the spread of human settlement. They are the most widespread swallow species – in fact the most widespread perching bird – and they prefer artificial structures to natural nesting sites.

Barn Swallows in August, 1977

Barn Swallow and Horse Collar, 1987

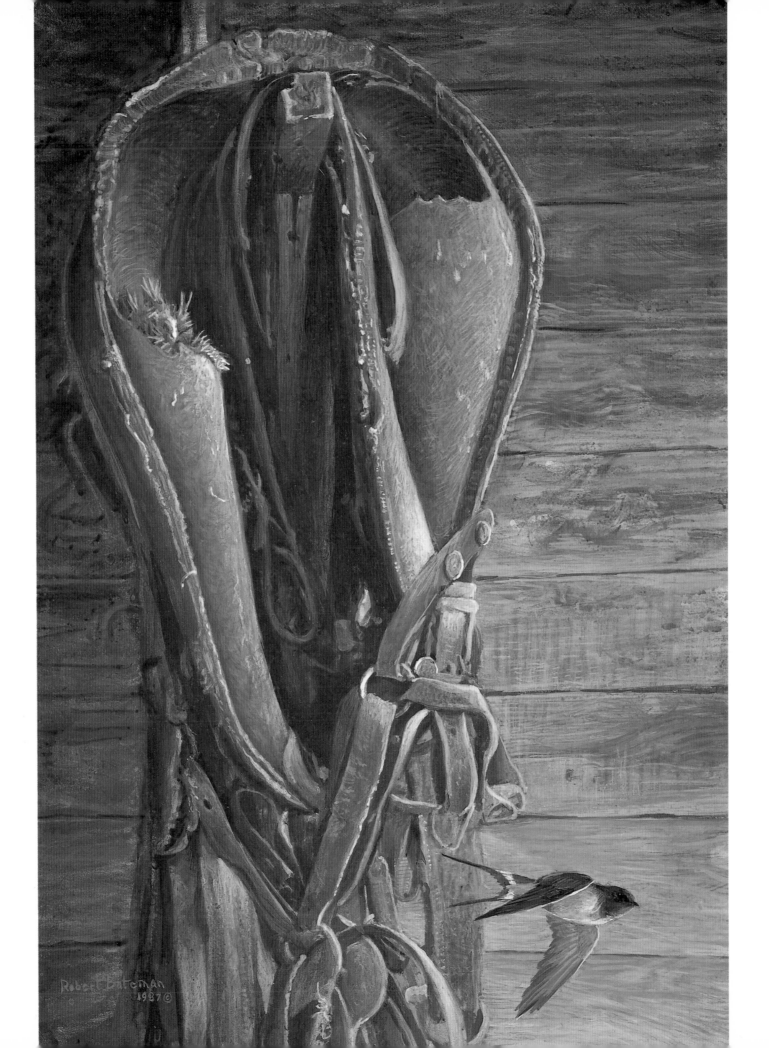

64

A FEW YEARS AGO I spent a night on a farm near Wiarton, Ontario, which is at the base of the Bruce Peninsula between Lake Huron and Georgian Bay. Early in the morning I looked out the upstairs window to see this beguiling scene, the mist rising off the meadow and the cows grazing contentedly. In *Summer Morning Pasture* I wanted to recapture the peaceful tranquility of that moment, the feeling that our farming ancestors must have experienced more often than we do, that "God's in His heaven and all's right with the world." There's a deliberate wistful quality here as well, because I'm afraid this scene may not be one our grandchildren will ever see. The beautiful elms are almost extinct, and the family farm – farming on a human scale – is being replaced by agri-business.

The painting is also a deliberate echo of the pastoral scenes depicted in nineteenth-century landscapes. When I was younger, I would never have admitted to being influenced by these paintings since they all seemed stale and hackneyed. But today I'm taking a second look at the nineteenth century and learning to appreciate its art.

Of course, behind the mellow feeling of peace and quiet in this painting, there is much going on. A great variety of wildlife coexists with domestic animals, including meadow mice and voles, which are favorite foods of the red-tailed hawk and the screech owl.

Summer Morning Pasture, 1987

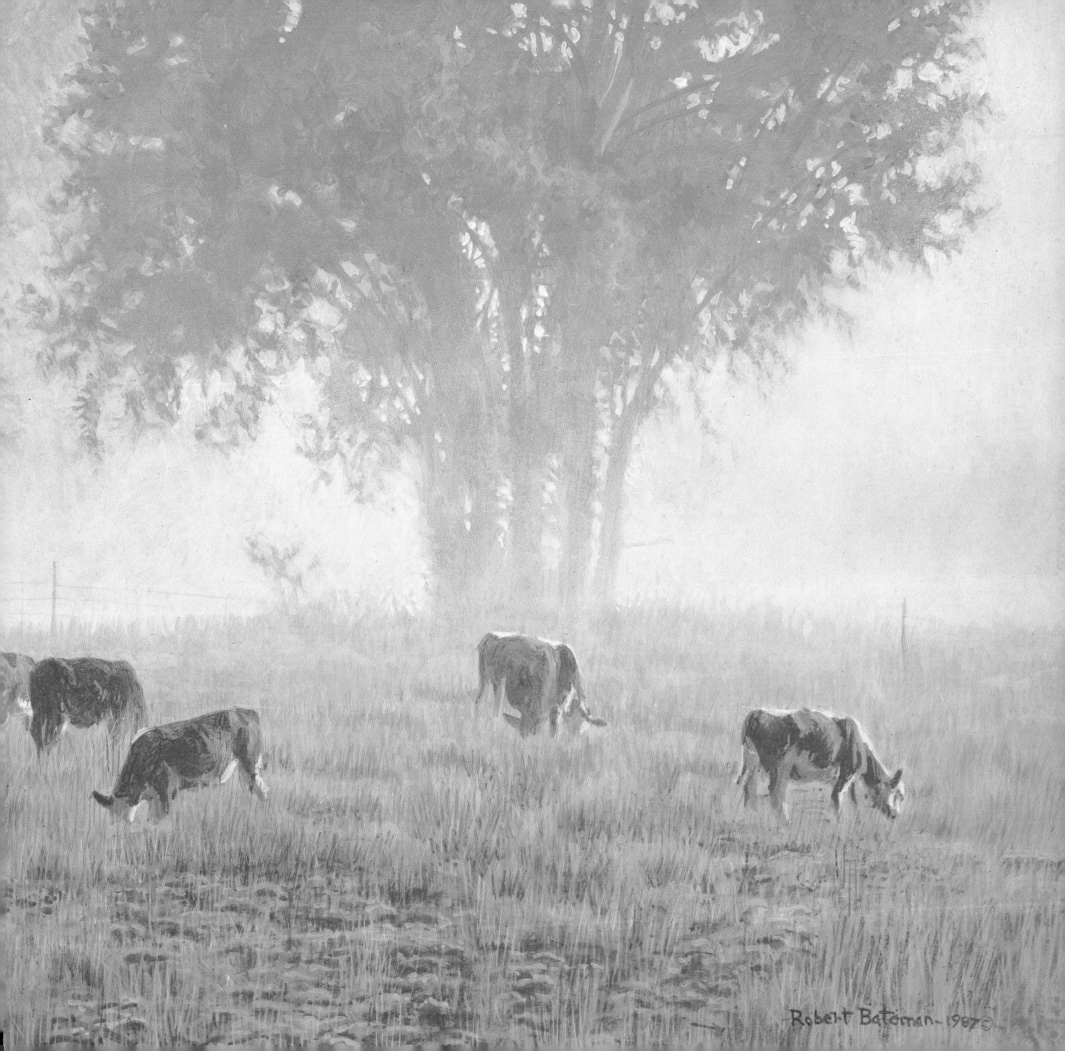

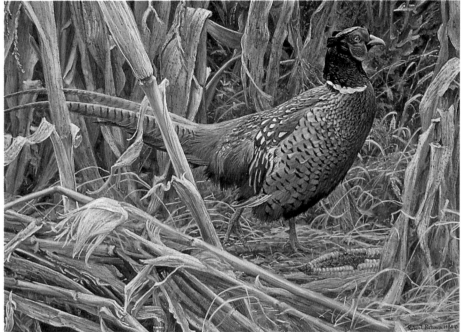

THE BUILDING in *Pheasants at Dusk* was a former cheese factory, until vandals burned it down a few years ago. The factory itself had closed because of competition from a large monopoly. With it died one example of a particularly vital form of economic democracy – the farmers' cooperative. This was where my grandfather and his neighbors took their milk to be made into cheese. You can see the curving drive and part of the covering over the loading platform where Grandad would have pulled up his horse-drawn wagon.

The split rail fence comes at you into the foreground – almost landing in your lap – then leads you back into the picture and toward the male pheasant in flight. The pheasant provides a hint of opulence in an otherwise stark, late-autumnal scene, perhaps a faint reminder of summer. Brought over by settlers from the British Isles as a game bird, the pheasant has survived better than my grandfather's way of life, although its numbers have declined drastically in the last ten years. I really enjoy painting its rich tapestry of feathers. I don't think the human imagination could devise a more surprising or pleasing visual combination.

Strutting – Ring-necked Pheasant, 1985

Pheasants at Dusk, 1977

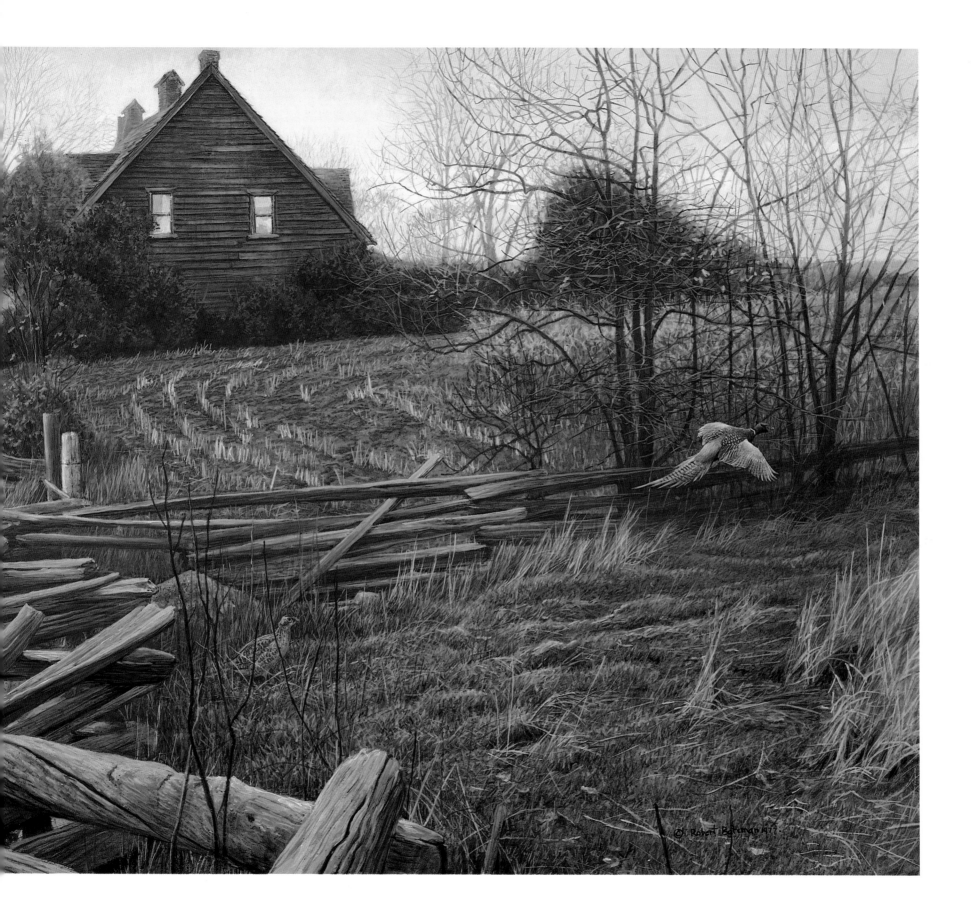

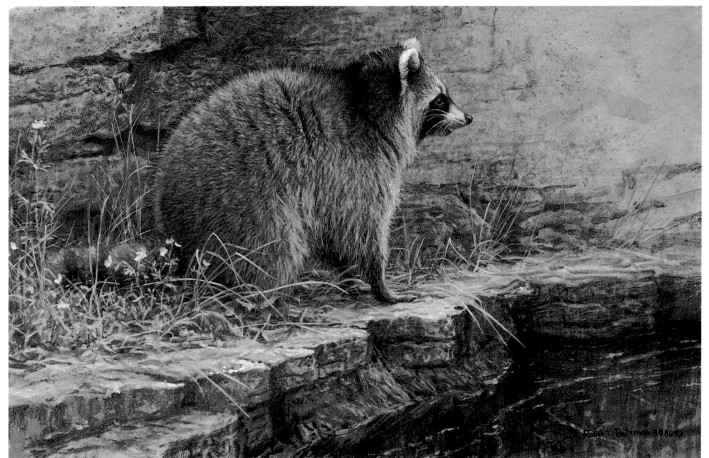

Distant Danger – Raccoon, 1988

Summer Garden – Young Robin, 1987

BOTH THESE paintings portray a small patch of nature that might easily be overlooked. And both paintings suggest very strongly the nearby presence of man. Man-made orderliness is combined with the robust unruliness of nature in *Summer Garden – Young Robin*. And the cabbages have a strong sculptural quality; when the outer leaves are worm-eaten, as they are here, they have a kind of baroque grandeur.

In *Distant Danger – Raccoon* the animal is alert, aware of some potential threat. The raccoon is one of those wild animals that has successfully adapted to the presence of humans and even profited from the association. The raccoon population is probably higher near cities than it is in the wilderness. In Toronto, where I grew up, the city ravines provided these masked bandits with a perfect set-up – wild havens from which they could conduct nocturnal raids on unguarded garbage cans.

Both these paintings are "landscapes" with no horizon. Before I saw the works of Andrew Wyeth, a horizon was *de rigueur* in my work. I am now perfectly happy painting a landscape of one square yard, looking down from above as with *Summer Garden*.

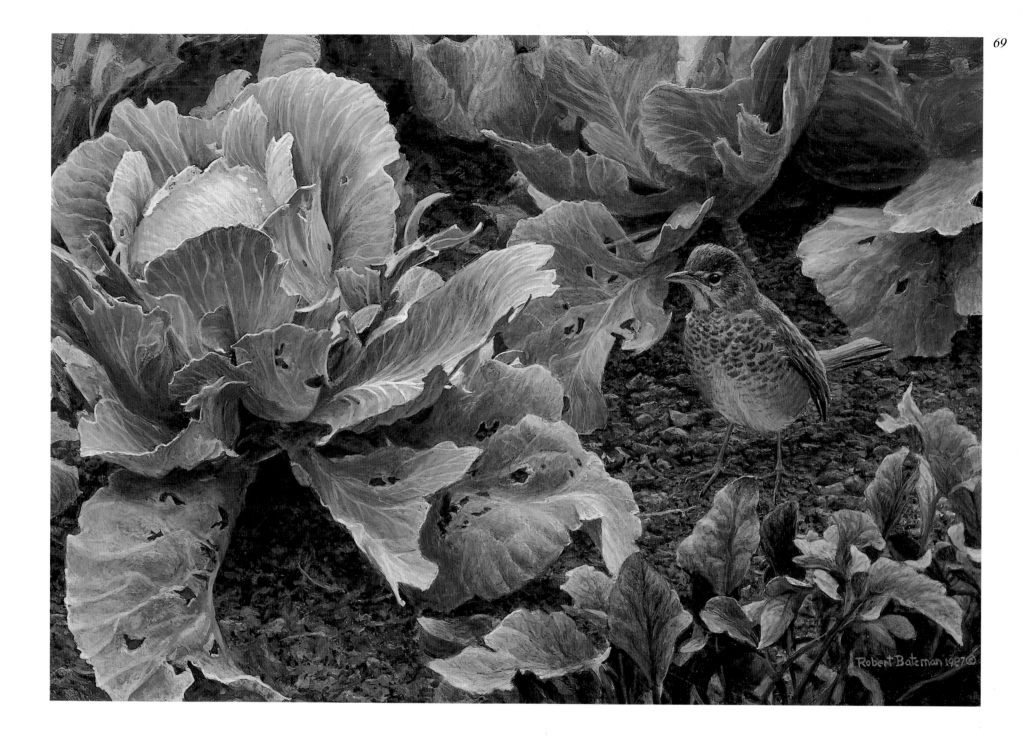

Robert Bateman 1987©

THE HOUSE and garden in this painting were built by United Empire Loyalists, American colonists who fought on the British side during the revolutionary war, then fled to Canada in its aftermath. They brought refinement to what was still a very rough-hewn pioneer culture. The house I used as a model is in Upper Canada Village east of Kingston on the St. Lawrence River. The original, though the same Georgian style, is red brick. I covered it with white clapboard because I felt this gave it a more classic feel, a stronger sense of the elegance and civilized restraint the Loyalists brought to Canada.

Colonial Garden, 1987

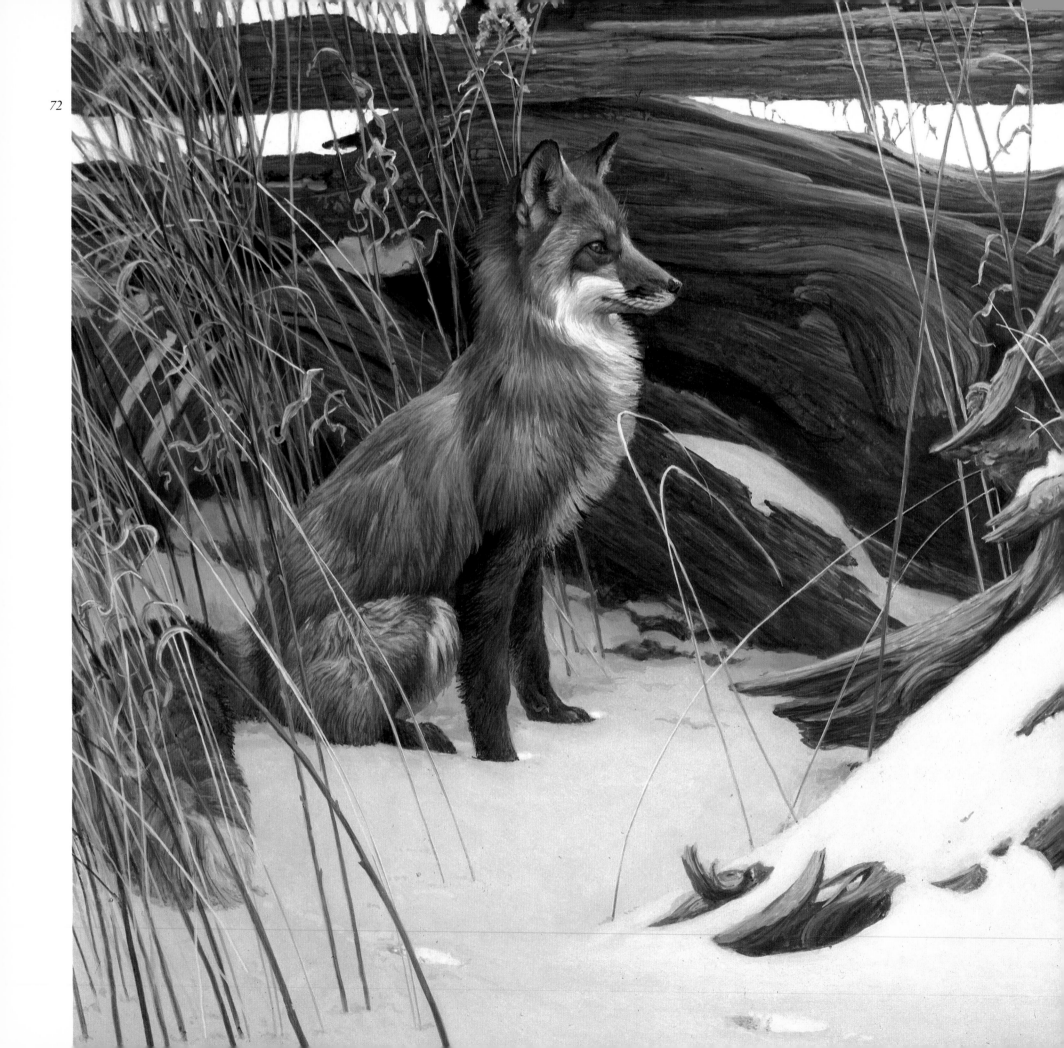

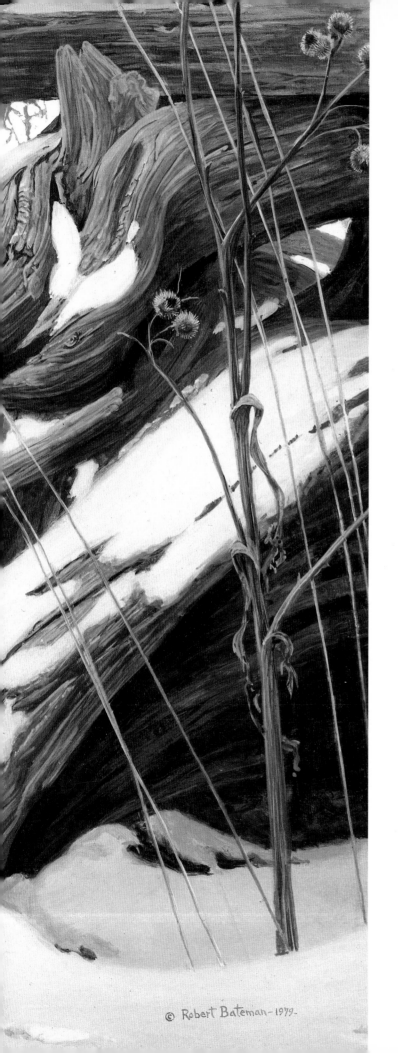

THE OLD STUMP fence this fox is using for cover won't likely last much longer – if it isn't gone already. It is one of the original fences made by the first settlers from great stumps of virgin white pine. White pine forests once covered much of the north eastern half of North America, and the pioneers found multiple uses for this versatile, easily worked, soft wood. After the trees were cut down, the stumps were pulled out using draft horses or oxen, and then dragged to the edge of the field. Those fences that haven't been torn down or burnt are still in pretty good shape as much as two hundred years later.

It has been said that if one of the Pilgrim fathers had startled a red squirrel in a pine tree at Plymouth Rock, the squirrel could have scampered from white pine branch to white pine branch all the way to the upper Mississippi River. Now only a very few virgin stands of white pine remain, but we can be reminded of them by the old fences and pine-board barns that still inhabit the landscape.

Wily and Wary – Red Fox, 1979

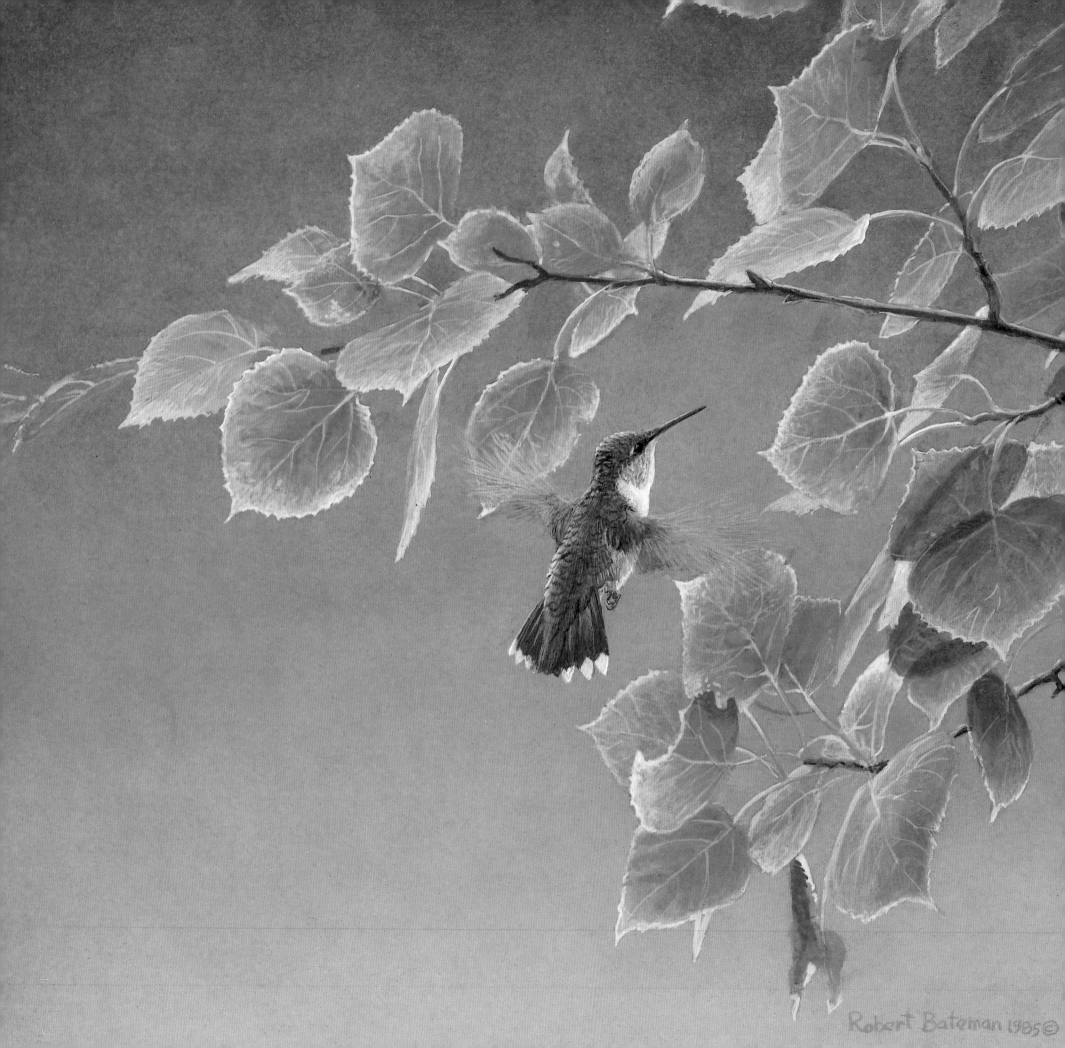

Robert Bateman 1985

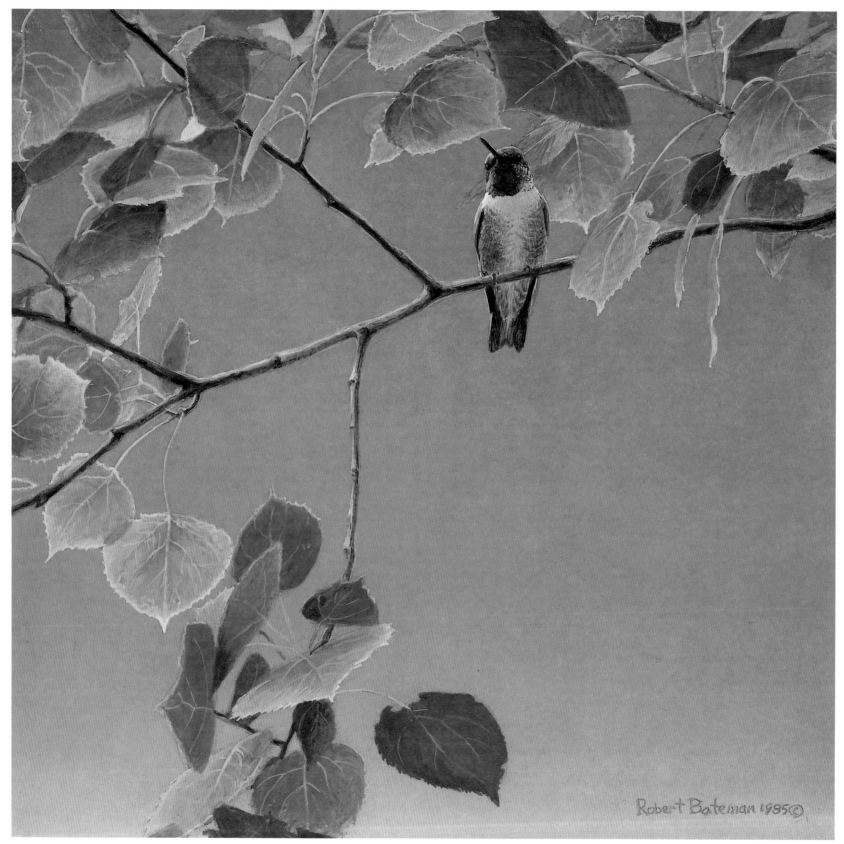

Female Ruby-throated Hummingbird, 1985 (left)

Male Ruby-throated Hummingbird, 1985

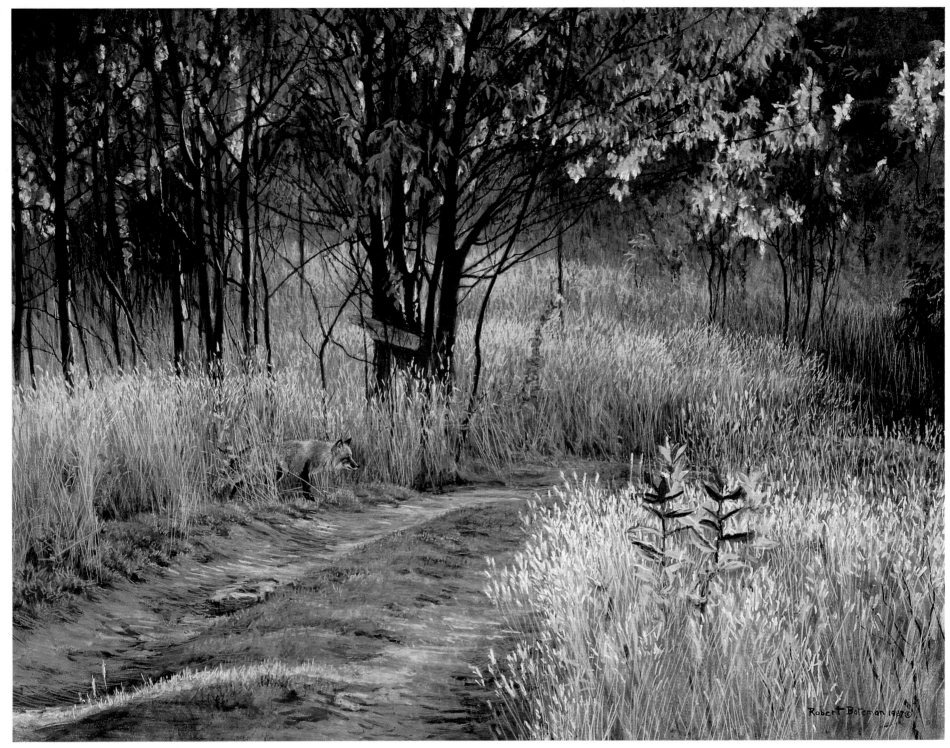

THE LANE in *Cottage Lane – Red Fox* leads to the scene of some of the happiest memories of my childhood. It is the road into the summer cottage where I spent many summers when I was growing up. But it looked very different then. When we started going to the cottage in the late 1930s, you could see sheep pasture and a split rail fence running along one side of the road to keep the sheep from bothering the cottagers. Now the farms are abandoned, the trees are coming back, and my father's hand-made sign that reads ''Bateman'' is considerably the worse for wear. But when I look at this picture I can imagine myself running along in bare feet playing kick the can. I can hear the shouts and laughter of my friends, and I can smell the hay drying in the nearby farmer's barn.

Cottage Lane – Red Fox, 1987

Farm Lane and Blue Jays, 1987

Robert Bateman 1987©

*P*RIDE OF AUTUMN – CANADA GOOSE was commissioned as the first conservation stamp of the U.S. National Fish and Wildlife Foundation, which is dedicated to protecting wildlife and preserving its habitat. I chose the Canada goose because it has always been a special bird for the people of North America. It was a staple food for the native population and a welcome supplement to the diet of the European settlers. Each autumn, the southward migration of the geese from their northern breeding grounds ushered in a period of feasting and celebration, as well as the serious work of storing food for the winter.

Although the painting is dominated by a proud gander who has just emerged from the water, his mate is not far away – you can see the ripples in the background that suggest she has just swum by. Like all geese and swans, Canada geese mate for life, another fact that has contributed to their popularity among nature lovers.

While the Canada goose is a bird I associate with autumn, the yellowthroat is inextricably linked in my mind with spring, my favorite season in the marshes and swamps. The yellowthroat's cheery "whitchety, whitchety, whitchety" makes me think of luscious teeming life. In *Cattails, Fireweed and Yellowthroat*, however, I've shown this bird in a late summer setting, when the marsh has become a lavish feast for the eye. The magenta flowers of the fireweed are giving way to its fluff-borne seeds, and the fruiting cattail heads are about to explode.

Cattails, Fireweed and Yellowthroat, 1987

Pride of Autumn – Canada Goose, 1986

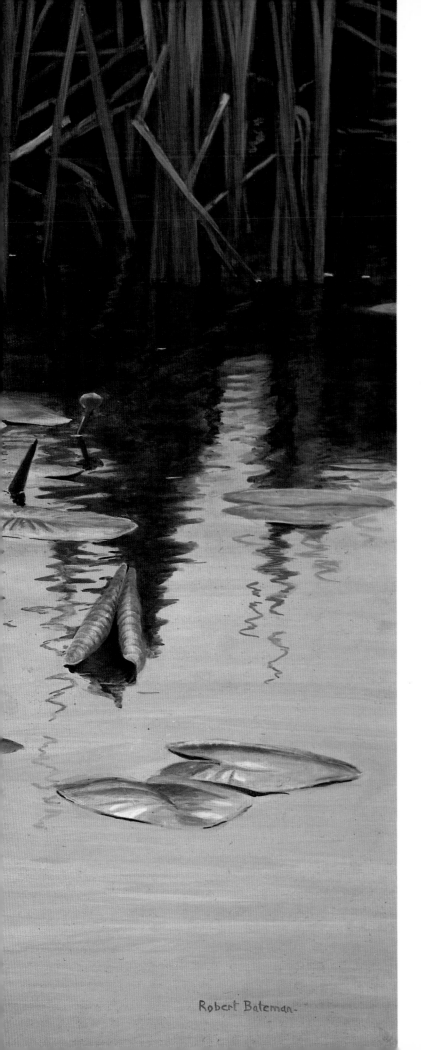

I HAVE spent many happy times birdwatching during spring migration. Every year I try to visit one of the staging areas for waterfowl, where you can see great concentrations of ducks, geese and swans. There is really nothing in nature to compare to the thrilling massed flight of these birds. The staging area I've been to most often is Point Pelee National Park in southern Ontario, which is where this painting is set. Pelee is more famous for its early May warbler migrations than it is for its waterfowl. Warbler week at Pelee has now become so popular with birders that there sometimes seem to be as many people as winged migrants. A month or so earlier, in the chill of late March, there aren't nearly as many human visitors, but great numbers of waterfowl are passing through, including the pintails.

Grace seems to be the operative word for pintails, whether in the air or on the water. They are fast and strong flyers – some western birds migrate 2,000 miles from Hawaii to their Alaskan breeding grounds – and at rest they are among the most attractive of waterfowl. In this painting I was interested in the vertical patterns made by the cattails and their reflections, and the way these relate to the elegant proportions of the ducks.

Spring Marsh – Pintail Pair, 1973

Leopard Frog (sketch), 1985

*D*OWN FOR A DRINK –
MOURNING DOVE and
Edge of the Ice – Ermine are as
much studies of frozen water as they
are of a mourning dove or a short-
tailed weasel. I've spent many hours
studying ice in all its forms, observing
what happens when light hits it from
different angles at different times of
day, watching it spread out from the
edge of a pond.

I consider it a remarkably wonderful
piece of good fortune that water is the
most common substance on earth.

Water is the only naturally occurring
substance that can be found in all
three states – solid, liquid and gas – at
normal earth temperatures. The
earth's climate is inextricably tied up
with the three states of water. And it is
also the only naturally occurring sub-
stance whose solid state is lighter than
its liquid form. Especially beneficial
for nature, ice floats, forming a thin
skin that insulates the water beneath,
keeping it liquid and so protecting
submarine life, both plants
and animals.

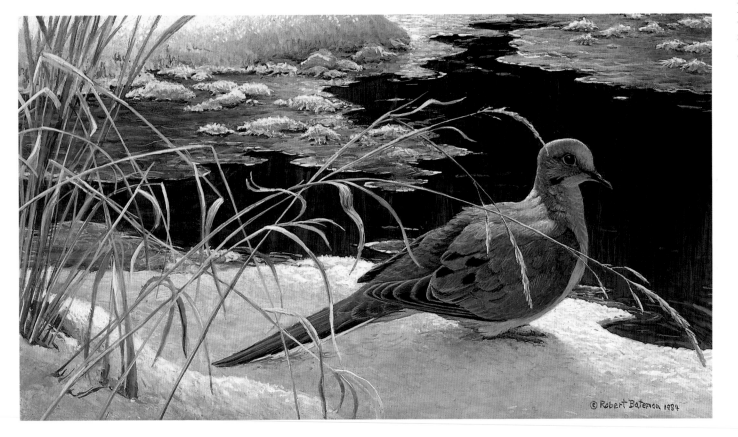

© Robert Bateman 1984

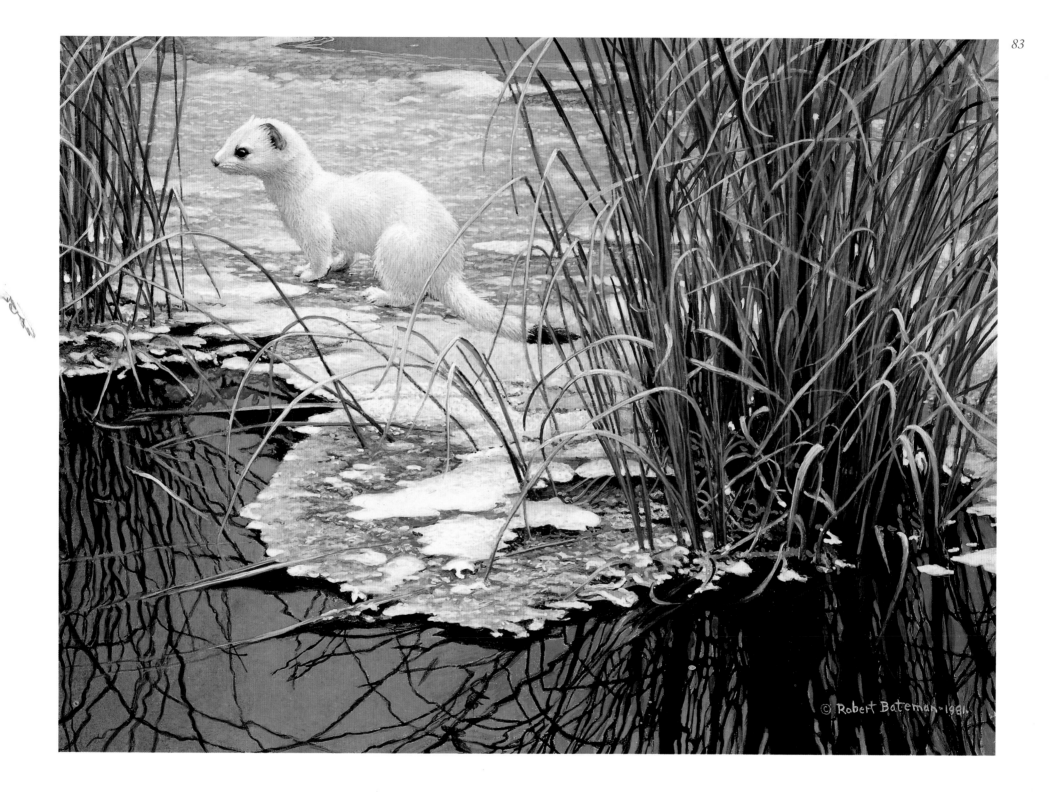

Down for a Drink – Mourning Dove, 1984

Edge of the Ice – Ermine, 1981

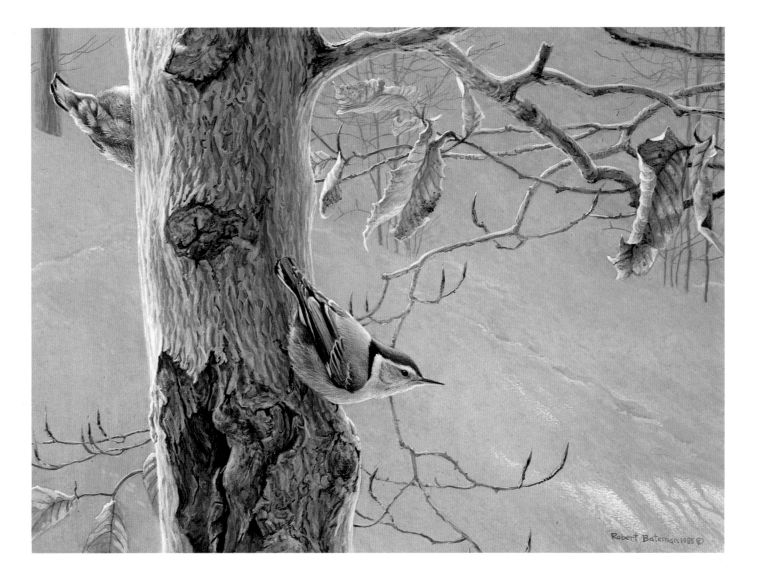

*White-breasted Nuthatch
on a Beech Tree, 1985*

Cherrywood with Juncos, 1987

THE MALE nuthatch is particularly natty with his black cap, gray back and crisply marked wings and tail. The nuthatch's eye, with the little line traveling from the back of it, has the look of an eye done in Oriental stage makeup. But this formal effect is undercut by his fluffy rust-colored bottom – it's almost as if he had put on a dinner jacket over his pajamas.

White-breasted nuthatches were frequent winter visitors to my bird feeders when I lived in Ontario; I could watch their zany hyperactive behavior from my studio window (I don't recall ever seeing a nuthatch in repose). When I moved to Canada's west coast, I left this species behind. But its close relative, the red-breasted nuthatch, is found near my new home, so I can still enjoy watching a pair of nuthatches explore every crack and crevice of a tree, making use of every body angle to reach hard-to-get-at places.

Cherrywood with Juncos could easily be set a few feet from the scene shown above, since dark-eyed juncos are also frequently seen at feeding stations. During the summer breeding season, these slate-gray finches are in the northern coniferous forests, but they are common winter birds where I grew up. Throughout their winter range they appear in flocks, feeding on seeds from crops and weeds in roadsides and fields.

In this painting I was as interested in the textures of the wood, which came from several large black cherry trees that had died on my property, as I was in the subtle modulation of grays in the birds. I was attracted to the cut wood's fine grain and rusty golden color that glowed against the snow.

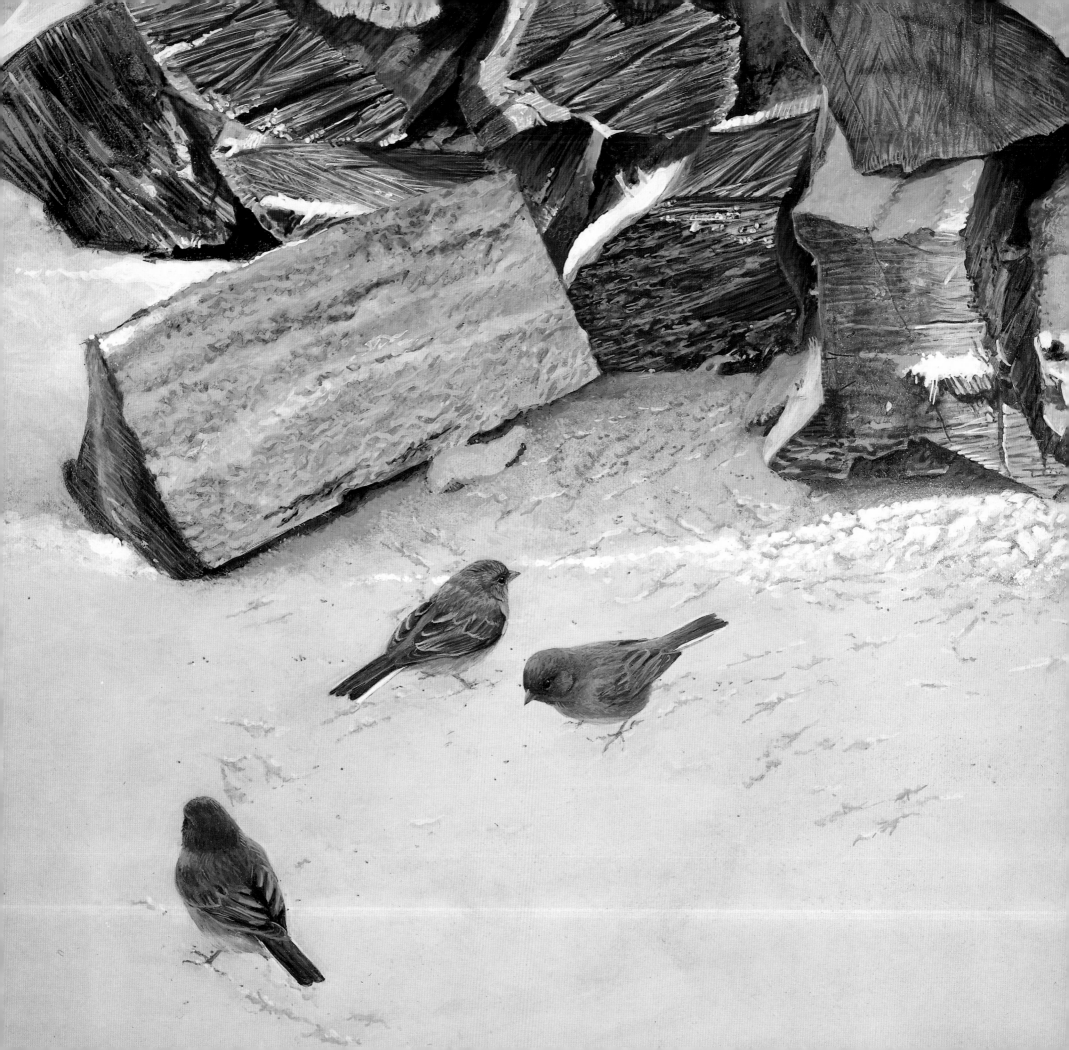

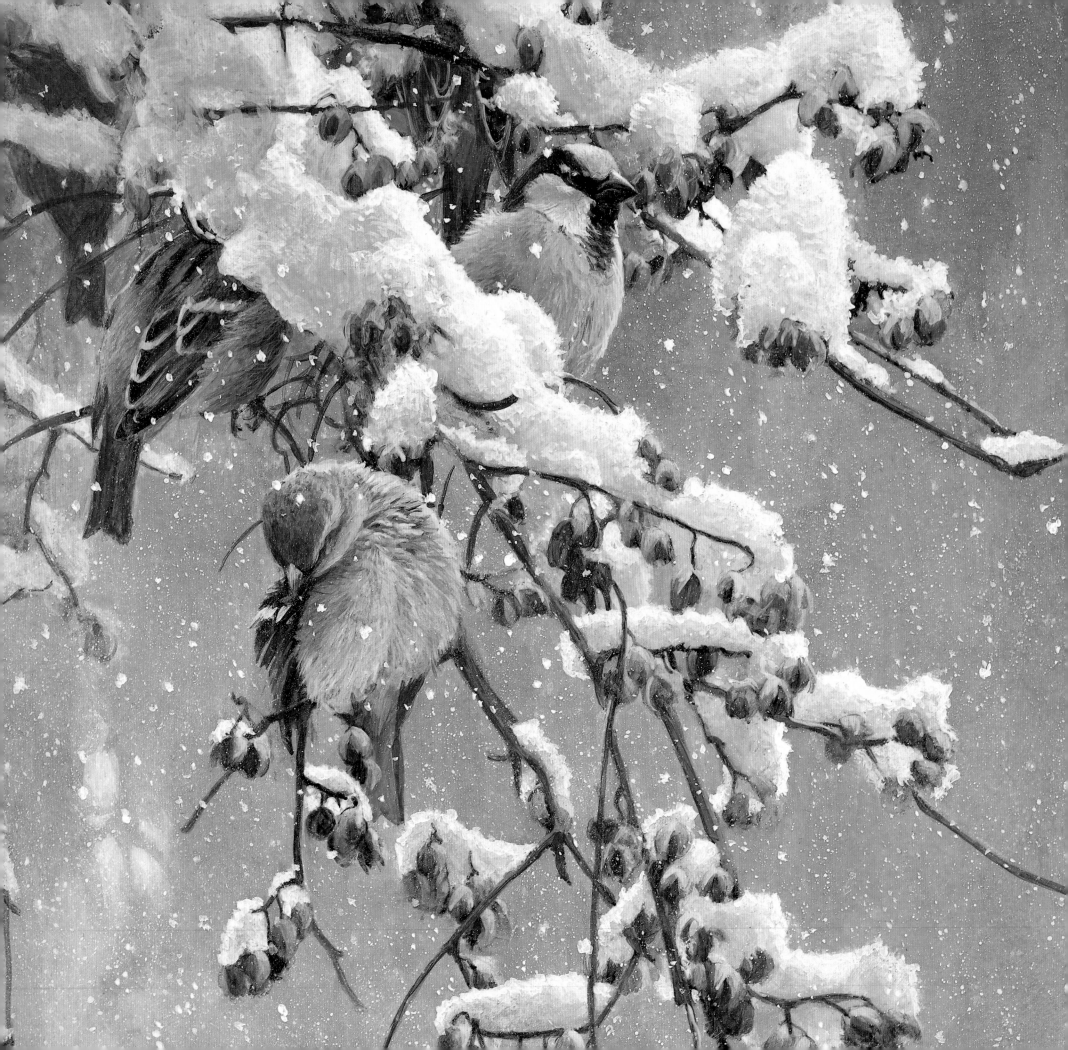

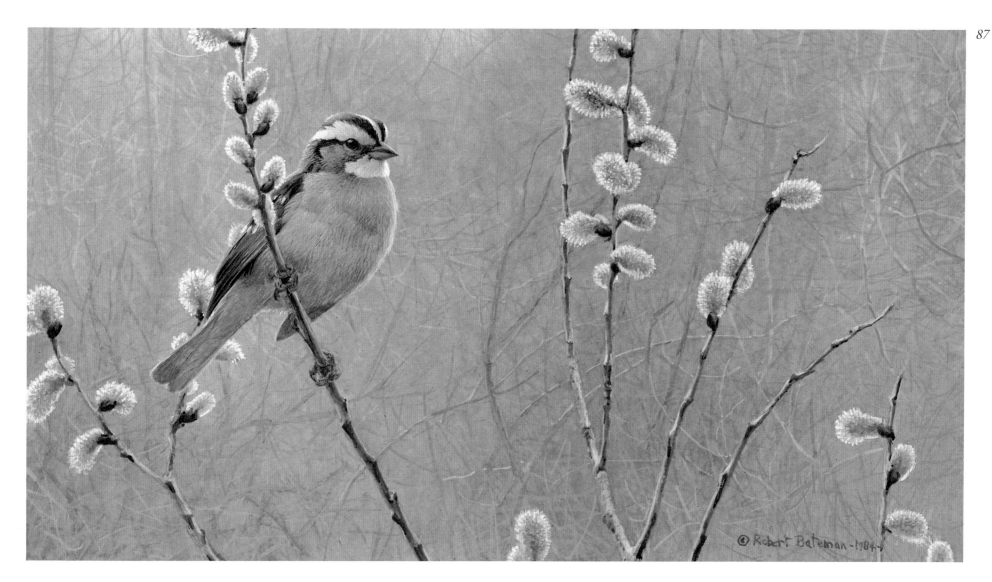

THE HOUSE SPARROW, or English sparrow, one of the commonest city birds, is not really a sparrow at all. It actually belongs to the weaver finch family of Eurasia and Africa and was introduced to North America in 1850 in an effort to control insect pests. Instead it thrived to the point of displacing native birds. The weaver family derives its name from the intricately woven nests of some of its African members, but the house sparrow's nest is more a tangle than a tapestry. Like other weavers, however, it is gregarious and garrulous. The group of sparrows in this painting are settling down for the night in a tangled mass of bittersweet, a place where they might build a nest and which provides shelter in wintertime.

I strongly associate the white-throated sparrow with the wilder places in its territory – cottage country, canoe country and the margins where forest meets farmland. To Canadians its high, clear whistle says, "Oh sweet Canada, Canada, Canada, Canada." To Americans it sounds like "Old Sam Peabody, Peabody, Peabody, Peabody." Either way, to me it speaks of a world of contentedness and clear air. In *White-throated Sparrow and Pussy Willow*, however, I've shown the bird during its spring migration through southern Ontario, which begins when the pussy willows are in bloom. The grays of the bird's plumage are complimented by the gentle grays of the spring landscape before the green leaves have popped from their buds.

House Sparrows and Bittersweet, 1987 (left)

White-throated Sparrow and Pussy Willow, 1987

Squirrel (sketch), 1987

Winter Wren, 1979

ONE OF the reasons I'm fond of wrens is that they draw your attention down to the world at your feet, a world that is easy to overlook. The winter wren has been one of the commonest wrens almost everywhere I've lived – in Europe it is the only representative of this widespread North American family. I like the contrast between its subdued brown plumage that helps it blend in with its surroundings, and its surprisingly loud and joyous song that reminds me of the gushing springs and tumbling brooks so often found in its territory. It also has a wonderful scientific name, *Troglodytes troglodytes.* According to legend, troglodytes were secretive prehistoric creatures who lived in caves. True to its name, the winter wren prefers nooks and crannies in cliffs or rock walls and the caverns under tree roots. It will poke and peer under things and will disappear and reappear almost like magic.

My main reference for the bird in this painting was a little watercolor I did in my late teens when I was working in Algonquin Park. When I began *Winter Wren,* I went back to my old sketchbooks, and it gave me great pleasure to rediscover this early effort and find it useful to my mature work. But the overall concept for this painting has very different sources. The composition is strongly influenced by Paul-Emile Borduas, the French-Canadian abstract artist whose paintings consist primarily of black and white blotches. It is partly from him that I learned to appreciate the Yang and Yin of dark and light, which is what this picture is about as much as the bird.

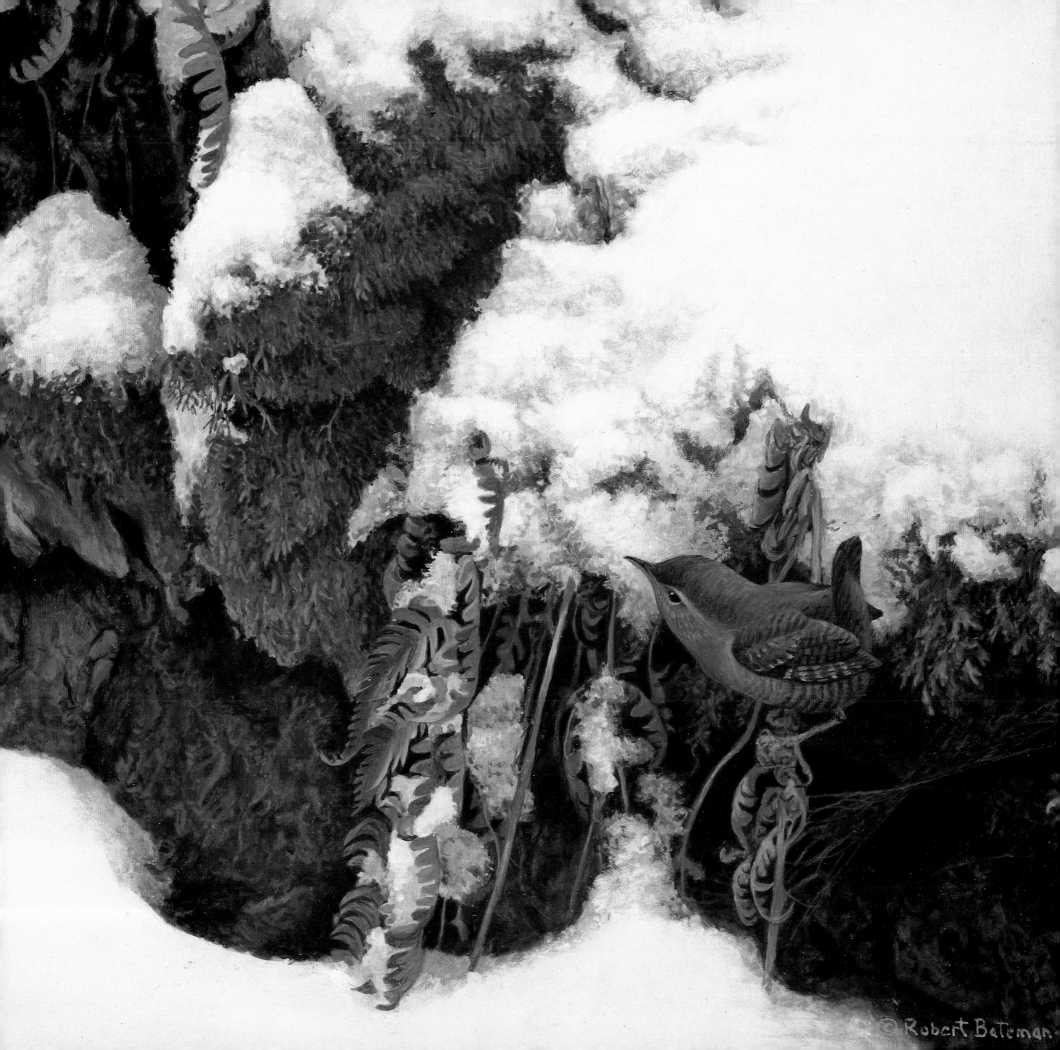

BOTH THESE PAINTINGS portray pieces of the disappearing world. Almost all our elm trees have been wiped out by Dutch elm disease, and soon all our farm fencelines will be made of metal and will be put up entirely by machines. The older fencelines have individuality and personality – and they are primarily the product of manual labor. Wood fences are also friendly to wildlife, providing nesting places for birds and other animals. The fence in *By the Roadside – Horned Larks* is actually a transitional fence with elements of both old and new technologies. It is made of wooden posts, rails and some wire, and was built in the days when farmers were largely self-sufficient and relied almost entirely on local materials for building. With the advent of "industrial" agriculture, farmers have come to depend increasingly on expensive machines, pesticides and fertilizers – which look efficient until their environmental cost is factored in. Along with these changes, the old spirit of community is vanishing. So an old fenceline is not just something I find aesthetically pleasing, it represents a whole way of life that has been virtually lost.

Robert Bateman

Great Horned Owl Study, 1987 (below)

Snowy Owl and Milkweed, 1986 (right)

Woodland Drummer – Ruffed Grouse, 1980 (overleaf)

LIKE MANY PEOPLE, I'm fond of owls. I think part of their appeal is the fact that they have frontal vision, which gives them a vague resemblance to human beings. Partly it's their elusiveness, because most species hunt only at night. Their popularity may also be due to the eerie calls of a number of the nocturnal species. For whatever reason, owls have a mystical quality. This is true even of the two North American species that are active by day, the short-eared owl and the snowy owl.

As a young birdwatcher my first sighting of a snowy owl was along the Toronto waterfront, which I and my birdwatching chums haunted during the cold months, looking for the various species of ducks and gulls that spent the winter there. One day on the breakwater stood this magnificent white predator, his golden eyes looking at me.

I've painted quite a few snowy owls, in part because I like the artistic challenge of putting white on white. *Snowy Owl and Milkweed* was done for my alma mater, Victoria College at the University of Toronto. I chose an owl because of its connection to Minerva, the goddess of wisdom. I placed it beside a milkweed plant, which is common in southern Ontario, because the wind-dispersed milkweed seeds represented to me the widespread dispersal of knowledge by the graduates of the university.

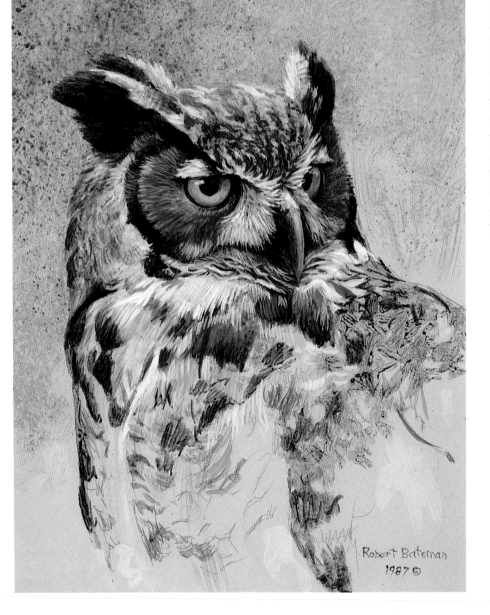

Robert Bateman
1987 ©

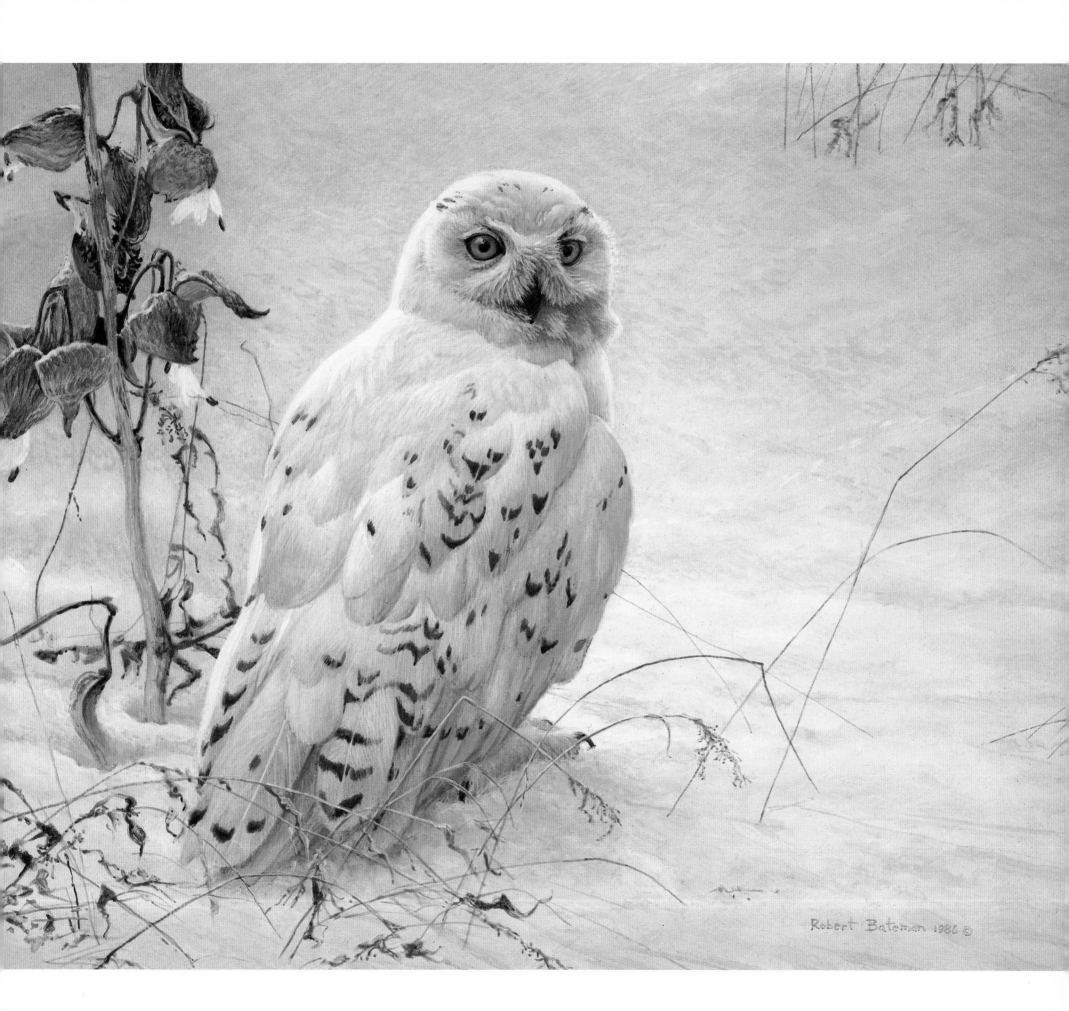

Robert Bateman 1986 ©

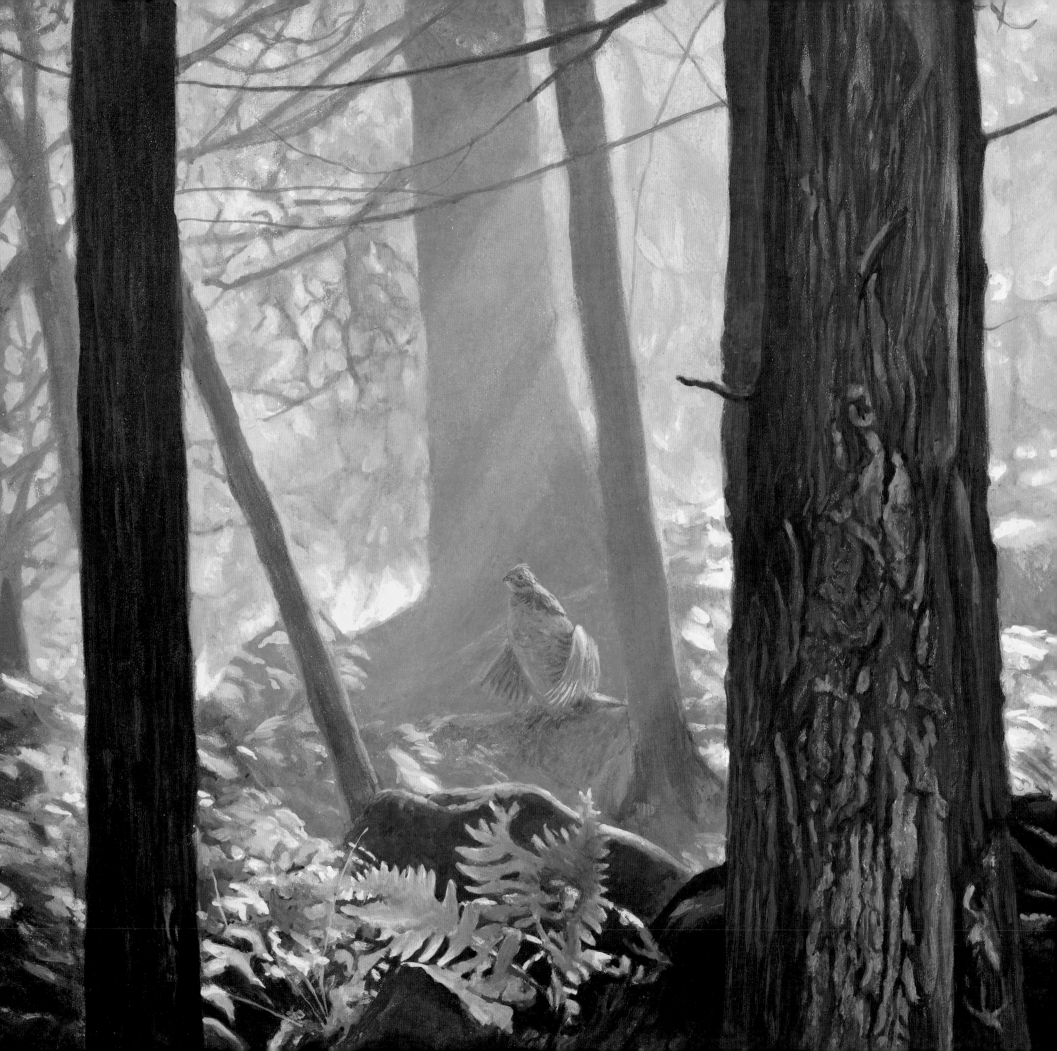

© Robert Bateman – 1980

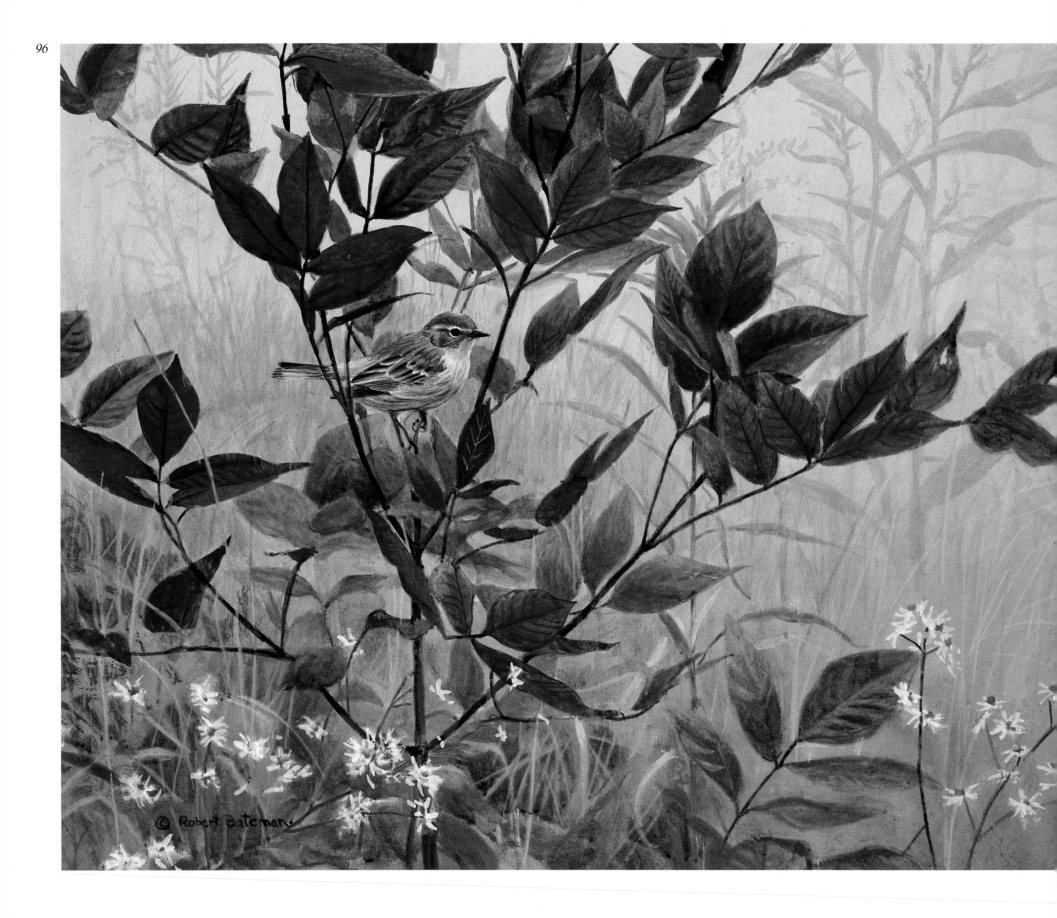

OUR FORESTS are the most precious pieces of nature we have. Their continued destruction, whether in Europe, China, the Amazon or the Pacific northwest is one of the most serious challenges to conservationists. The amount of forest we have left by the beginning of the next century will have a lot to do with how livable our planet will be for our children and grandchildren. The paintings on this page, and on the preceding and following pages, are at least in part about forests in eastern North America. In *Woodland Drummer – Ruffed Grouse* (previous page), the setting is a mixed forest, which provides the grouse with adequate cover, especially in winter. The staghorn sumac in *Yellow-rumped Warbler and Sumac* is a shrub or small tree characteristic of the brushy edges of the eastern forests. And *Hardwood Forest – White-tailed Buck* (overleaf) shows a particular kind of deciduous forest – a forest reaching its climax and primarily inhabited by beech and maple. One of the beautiful things about forests is the way they look after themselves from generation to generation and how different species of trees succeed each other as the forest matures. At one time this beech-maple forest was populated mostly by birch and aspens – softwood species that provided the dappled shade hardwood seedlings thrive in. Once the hardwood trees grew, the shade increased to the point that the birch and aspen started to die out – you can see a few birch trees remain in the painting, but these will soon be gone. After a forest has reached its climax it can continue in this state indefinitely. Think of the giant redwoods of California or the awesome rain forests of British Columbia with their towering Sitka spruce.

I enjoy the eastern forests throughout the year, but late autumn after the leaves have fallen is one of my favorite times. Then the forest becomes stark and primordial. In *Hardwood Forest* this effect is heightened by the mist. The atmosphere of a misty day appeals to my artistic sensibilities because mist tends to separate the elements of a landscape. And this is always one of the key things I'm after in my work – the delineation of separate elements.

Yellow-rumped Warbler and Sumac, 1977

White-tailed Buck (sketch), 1987

Hardwood Forest – White-tailed Buck, 1987 (overleaf)

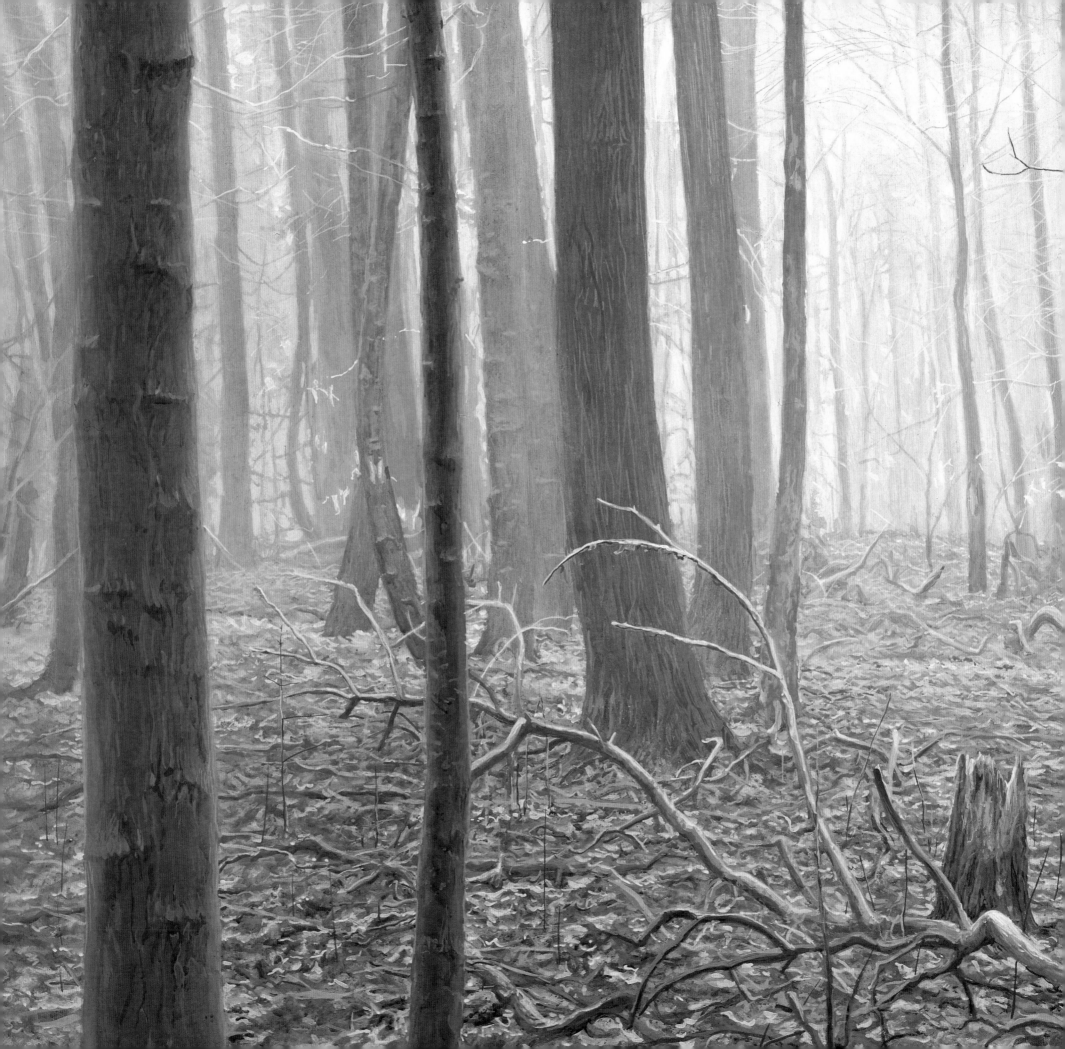

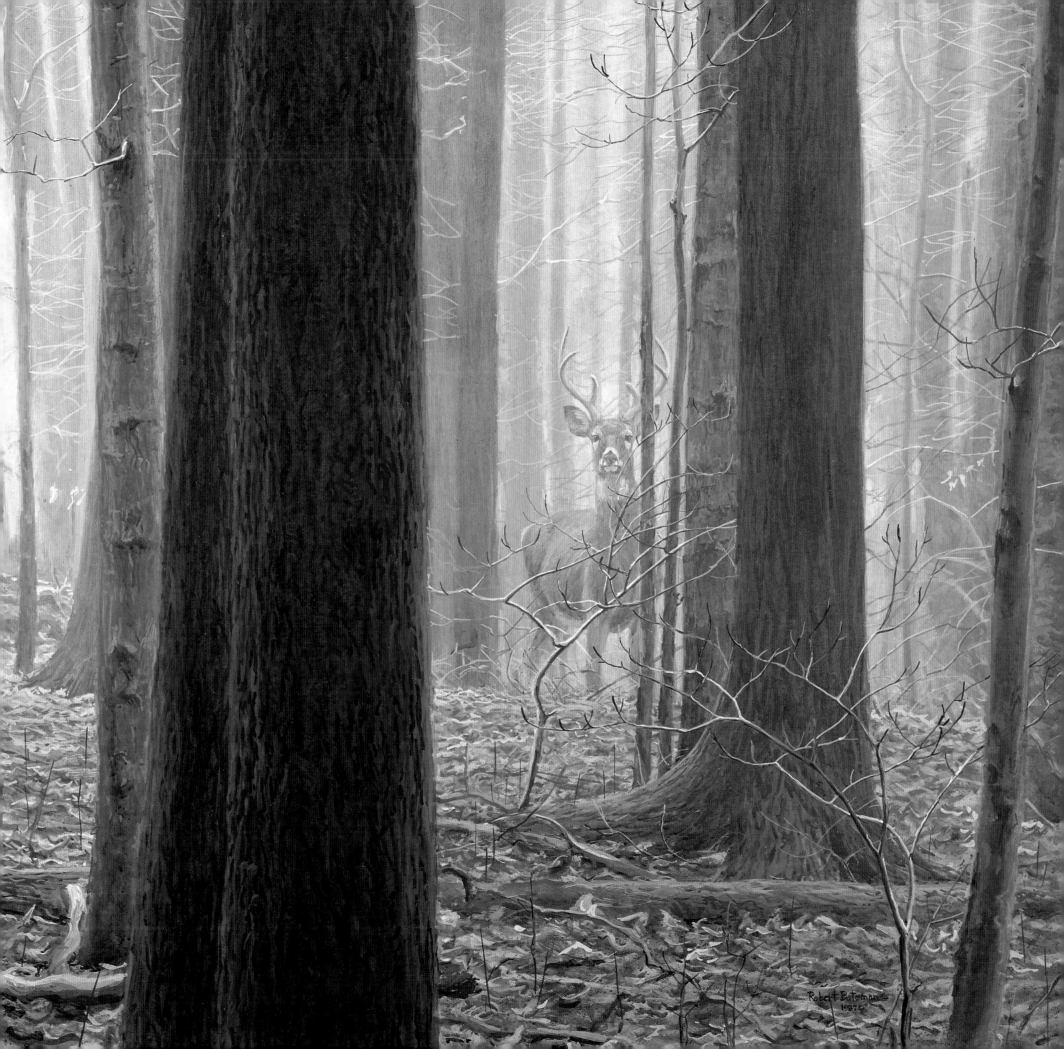

IN THE lush tropics and sub-tropics there is so much life densely packed into a small space. The most tropical areas of North America are the swamps of Florida, which are full of bird species – coots and gallinules, herons and anhingas, egrets and ibises. Swamps are full of sounds and smells as well as sights; to me they smell fresh, not putrid, a bit like being inside a greenhouse. In the Florida swamps there are animals at every level from the water to the tree-tops. It's like being in a multi-storey animal apartment building.

Mangrove Morning – Roseate Spoonbills is loosely based on a scene I witnessed one beautiful Easter morning in the Everglades, but the elements have been rearranged to create the feeling of an Oriental tapestry with the texture of old shot silk. The roseate spoonbill, despite its awkward face, has an extremely elegant form and plumage that seemed right for this treatment. As I worked, I played with the colors of both bird and swamp to heighten the effect of something tropical and lavish.

Each time I visit Florida, I wonder how much longer its biological diversity will endure. The Everglades, only part of which is protected by the Everglades National Park, is gradually drying up due to the rapid increase in population, which has meant both increased water use and the alteration of drainage patterns. Throughout the world, protected areas are facing similar problems. As civilization pushes up against their boundaries, these areas are increasingly becoming fragile islands of sanctuary.

Spoonbill Crane (sketch), 1986

Mangrove Morning – Roseate Spoonbills, 1988

Young Sandhill Cranes, 1987 (overleaf)

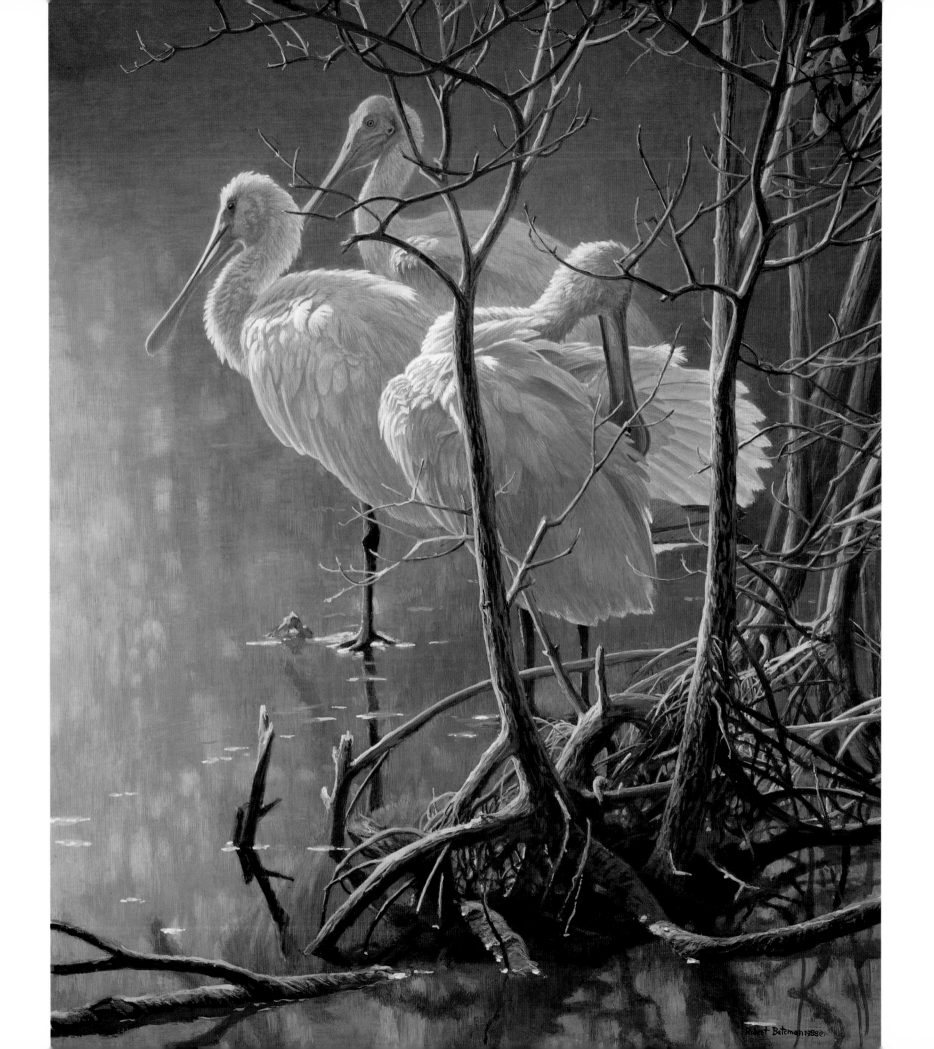

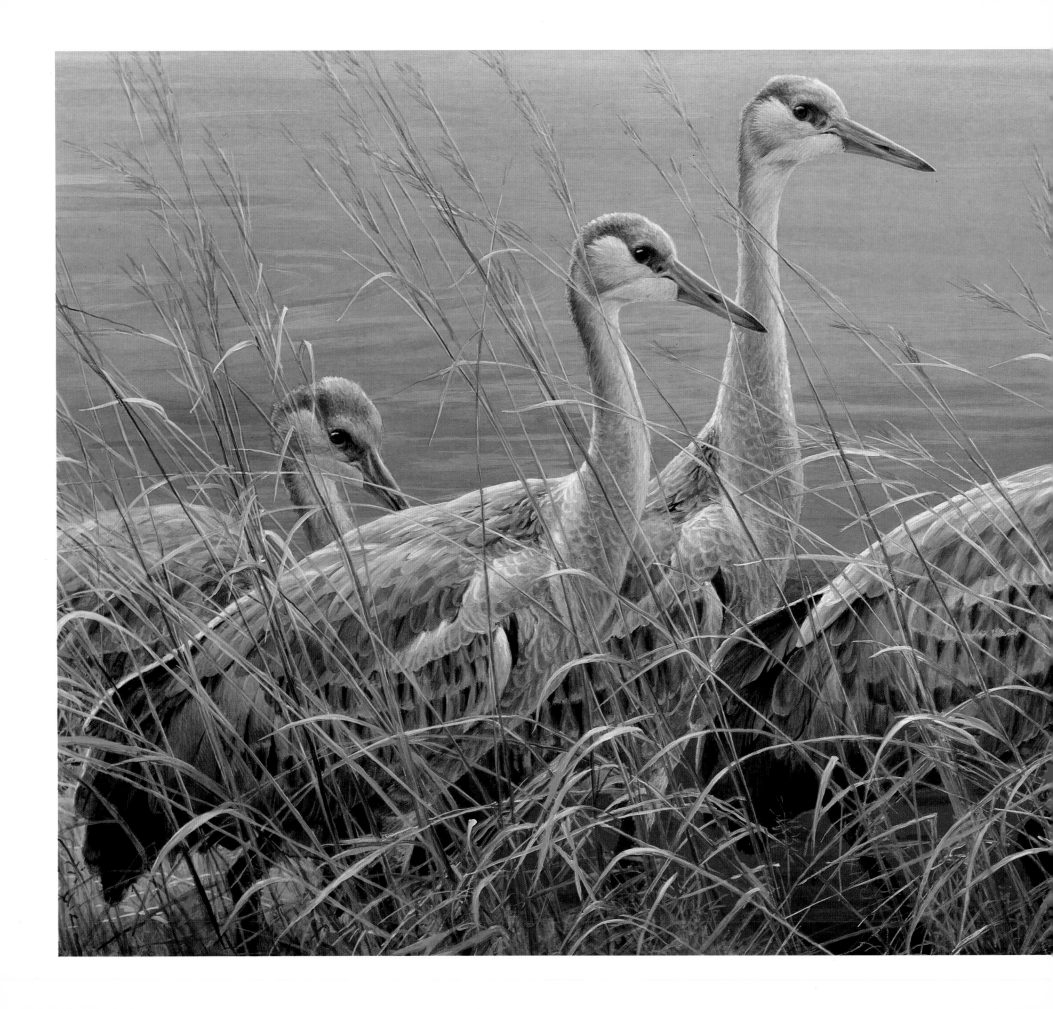

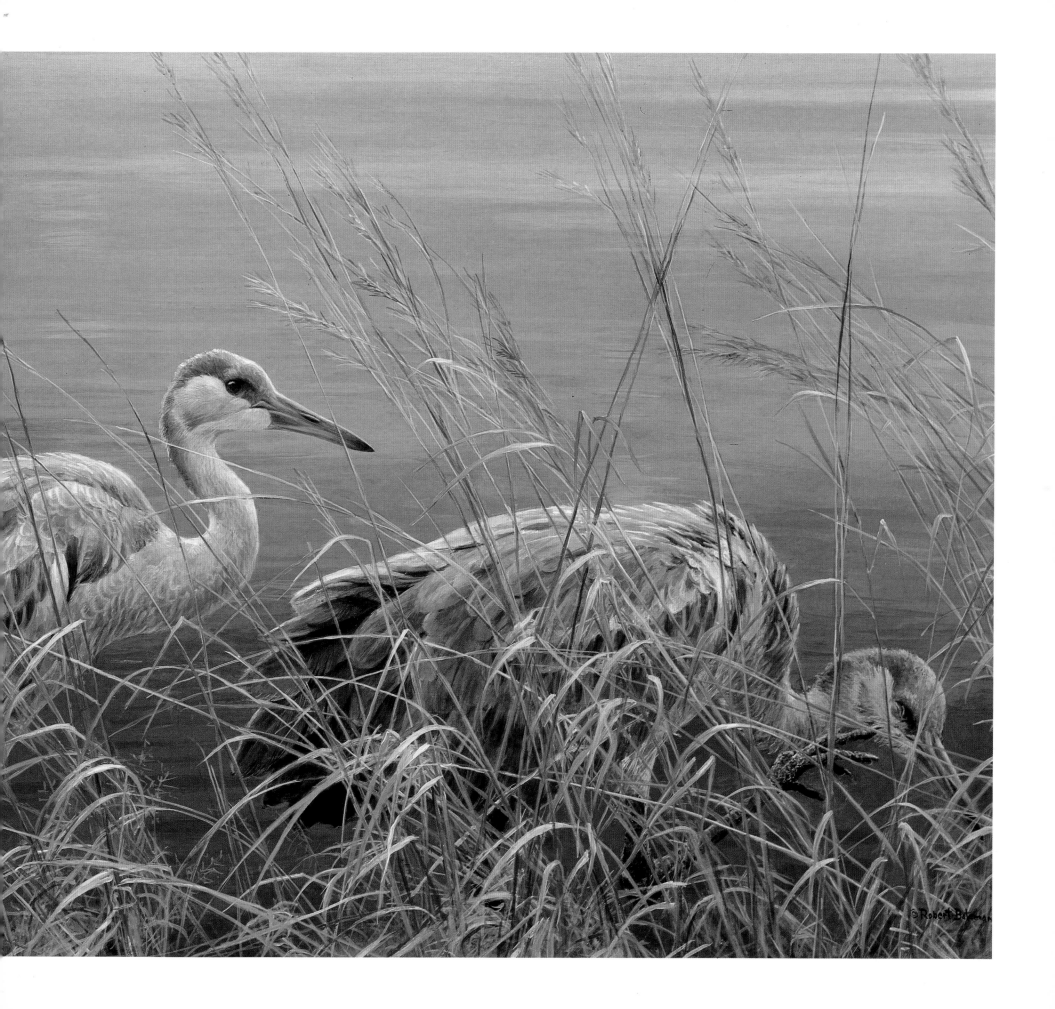

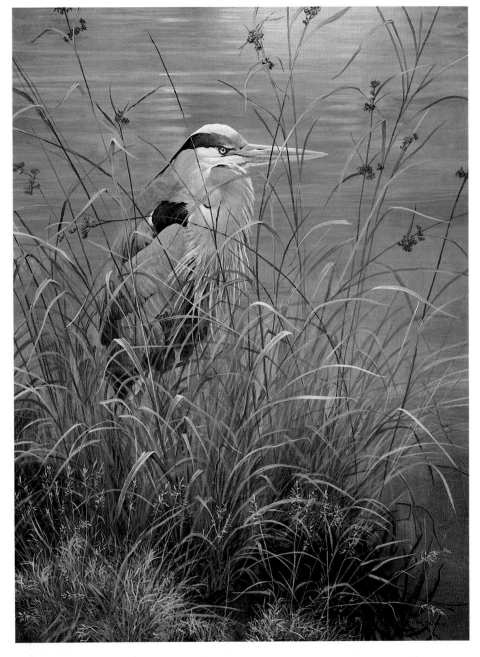

*G*RASSY BANK – GREAT BLUE HERON is one of a number of heron paintings I've done over the years. Great blues are among my favorite subjects: they combine grace and fierceness. From an artistic point of view, one of the fascinations of herons is that they can assume so many different shapes. At times they look like lethal weapons with their necks coiled back and ready to strike; at others they appear frail and sticklike; at others they are all elegant curves and angles. This heron has eaten its fill of frogs and minnows and folded down into its resting pose. Within its "hunkered down" silhouette, however, there are beautiful sculptural arrangements. This combination reminded me of a circular Mayan stone carving that holds within it a series of interlocking geometric shapes.

Tree Swallow Over Pond is meant to lack any center of interest. It is simply a view down into a pond. All of us have discovered the meditative Zen-like state that can be achieved by simply staring at water as we let our minds wander, thinking about nothing in particular. The water itself has no meaning; it is simply there. In the painting I have interrupted the viewer's reverie with the metallic glitter of a tree swallow entering from the right. The swallow provides only a momentary focus; in another moment it will be gone.

Grassy Bank – Great Blue Heron, 1978

Tree Swallow Over Pond, 1987

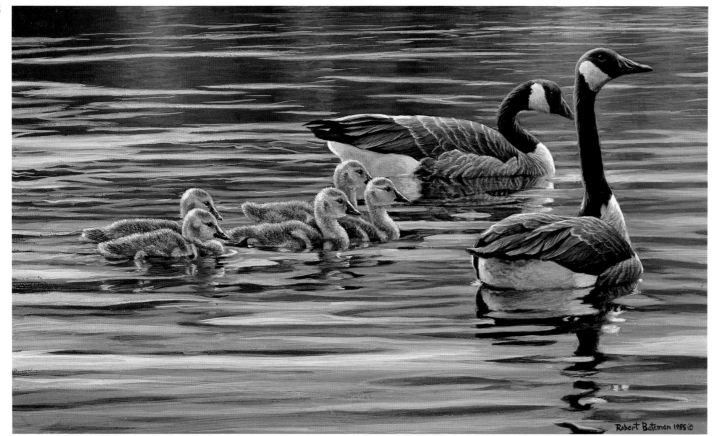

Canada Geese With Young, 1985

Loon Family, 1979

THESE TWO PAINTINGS are as much about water as they are about Canada geese and loons. Still water is like a gently undulating mirror in which reflections are constantly changing. In my early days I used to spend many hours looking at calm water and trying to understand what was going on with it. I would watch for a while and then turn away and attempt to sketch what I had observed. I would first draw the water from memory to see what residual images were left in my mind, then turn back and continue my investigation.

Now whenever I paint water I draw on this reservoir of experience. One can easily copy a photograph of water frozen in an instant of time, but the result is usually unsatisfying, stilted. There is a whole series of complex and subtle factors that govern the way water looks and what it does. These depend on the color of the water itself, the color of the sky, the color of the far shore that's reflected in the water, the presence of currents, the wind pattern, the wave pattern and, of course, the motion of an animal swimming on its surface or underneath. A patch of water produces a different abstract composition every second. It is as changeable as a kaleidoscope, an infinite source of shapes, colors and textures.

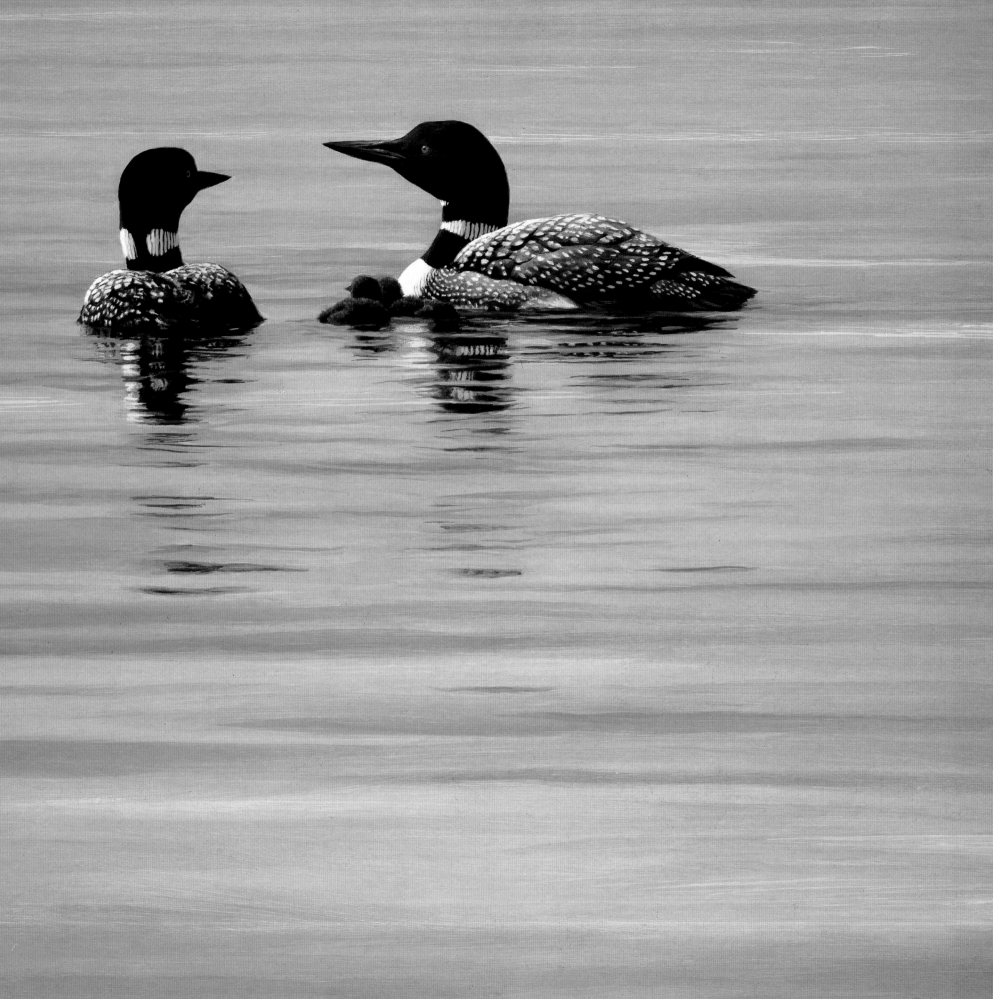
© Robert Bateman-1978

THE TWO LOONS shown here are an adult and an almost fully-grown young loon. The mottled gray coloring of the younger bird is similar to that of the adult's plumage in winter. Although it isn't as striking as the adult's summer pattern of black and white, it is very pleasing.

Loons evoke unspoiled wilderness for many people, and probably no sound in nature better captures the feel of the great outdoors than a loon's haunting cry echoing across a northern lake at night. But although they symbolize wilderness, I have never had to travel too far away from civilization to encounter them. For years, they were a common sight on the clear, rockbound lakes of the Canadian shield. Increasingly, however, the bird finds itself under assault. Loons build their nests on the shore quite close to the water; they can't walk on land because their legs, intended for swimming and diving, are set too far back on their bodies. As a result, the waves kicked up by passing motor boats often wash their eggs right out of the nest. Far more serious for the loon's future, however, is acid rain caused by industrial pollution, which is poisoning lakes, killing off the small fish that make up its diet. Unless acid rain is stopped, there will come a time when loons have retreated into what little wilderness remains, and few people will have a chance to see them or hear their call.

Muskoka Lake – Common Loons, 1988

Ready For Flight – Peregrine Falcon, 1983 (overleaf)

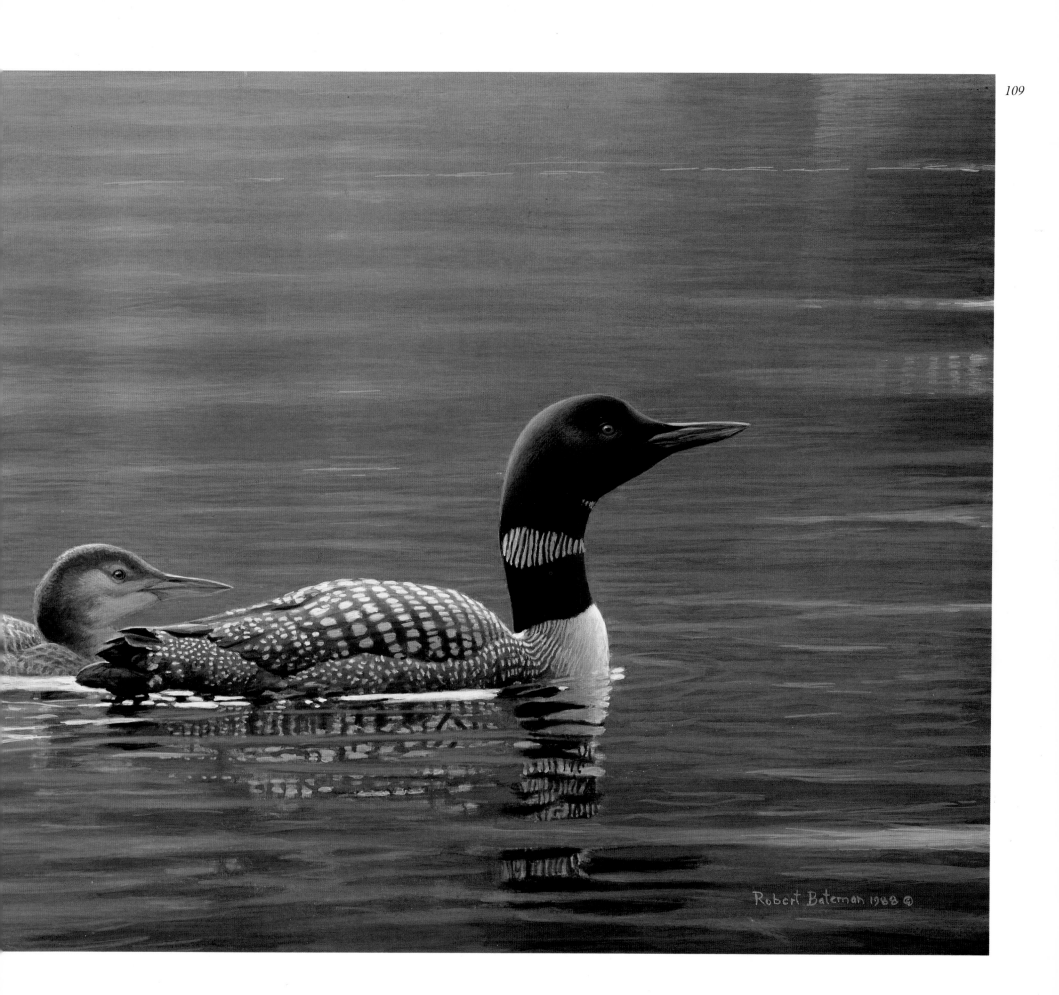

Robert Bateman 1988 ©

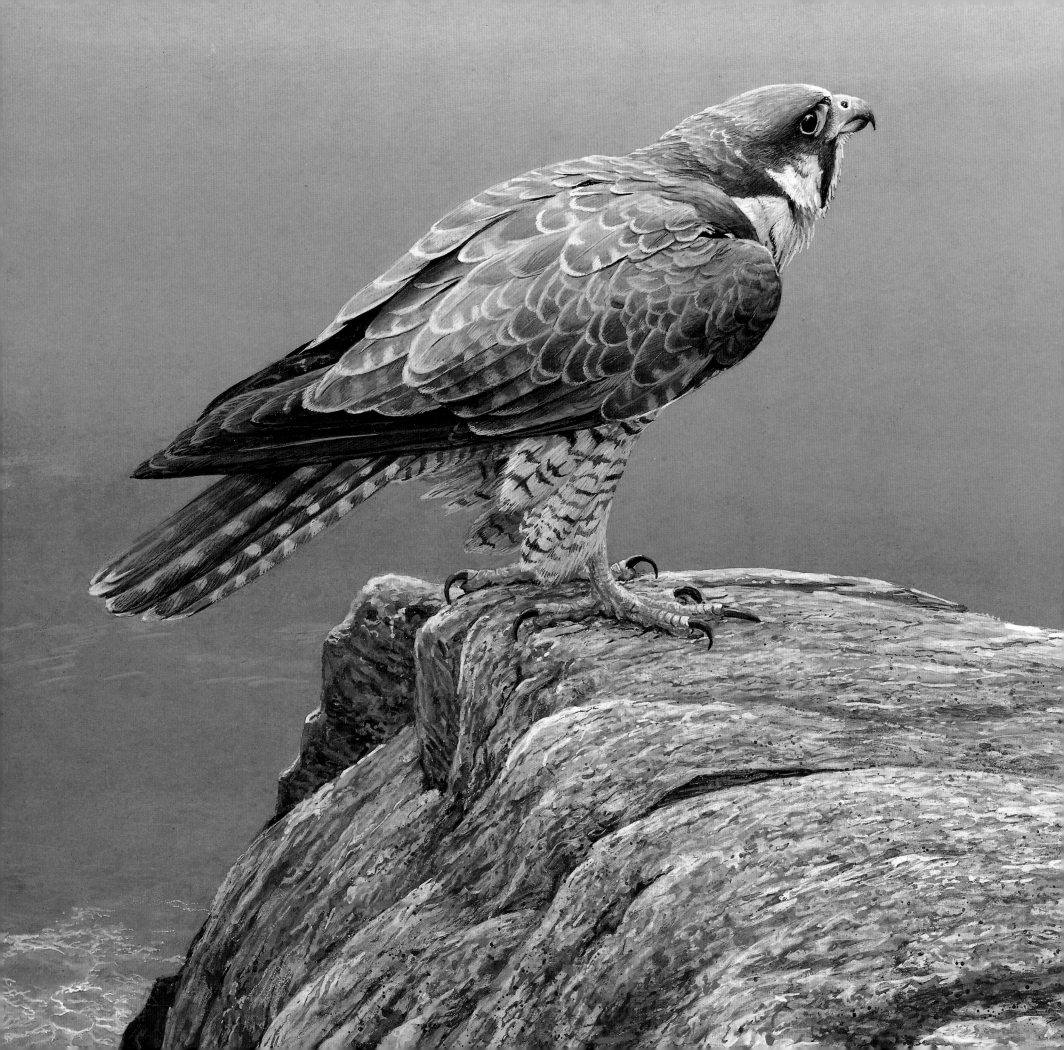

© Robert Bateman. 1982

LIKE MANY painters of wildlife, I am drawn to the big birds of prey, or raptors. They are the masters of the air, breathtaking to watch both in terms of their size and their aerodynamic skill. Each raptor species has a particular look – the osprey has rather wild, demented features that seem almost a cross between an owl and turkey. In *The Osprey Family* I've shown the bird with its screaming expression, which seems most appropriate to its intense and forceful appearance.

Ospreys are the great fishers of the raptor clan. They can be seen along coastal waters, forested lakes or mountain rivers on every continent except Antarctica. Because they live off the water, they are sensitive indicators of the state of the environment. Not long ago, the pollution of North American inland waters was such that the osprey population dwindled rapidly. Now they are coming back, one hopeful sign that as a species *homo sapiens* can mend its ways.

The osprey nest is a marvel of bird engineering. The same powerful talons that carry a freshly-caught fish home to the nest carry sticks and branches for the nest's construction. Transporting a heavy load of fish or building material is no easy feat, and ospreys are adept at arranging their burden to cause the least drag so they can gain the necessary height to reach their destination. Once the house is built it is used, with repairs and additions, year after year.

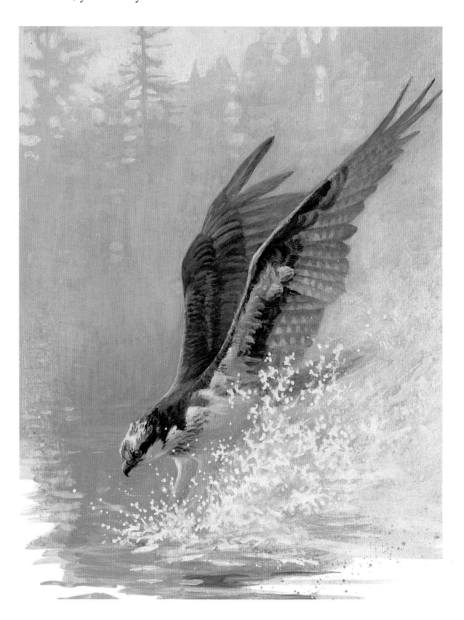

Osprey, 1989

The Osprey Family, 1980

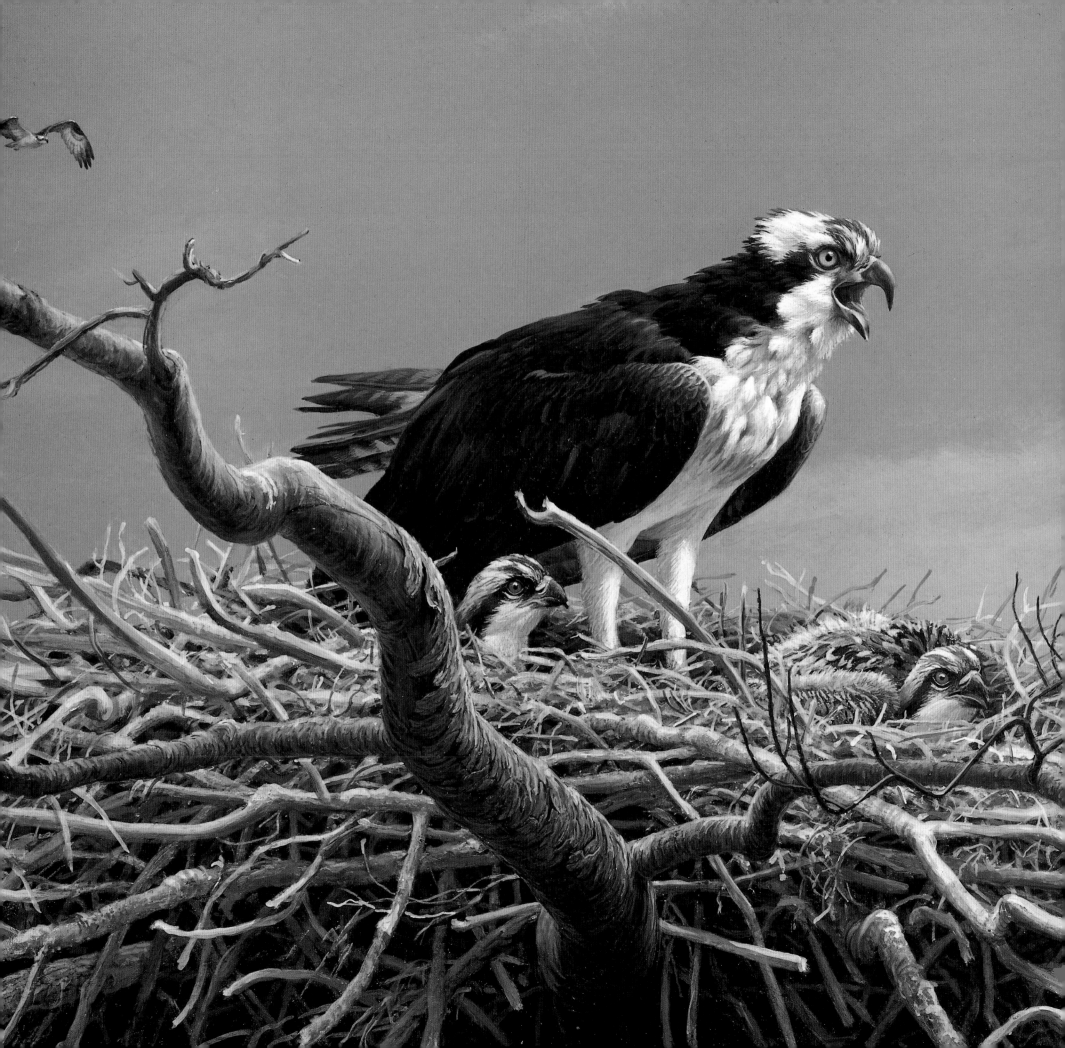

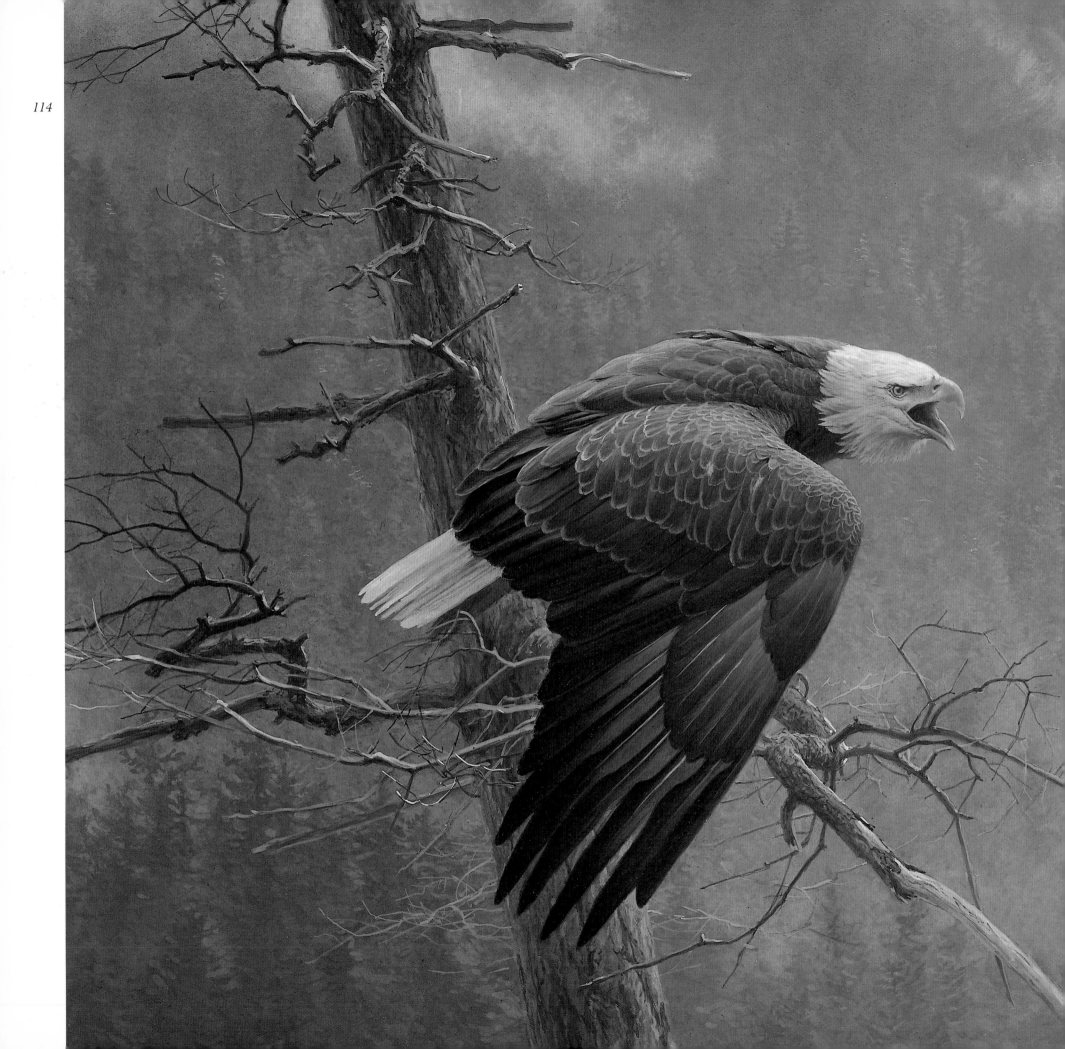

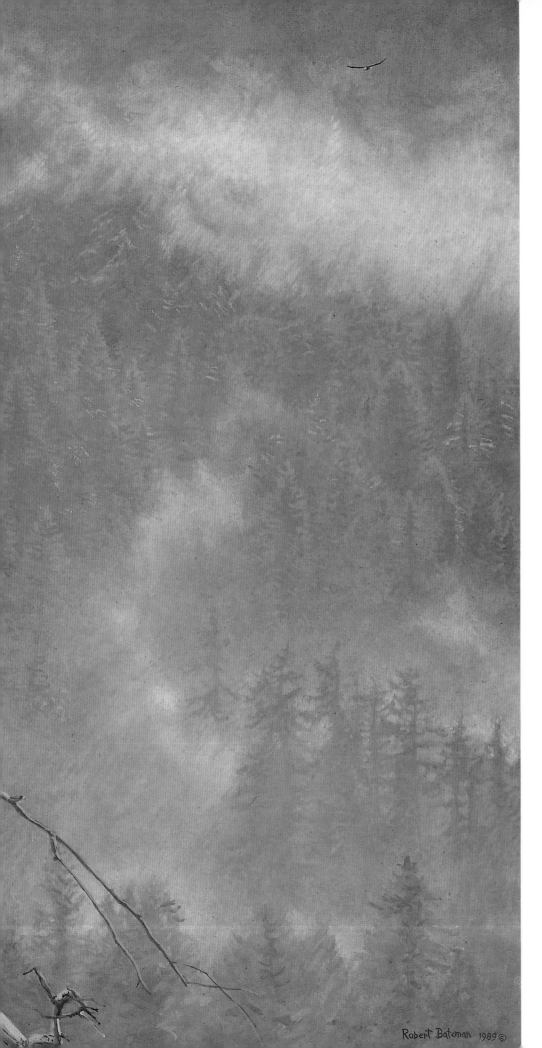

I COULD PAINT bald eagles for the rest of my life – their feathers provide a range of abstract shapes that are a challenge for the artist, and their strong faces remind me of a primitive carving. Now that I live on Canada's west coast these magnificent raptors pose for me in the wild. In fact, the setting for this painting is the view from my studio window. It's a winter day, a very rainy time of the year in my part of the world, when the cloud cover is quite low, and the mist in the air brings out the contours of the tree-lined slopes across the bay.

This painting was commissioned by the National Wildlife Federation as a special print for the 1990 Earth Day celebrations. I chose the bald eagle because it's a good example both of how man can harm nature and how we can reverse some of the effects of his depredations. Twenty years ago these birds were in big trouble. DDT had contaminated their food supply, and the levels of it in their bodies had affected their fertility. What few eggs the birds could lay had such thin shells that they often broke while being incubated. Like the canary in the coal mine, the bald eagle was sending us a warning. After DDT was banned in North America in the early seventies, the bald eagle began making a comeback.

The Air, the Forest and the Watch, 1989

*T*RUMPETER SWANS AND ASPEN is a painting with no clear source of light – you could almost say it is without light. This is deliberate. I wanted to give the picture a flat delicate quality, something like a Japanese screen. To heighten this effect, I chose one of my favorite trees, the aspen, with only a few leaves still clinging to it. Because of its soft wood, an older aspen loses branches during storms, giving it an oriental, almost "bonsai" look. The use of empty or negative space is typical of Japanese art. And I employed a gentle yellow-green and olive color harmony to heighten the tranquility of the scene.

I painted this in 1975 for a show on endangered animals. At that time, this western bird, the largest swan in North America, was in very serious trouble – in fact it was on the brink of extinction. Since then, thanks to the combined efforts of conservationists and the public at large, the trumpeter swan has made a comeback. Now its unique call – it really does sound like a trumpet – will continue to be heard.

Trumpeter Swans and Aspen, 1975

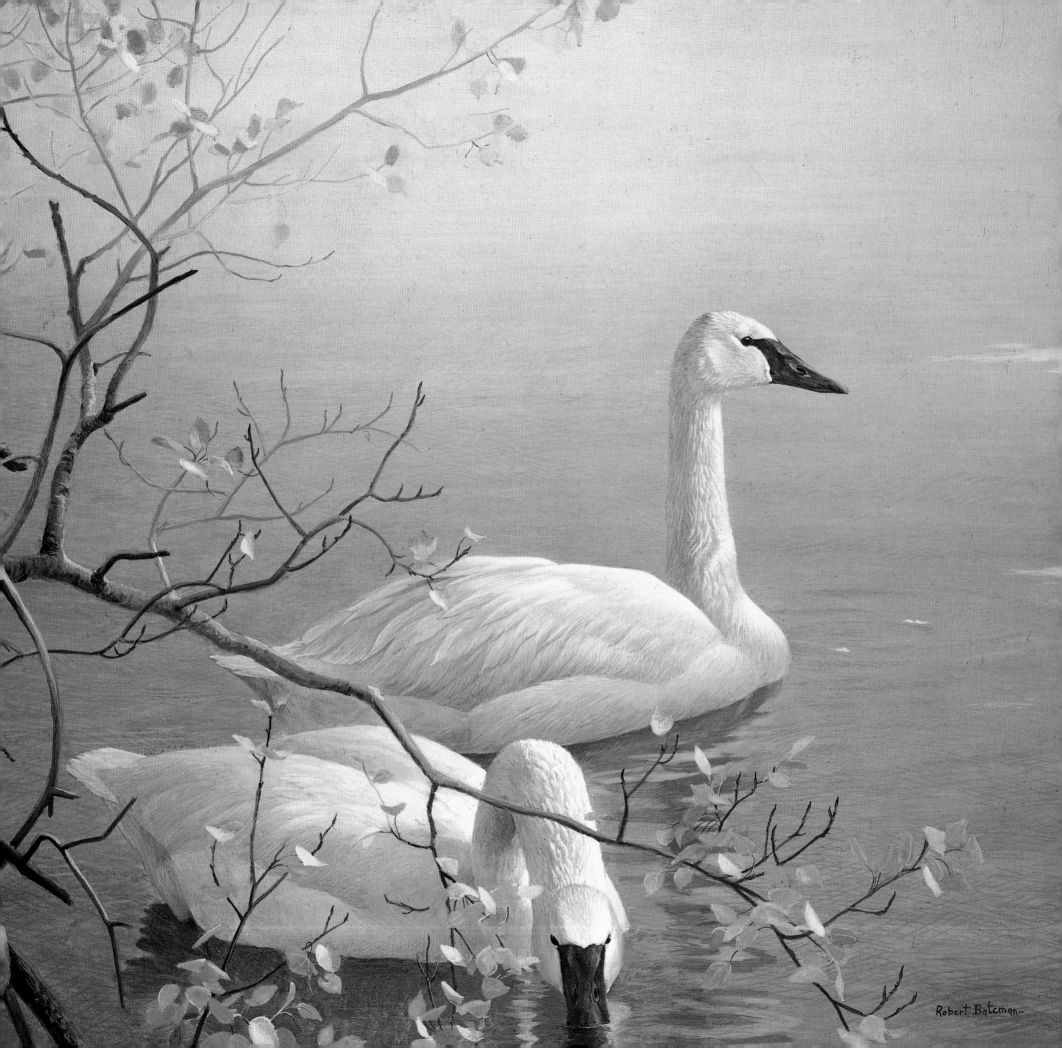

Robert Bateman

I N THIS PAINTING I wanted to show the ominous presence of a mature, lone wolf who has temporarily separated from his pack. (Like humans, wolves sometimes go off by themselves for a while before rejoining the group.) Here I wanted to create a mood of seriousness and respect – not threat – but given the scary place wolves occupy in the human imagination, I knew that some people would find this painting somewhat frightening. However, I wasn't prepared for the response from several friends who saw the original version. They would ask me quite innocently, "Why did you make the wolf the size of a dinosaur?" They assumed I had deliberately created a surrealistically huge nightmare wolf. This had not been my intention.

Their confusion about scale resulted from two things: the way I handled the trees both in the foreground and the background and the fact that what people saw first was the dark grove of trees; then they saw the wolf. (This latter was something I intended; it was part of the challenge of portraying a black animal on an almost black background.) Originally I had the wolf standing among much skinnier trees, so if your eye first focused on the trees and you assumed they were big trunks, when you eventually spotted the wolf, it looked gigantic. As a result of the reaction to the original version, I reworked the painting, adding bigger trees and introducing a dusting of pine needles in the foreground. If you looked at the two paintings side by side you might at first be unable to tell them apart. But their effect is quite different.

Midnight – Black Wolf, 1989

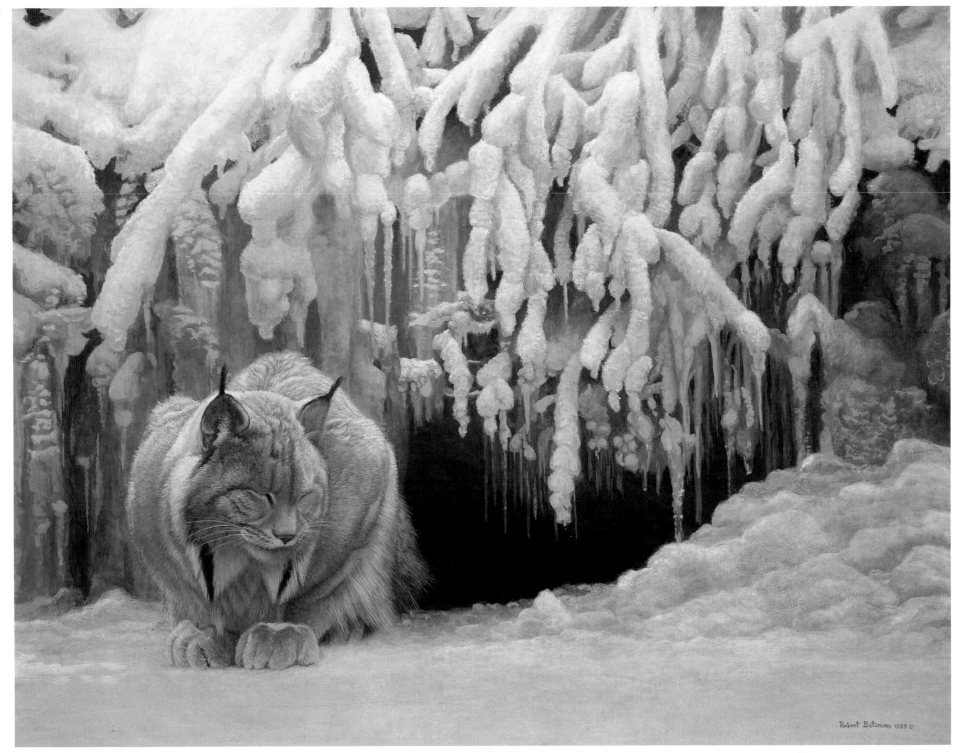

Dozing Lynx, 1987

Dozing Lynx (detail), 1987

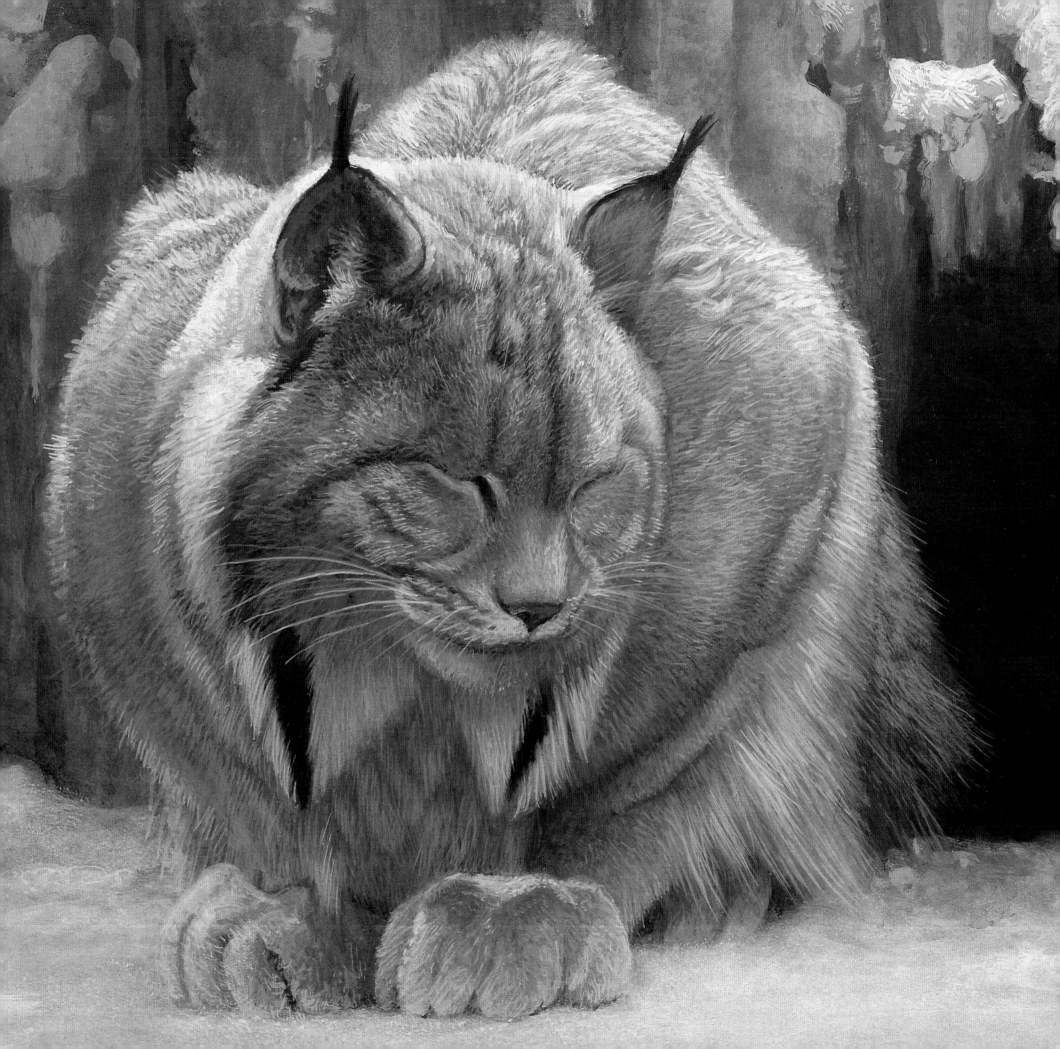

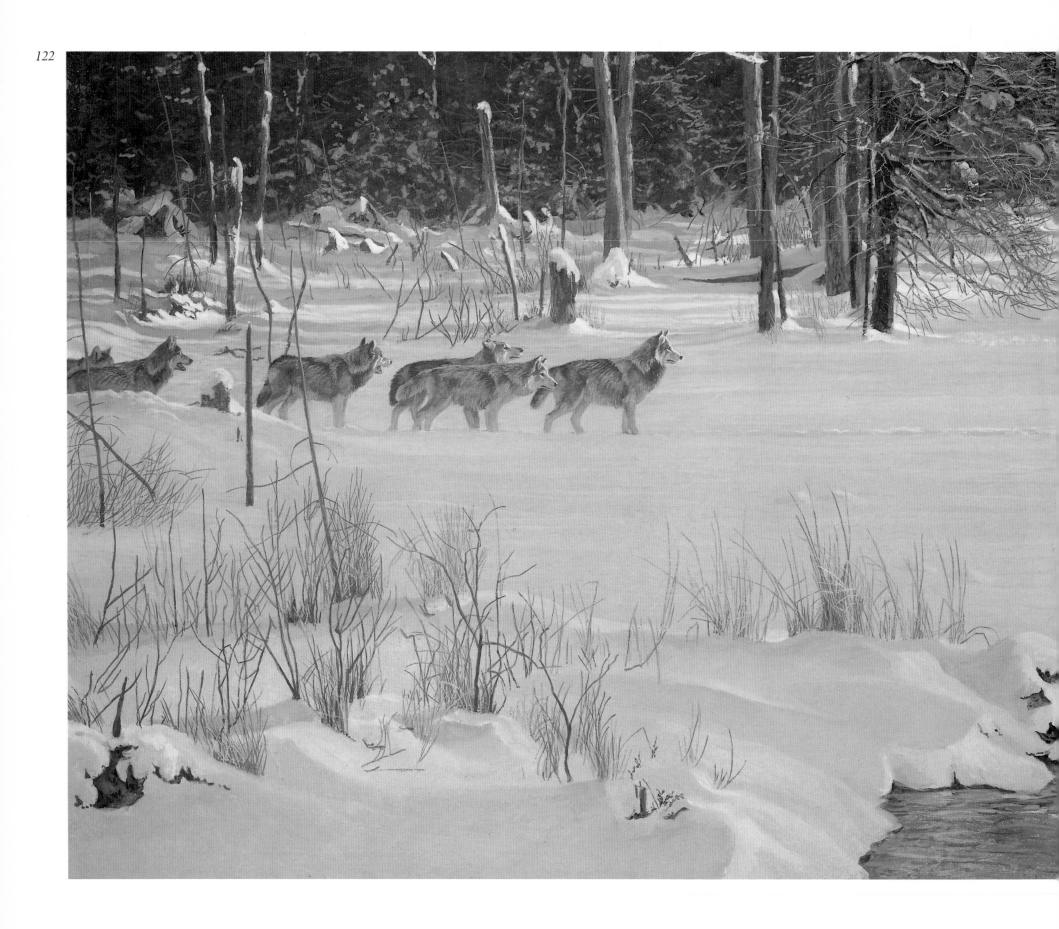

IN THE BOREAL FOREST, wolf packs are a moose-hunting culture (in mixed forest deer is the main prey). In *Wolves on the Trail* we are in moose country – thick forest, swamps, lakes and ponds. The pack has found a moose trail and followed it to the edge of a frozen beaver pond. Before leaving the cover of the trees, the wolves have paused to look and listen. They must be ready for anything. Should they catch up to a mature, healthy moose who turns to fight, they will be in trouble unless they beat an immediate retreat. One blow from the moose's cloven hoof could maim or kill a wolf – of every seven attacks on a moose, only one is likely to succeed.

Since wolves live in social groups and must cooperate in order to hunt successfully, they have a rather sophisticated society. (This is also true of African lions.) There is a clear hierarchy from the dominant male and female wolf down. Each wolf is an individual with a distinct personality (something I've tried to suggest in the painting). They're loyal, and they treat each other with great respect. In fact, the wolf has an undeservedly bad reputation stemming from European nursery tales such as Little Red Riding Hood. I know of no record of a North American wolf attacking a human being.

Wolves on the Trail, 1982

Moose's Head (sketch), 1984

124 I HAVE only done a few really big paintings, and this is one of them. As the size of a painting increases, the difficulty of working on it increases exponentially. It's not just that there is much more surface to cover, which obviously takes longer (just reaching certain parts of a big painting can present a physical challenge). The main problem is getting a sense of the whole as you're working. In the studio, it's difficult to stand far enough back to get a good look; and when I'm actually working on the surface I'm too close to see where these particular brushstrokes fit into the overall composition. Doing big paintings like this one or *Everglades* (pp. 8, 9) has given me a whole new respect for painters who have worked large.

The bull moose is a suitable subject for a big picture. It is one of the largest North American animals, the tallest hoofed mammal. With its antlers, a mature male towers well over six feet tall. These huge racks are shed each winter and regrown each spring. As with all my paintings of moose, this one is set in late autumn – the rutting season – when a magnificent bull such as this one is on the prowl for a female. When two males meet they may enter into a formalized duel, but seldom actually fight seriously. However, if their horns lock, they can both starve to death.

In this painting the moose's pose is deliberately ambiguous. It may be about to confront an adversary or it may simply be working its way through the brushy undergrowth. I wanted the viewer to be unsure just what the animal is doing and to be left somewhat uncomfortable by the confrontation with this mighty citizen of the wilderness.

The Challenge – Bull Moose, 1989

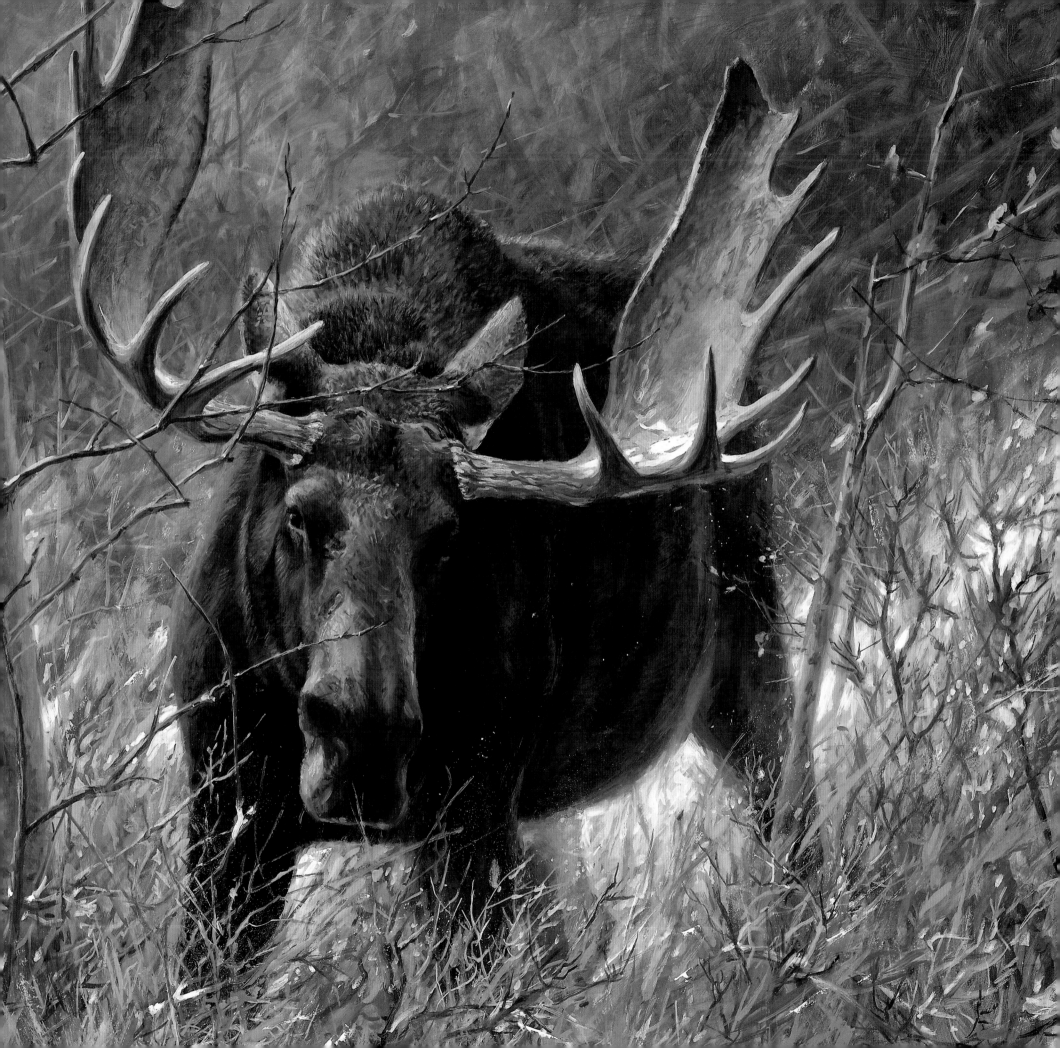

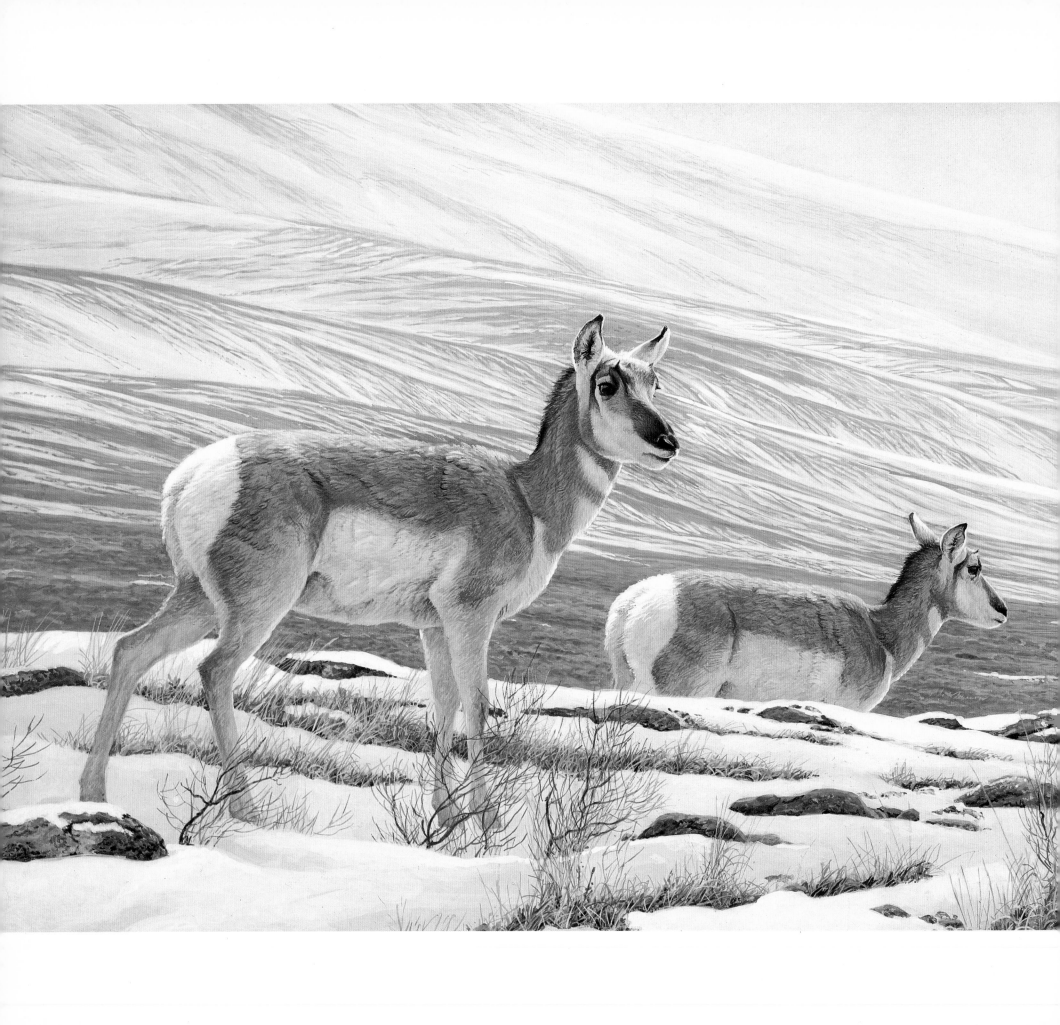

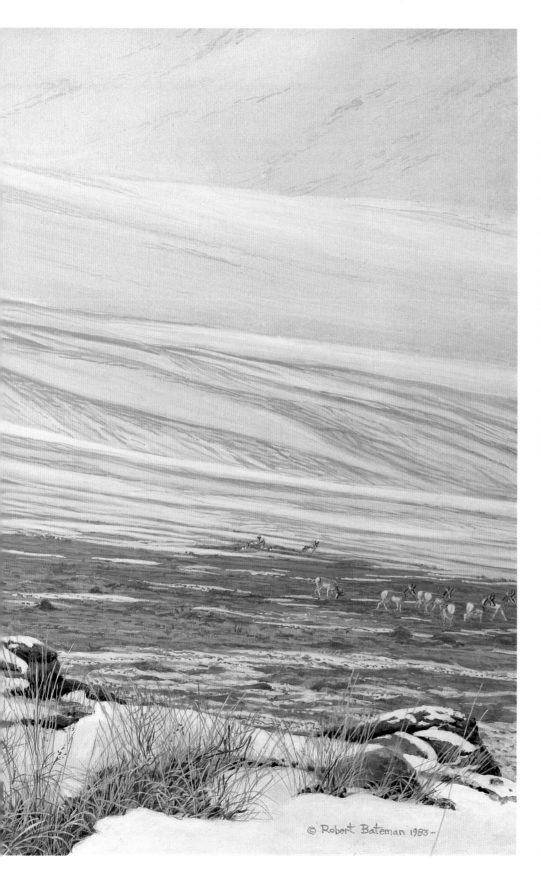

IN THE WORLD of mammals, pronghorns are unique, halfway between antelope and deer. A true Old World antelope has permanent horns (just like goats or cows). A deer has antlers that are shed each year. Pronghorns keep their antlers but shed the outer shells each autumn. The pronghorn's closest relatives are the antelopes of Africa and Asia. Like them it is remarkably fleet of foot – it is the fastest North American mammal. And unlike most other antelopes it has excellent long-distance vision; it's able to see three or four miles without difficulty. These characteristics aptly suit the big country of the midwest that is its habitat.

The feeling I wanted to capture in this painting was of the wide open spaces where the pronghorns live. I tried to achieve a translucent quality that evokes both the delicacy of the animal, with its large lustrous eyes and the subtle blend of whites and browns in its coat, and the sense of great space. The graceful shapes of the two females in the foreground are echoed in the gently undulating slopes behind them.

The continued survival of the pronghorn and other large mammals will require a real commitment by humans. Pronghorns, elk, cougars and the like need a lot of space to live in, and increasingly the wilderness areas they depend on have themselves become endangered. Expanding human populations and increasing requirements from logging, agri-business and strip-mining, to name just a few industries, all put pressure on their habitats. Our willingness to put aside large areas of land for the bigger mammals will be one real test of our environmentalist beliefs.

Big Country – Pronghorn Antelope, 1983

A FEW YEARS AGO my family and I went on a pack-horse trip in the high country of the western United States. Each day we passed by clear rivers, sparkling waterfalls and flower-scented meadows with snowy peaks in the distance. Each night, when we were through for the day, the wrangler would pitch old-fashioned tipis made of cotton duck and put the horses out to pasture. After supper we swapped stories around the campfire and sang cowboy songs as the horses grazed quietly nearby. Stillness and peace descended with the darkness.

The high country is a land of varied wildlife as well as great mystical beauty. The bird that seems to be the spirit of mountain streams and waterfalls is the dipper. Dippers are completely at home in these habitats, dashing like daredevils in their search for insect larvae among the rocks and crannies.

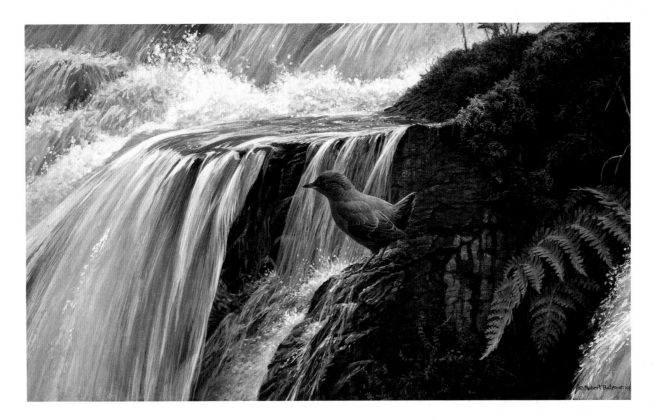

Dipper by the Waterfall, 1981

High Camp at Dusk, 1981

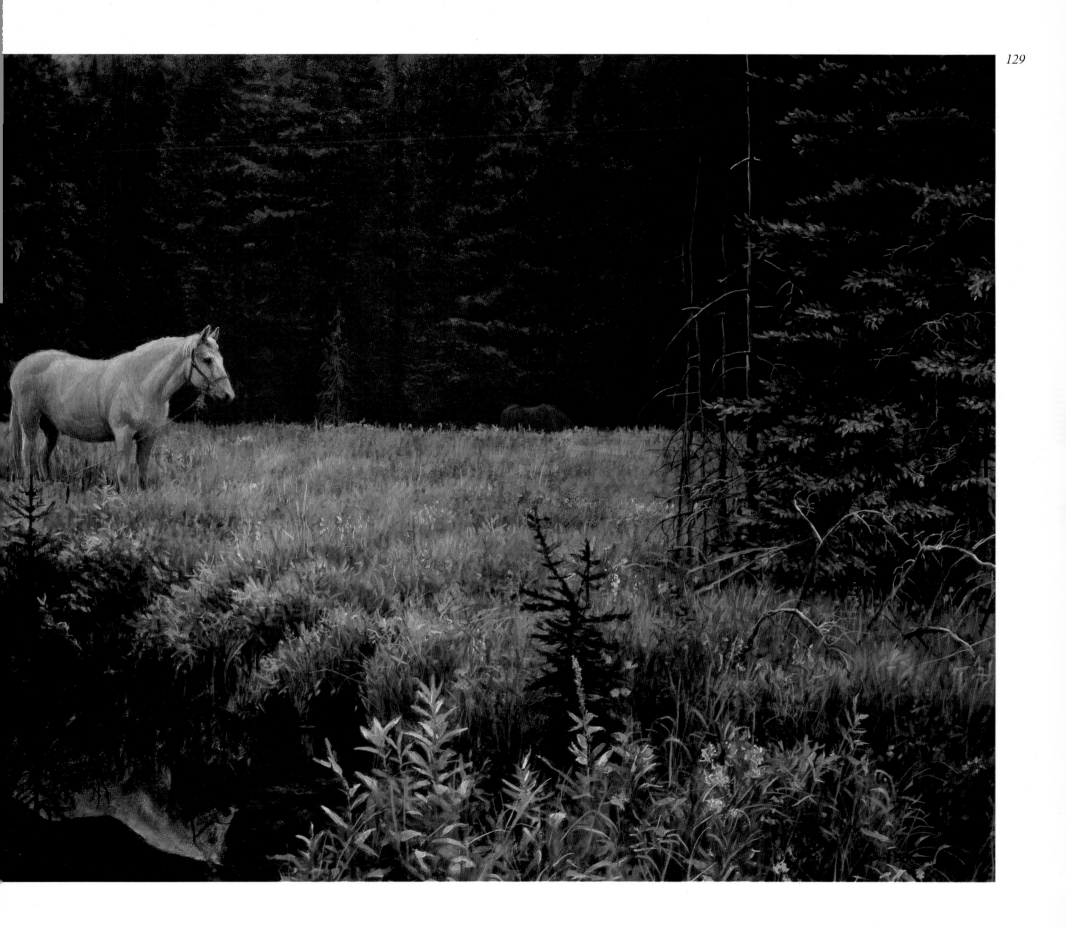

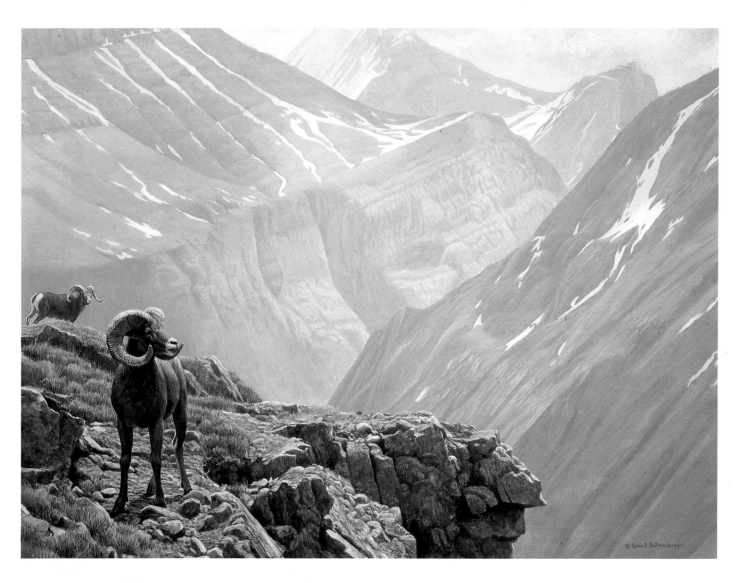

MOUNTAIN SHEEP are found almost the entire length of the mountain chain that runs up the western side of North America. They are the kings of the steep rocks and snowfields that are their domain, and although their numbers have been greatly reduced by hunting, they still thrive in parks and more remote wilderness areas. There are two species – the bighorn, which ranges from northern Mexico to southern British Columbia, and the Dall or white sheep, which ranges from northern British Columbia to northernmost Alaska. There are two races, or color phases, of the Dall sheep. The northern race is primarily creamy white and the southern race, known as the Stone sheep, is slate-brown except for white on the rump,

the muzzle, the forehead and inside the hind legs. Where these two ranges overlap you get hybrids of the two.

The bighorn is the larger animal and has truly earned its name. The old rams have long horns that have curved back on themselves and have visible growth rings similar to the growth rings of a tree. If you counted the rings on the horn you'd have a fair idea how old the sheep was. The Dall and Stone sheep are smaller and more elegant with smaller horns. All mountain sheep are gregarious and are usually seen in herds.

High Country Stone Sheep, 1977

White World – Dall Sheep, 1981

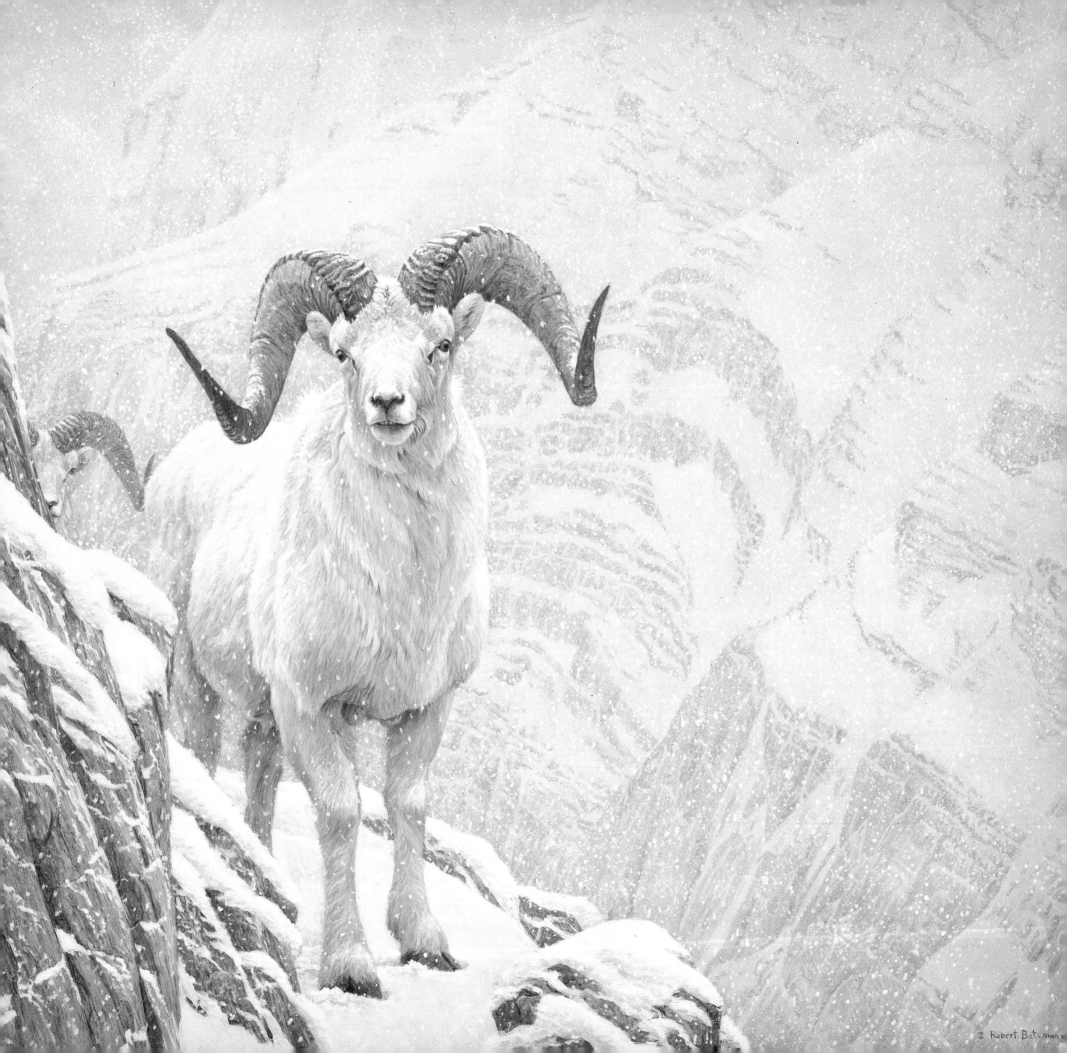

I DID THIS painting as a gift for Prince Bernhard of the Netherlands, who is one of the driving forces behind the World Wildlife Fund. It was presented to him at the annual meeting of the Convention on International Trade in Endangered Species, a particularly appropriate forum, since the painting can be read as an allegory of the endangered natural world. It has four major elements – water, birds, a large mammal and a fish (if you look closely, you'll see a salmon next to the rock in the stream). And all four are in trouble. In calling it *Grizzly – Endangered Spaces* however, I particularly wanted to draw attention to a problem that faces the largest mammals, which until recently in human history have been universally regarded as our competitors and enemies. Now the vast spaces they live in are threatened by the rapid growth of the world's population.

Like the grizzly, the composition of this painting is aggressive. You, the viewer, are face to face with an angry, maybe unpredictable bear, and the energy seems to spin out from him in a swirling centrifugal fashion. Through this somewhat alarming treatment, I want to force the viewer to ask this question: Am I willing to make the sacrifices necessary to set aside the space this creature needs to survive?

Endangered Spaces – Grizzly, 1989

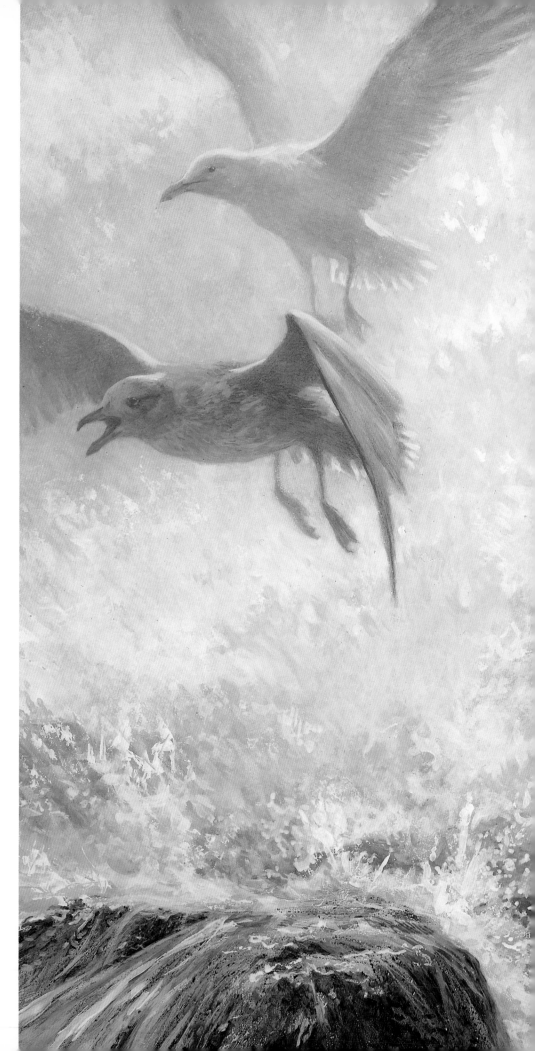

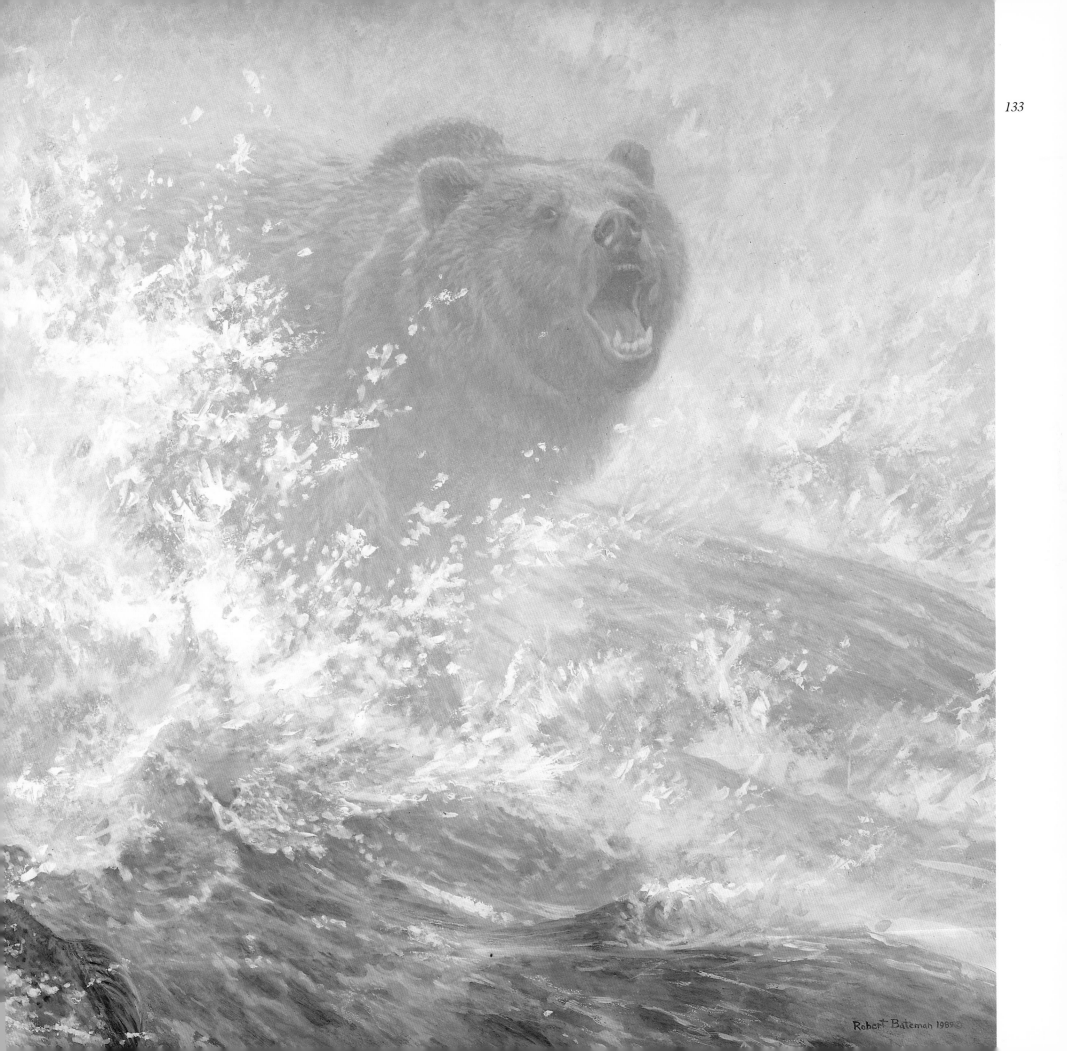

Robert Bateman 1989

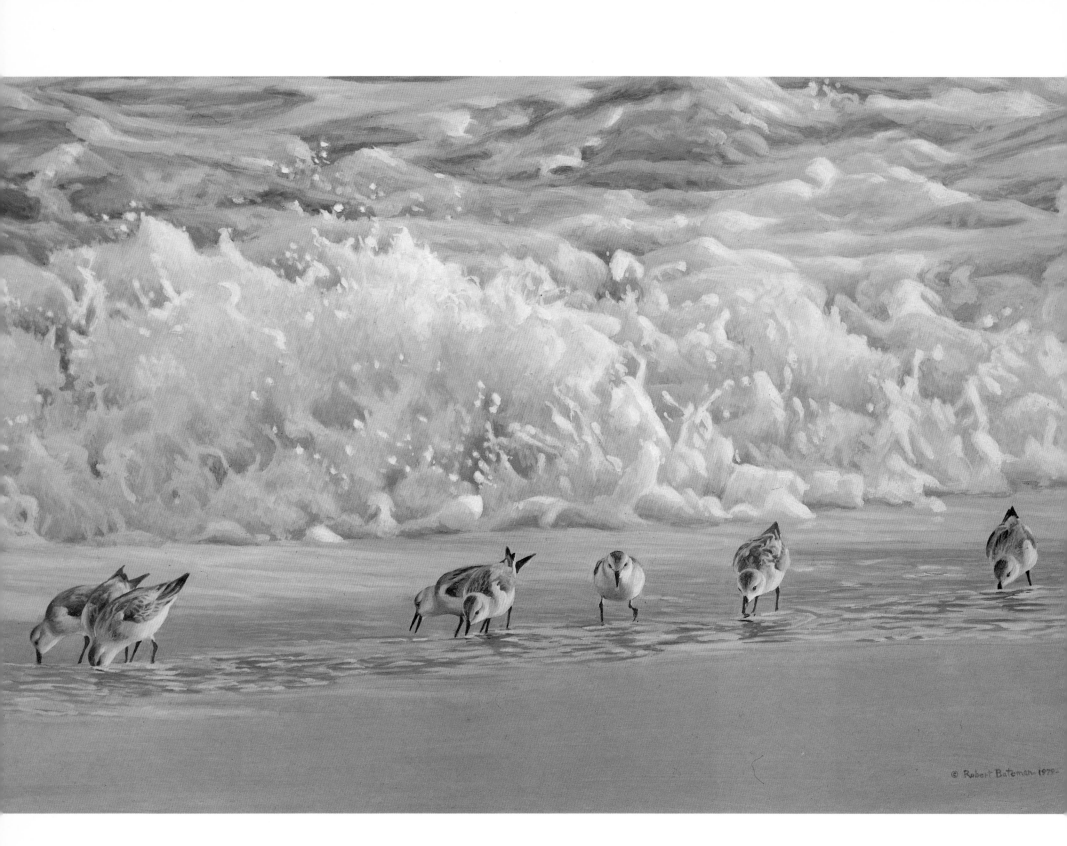

Surf and Sanderlings, 1979

Ruddy Turnstones, 1979

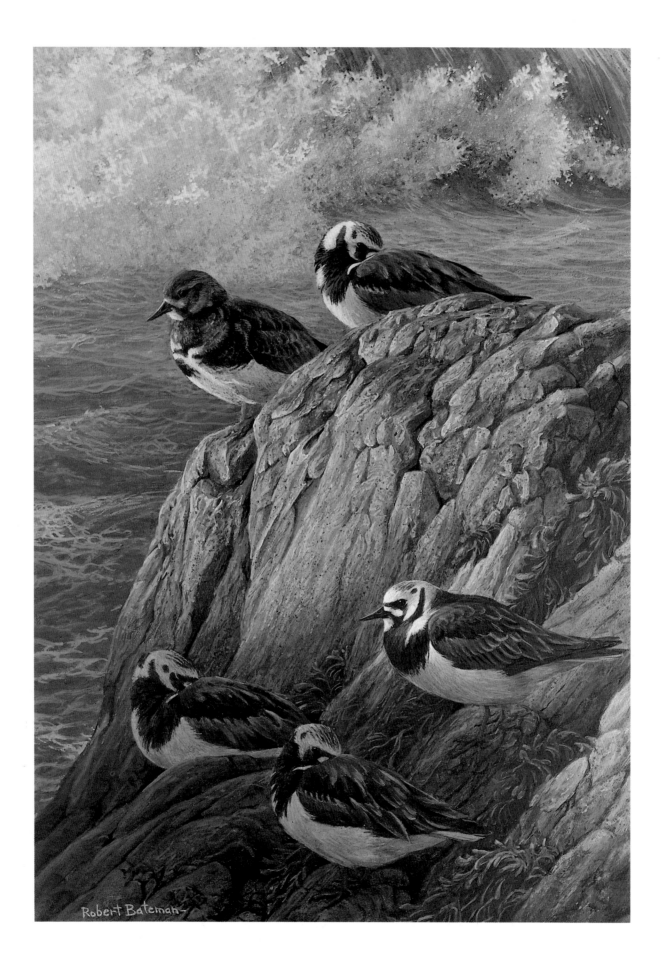

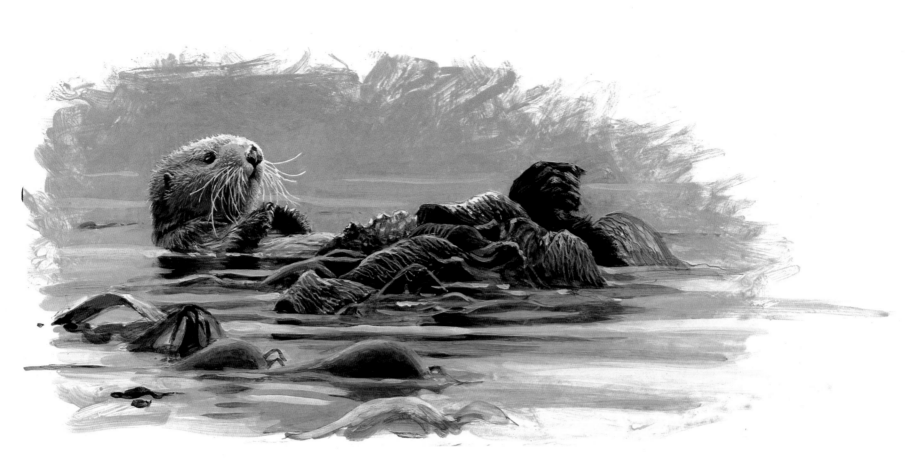

Sea Otter Vignette, 1989

Harlequin Duck – Bull Kelp, 1982

SEA OTTERS spend almost all their lives at sea, and floating bodies of bull kelp provide them with a convenient environment in which to rest. They like to tangle themselves up in it and loll about. The animal depicted here is in the sea otter's favorite position – on his back lying in a kelp bed. Sea otters often feed in this position, with their supper of shellfish balanced on their stomachs. One of their favorite foods is the sea urchin, which preys on kelp. Thus the kelp also benefits from having sea otters around. The more sea urchins the otters eat, the more kelp they have to float in. Sea otters once thrived along the Pacific coast, but because of their highly-valued pelts they were hunted almost to extinction. A few colonies managed to survive in Alaska and California. Recently a small community has been introduced off the northwest coast of Vancouver Island, and so far it is doing well.

Harlequin Duck – Bull Kelp, painted to raise money for conservation, was the third Washington State Waterfowl Stamp. It's a challenge to find a subject I know will be popular but to treat it in a way that satisfies me artistically. Here I was as interested in the sculptural properties of the kelp as I was in the duck itself. This is a scene I might see on an evening paddle near my house in British Columbia's Gulf Islands. Although these ducks breed near mountain streams, at other times they are birds of saltwater coasts where they feed on the abundant marine life. The harlequin duck is aptly named. The eccentric markings do make one think of the clown of the boisterous sixteenth-century Italian street theater, commedia dell'arte.

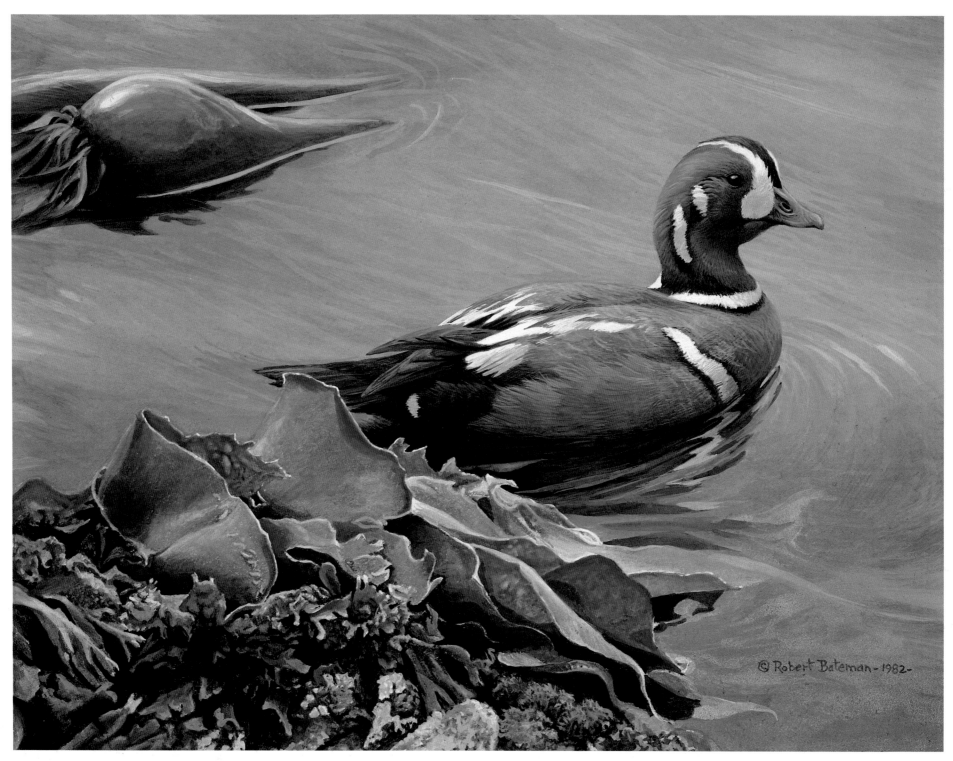

© Robert Bateman - 1982 -

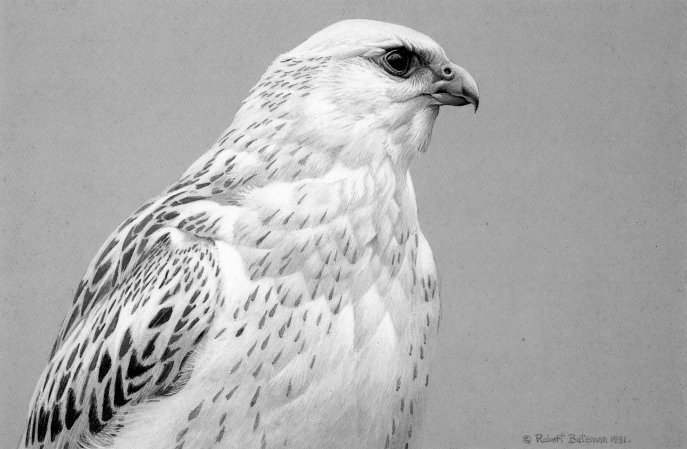

Arctic Portrait – White Gyrfalcon, 1981

Polar Bears at Baffin Island, 1975

I THINK OF BOTH these paintings as landscapes. To me the plumage of a bird is as varied and of as much visual interest as anything in nature. Although the white gyrfalcon is a straightforward portrait study, there were three interesting aspects to its painting. The first was the noble expression typical of falcons (no wonder falconry was considered the sport of princes). It is dignified yet strong, somewhat reminiscent of the expression of a thoroughbred racehorse. The second challenge was the interlocking shapes of the bill, mouth and bare skin in front of the eye, which made me think of the carved totem poles of the Pacific Northwest. Finally there was the modulation in the feather forms and markings. Painting this portrait turned into a fascinating exploration of the landscape of the falcon.

The gyrfalcon is the most magnificent of arctic birds and the largest of all falcons. Although it is not as fast as the smaller peregrine, it is still a swift and lethal hunter. In fact it is the most prized by falconers, and many have found their way from their arctic domain into the hands of Arab sheiks. And while it also occurs in black and gray phases, to me it is the white gyrfalcon that epitomizes the bird's arctic majesty.

In *Polar Bears at Baffin Island* I have deliberately directed your view into the background of the painting. I would like your gaze to travel back across the pack ice and up the rugged valley, exploring cliffs and waterfalls, convex and concave shapes along the way. At the end of your eyes' journey you will reach the permanent ice cap that covers a large area of Baffin Island – a simple yet massive sculpture.

Like the gyrfalcon, the polar bear is the largest member of its family and is a circumpolar species as common in the Russian Arctic as in the Canadian. It is normally a solitary creature. Males and females get together for only a two-week period during breeding season. The pair in this painting is a mother and her grown cub. Soon the cub will strike out on its own, hunting seals and walruses as its mother has taught it.

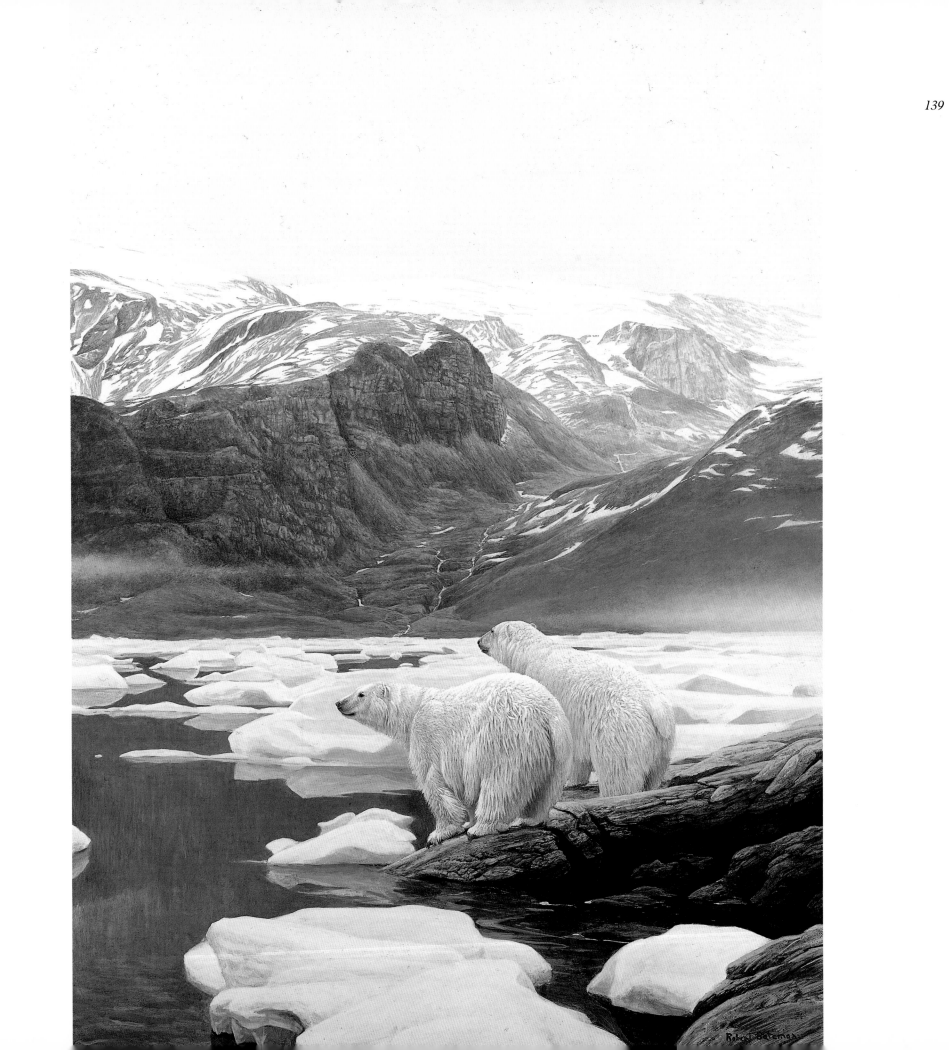

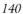

THE ARCTIC SUMMER is a time of brightness and incredible vitality: nature packs an amazing amount of activity into a few short weeks of long days and warm weather. Wildflowers are blooming, vast numbers of birds and mammals are breeding, and the tundra is teeming with life. I'll never forget my first visit to the near Arctic, the Ungava Peninsula of northern Quebec. I was in my early twenties and taking part in a scientific field expedition. Our Catalina flying boat set down on a jewel-like lake in the gorgeous long light of a May evening. It was as though I'd been transported into another world full of strange tundra plants I'd never seen before – bearberry, dryas – and the alien birds calling – the guttural clucking of the ptarmigan, the high-pitched, whistling yodel of the golden plover.

One of the fiercest defenders of its breeding territory is the arctic tern, which nests along rocky seacoasts and on the shores of tundra lakes. More than once I have strayed onto a tern's turf and been the victim of repeated diving attacks at my head as it attempted – successfully – to drive me away. It could be said that the arctic tern is addicted to daylight, traveling farther than any other bird between its breeding grounds and its wintering spots. It migrates as far south as Antarctica, and so spends both winter and summer in the realms of the midnight sun. As a result it probably sees less of nighttime than any other bird. Arctic terns have compiled some astounding long-distance records. One bird banded in Wales was found six months later in New South Wales, Australia, a distance of roughly 11,000 miles.

In *Arctic Tern Pair* I have placed the birds in their element – sunlight and water. And I have tried to capture the lightness of a sparkling summer's day on the Arctic coast.

Arctic Tern Pair (sketch), 1989

Arctic Tern Pair, 1985

142 THE RAIN has just started and a European (or Eurasian) widgeon is tucking his head under his wing to take a nap. When the rain stops he will continue feeding on aquatic plants, animals and insects. This is a very common European marsh duck, similar in appearance to the American widgeon and a close relative of the pintail and the mallard. European widgeons are not known to breed in North America, but they are fairly frequent visitors. There used to be one that hung out with a flock of American widgeons in the bay where I live. It always stood out because of the orange on its head (in contrast to the American widgeon's green and white).

In this painting, as with a number of my works, I was attempting to create an Oriental feeling. The painting itself is rather colorless, and the main interest is the dynamic patterns in the water and in the bird. The result is a flat, decorative quality which is also found in the works of the Japanese masters Hokusai and Hiroshige.

European Widgeon in the Rain, 1988

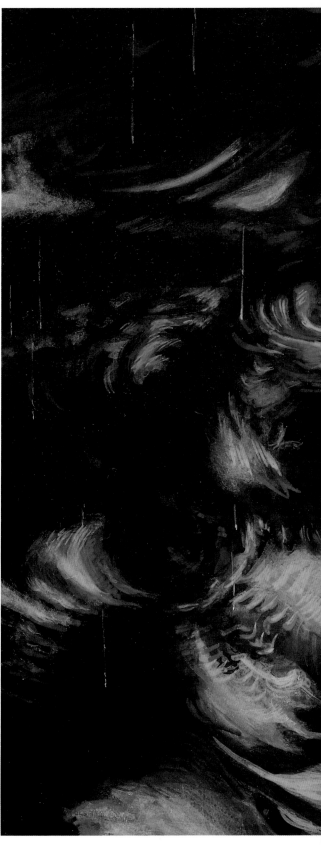

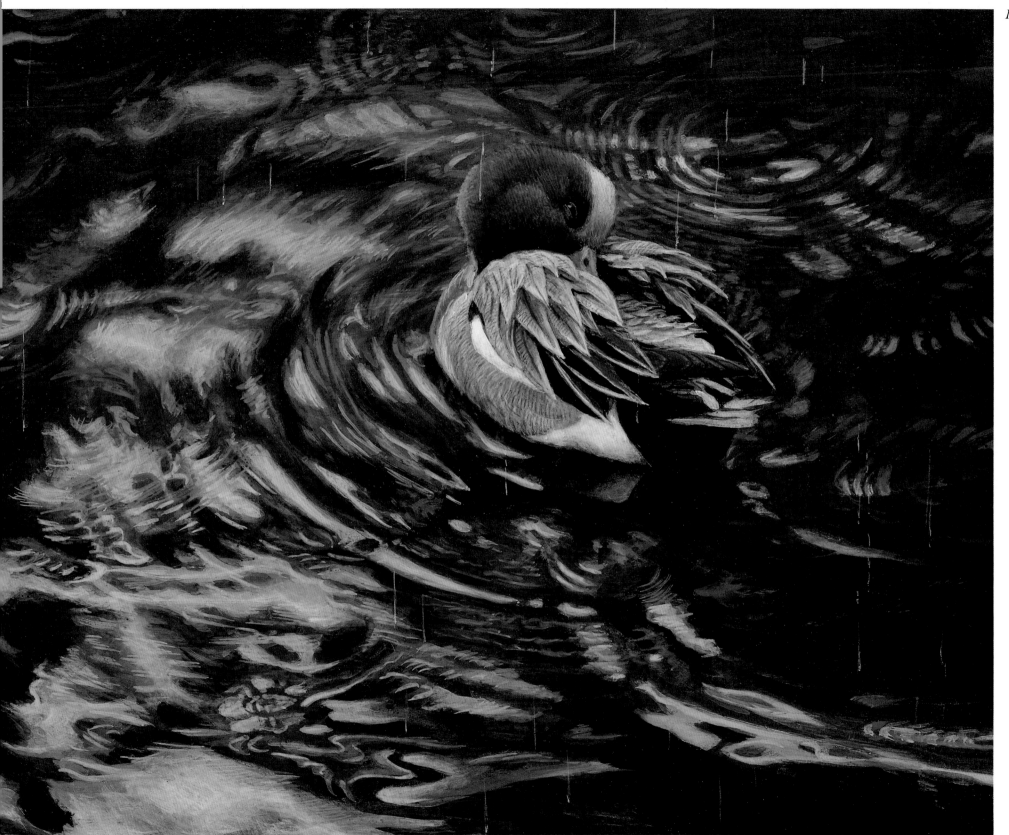

THE EUROPEAN ROBIN is not the same species as the North American bird of the same name. Our robin was christened by homesick immigrants, because its orange-red breast reminded them of the robin of the Old World. In fact, both birds are members of the thrush family, but the North American robin is a closer cousin of the European blackbird than of its namesake. European robins are small birds, about the size of a chickadee, and I emphasized this by placing one perched delicately atop a hydrangea blossom in a garden, a favored habitat.

The hedgehog is common throughout Europe, although most North Americans are familiar with it only through characters such as Mrs. Tiggywinkle in the Beatrix Potter stories.

The hedgehog shown here moved into the old stable next to our house in Bavaria. I found him one morning rolled up, asleep, in the cat's bowl. In addition to portraying the hedgehog, I was very interested in capturing the look of the old stone walls in our garden. I love the individuality of the walls that one sees throughout Europe – the sense of history and tra-

dition they evoke and the way they seem to be almost an extension of nature. The pattern of the stone wall that was my model, however, didn't play well off the shape of the hedgehog. After struggling with the problem, I found the solution in an idea I've had for years – the pattern of a map. If you look at the wall behind the hedgehog you may be able to make out a map of western Europe.

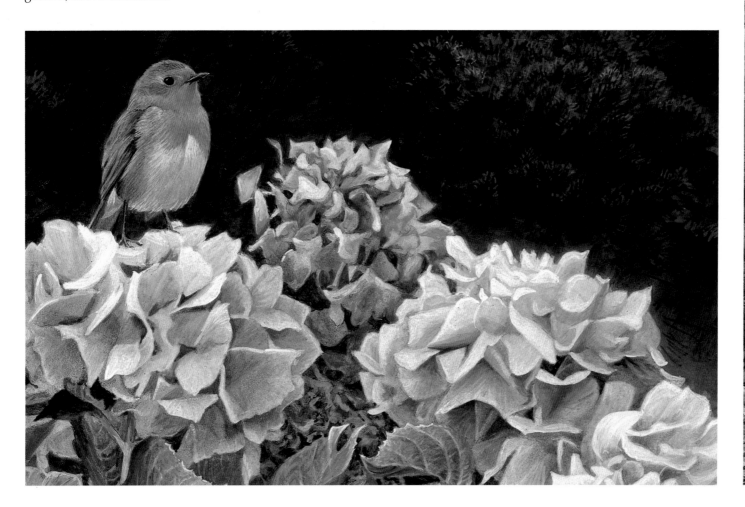

European Robin and Hydrangeas, 1985

Hedgehog, 1988

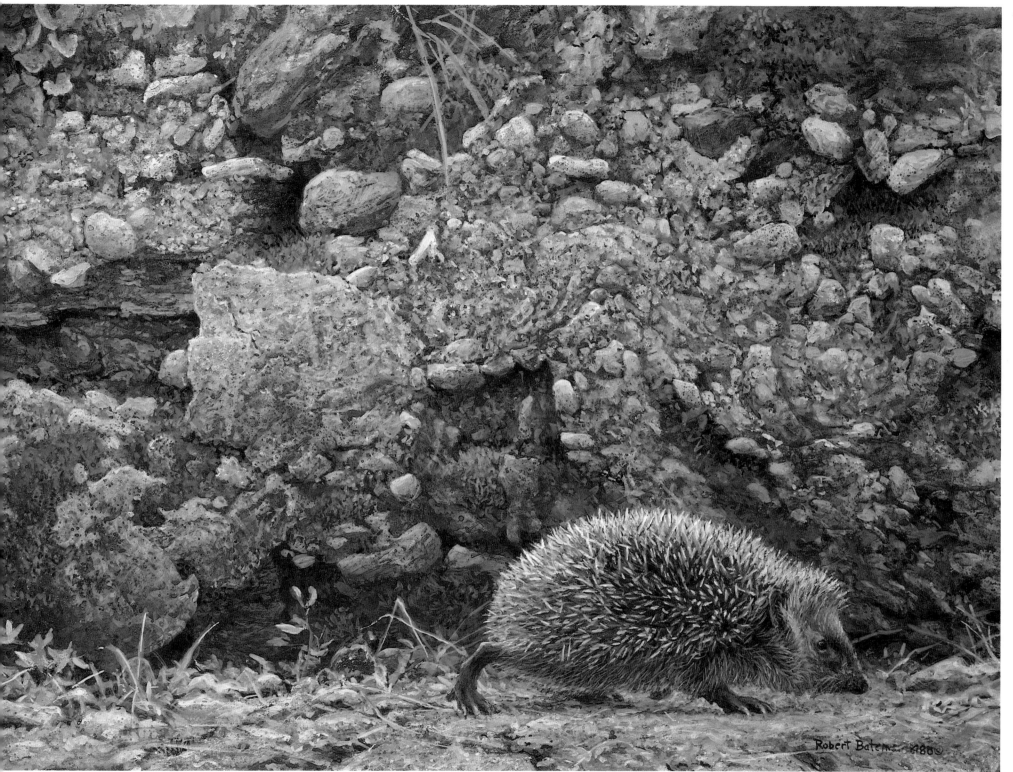

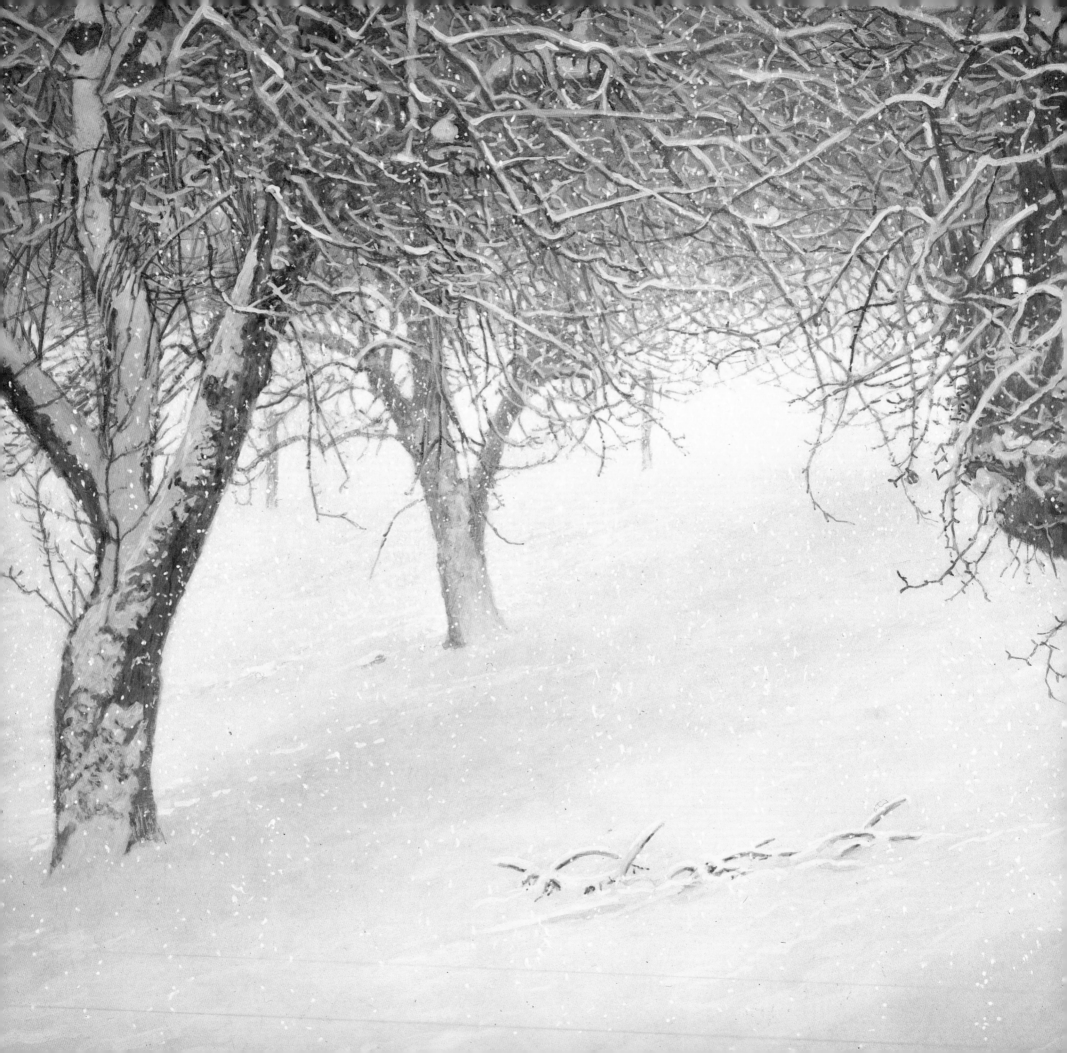

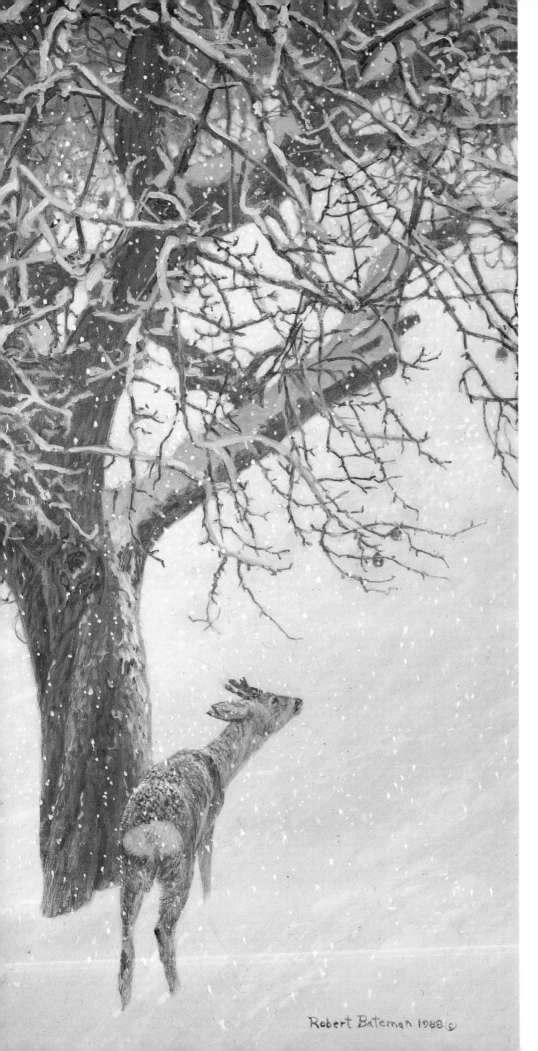

THIS IS THE VIEW from one of the windows of the farmhouse we lived in for a year in Bavaria. I saw roe deer almost every day while we were there – usually during a hike or an excursion on my bike. But they are shy and difficult to get close to. At the first sign of approach they simply melt into the woods. This is undoubtedly because they are often shot by hunters and have learned over centuries of sharing the landscape with humans that they must always be on the alert.

Deer are found in most parts of the world, but I think it is safe to say that no deer has adapted to human settlement better than the roe deer. They are small enough to hide easily in a farm field, a hedgerow or a wood lot. They have also benefited from their status as favorite game animals. As a result, the population has been managed and maintained for many years. A similar thing has happened in eastern North America, where the population of white-tailed deer remains high even near big cities and industrial areas.

Old Orchard and Roe Deer, 1988

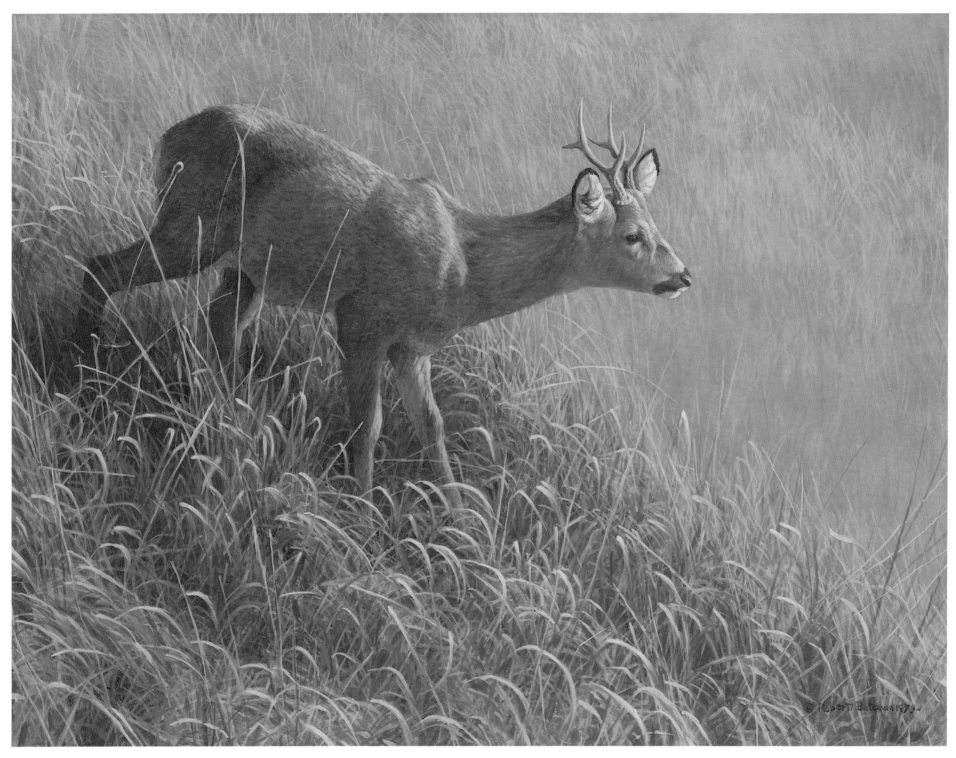

Morning Dew – Roe Deer, 1979

Tawny Owl in Beech, 1988

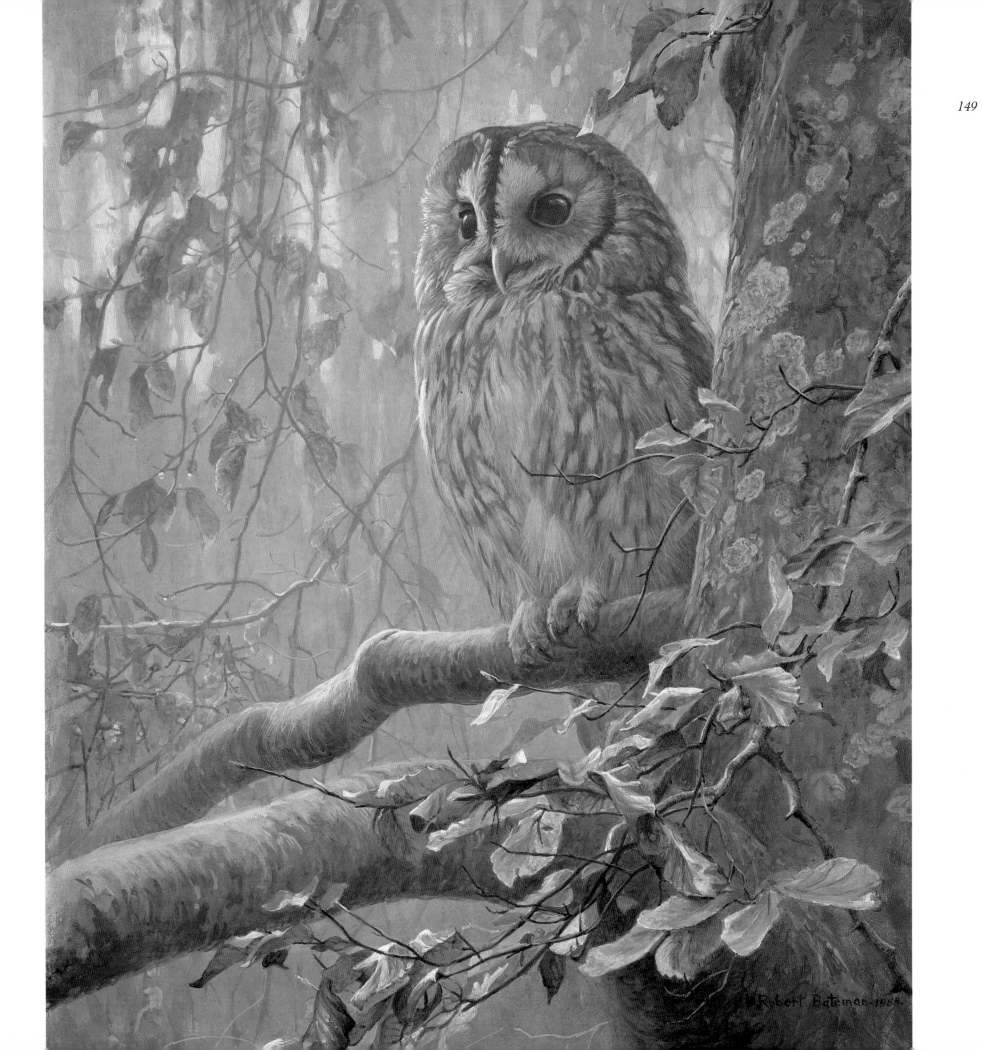

Snow Leopard (stone lithograph), 1989

High Kingdom – Snow Leopard, 1986

THE DOMAIN of the snow leopard is the mountains of central Asia, a land of icy crags and lonely vistas. Very few people have seen the snow leopard in the wild. In part this is because of the remote and difficult terrain it inhabits. But a more important reason is its declining population – probably no more than 8,000 animals remain in all of its vast range from Mongolia to the Himalayas. The surviving leopards live in isolated pockets where their principal prey, the blue sheep (bharal) and the ibex (tahr) still exist in sufficient numbers to support them. Snow leopards are no longer much hunted for their gorgeous pelts. The main pressures on them are the disappearance of prey species as a result of overhunting, and livestock grazing.

They are among the most endangered of the world's great cats.

Only in the last few years have we learned a little about the lifestyle and behavior of snow leopards. Unlike other large cats, they have a high-pitched yowl rather than a roar. Except during mating season they live solitary lives, roaming their mountain terrain in search of prey. However, contrary to their name, they seldom go above the snow line, except to traverse a high mountain pass.

In the painting *High Kingdom – Snow Leopard* I imagined this great cat sitting motionless, infinitely patient and watchful, almost a part of the ancient stone of the mountain and snow-laced air.

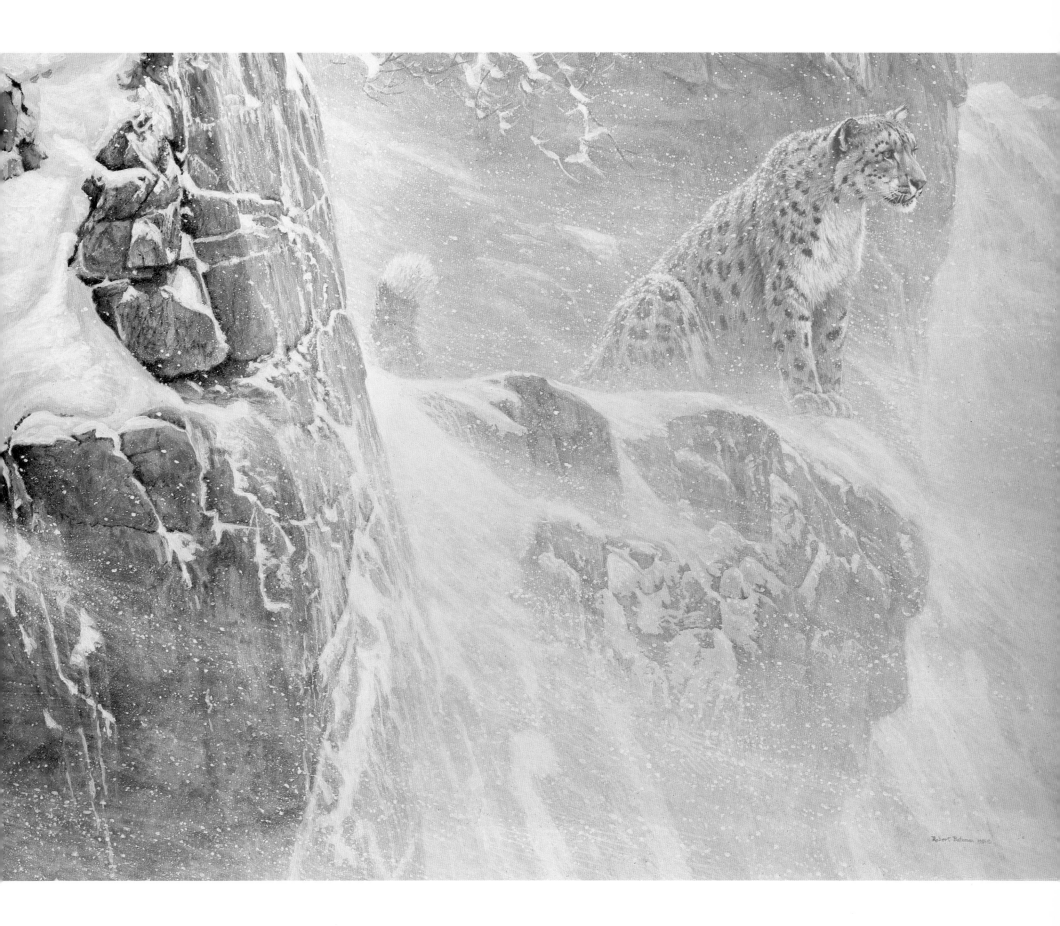

152

THE LEOPARD lounging in the acacia tree in *Leopard at Seronera* is nonetheless alert for prey. Along the tiny trickle that is the Seronera River in Serengeti National Park, there is a slash of dense vegetation with big trees that cuts through the plain and its large population of gazelles and antelopes. This is a perfect set-up for leopards. Perched in the jungly cover, they wait until a young or crippled impala or Thomson's gazelle wanders too close to the edge and then they leap down and make the kill. However, it is highly unlikely that a leopard would take on a healthy adult impala such as the one in the sketch above.

This painting is very much influenced by the abstract compositions of Franz Kline. Because of the balance between the negative shapes of the dark trunks and the white background, you aren't quite sure whether the dark is intruding into white or the other way around. The leopard seems almost part of the sinuous trunk he's resting on, except that he has raised his head to look at me before returning to his catnap.

Impala (sketch), 1980

Leopard at Seronera, 1974

Rhino at Ngoro Ngoro, 1974 (overleaf)

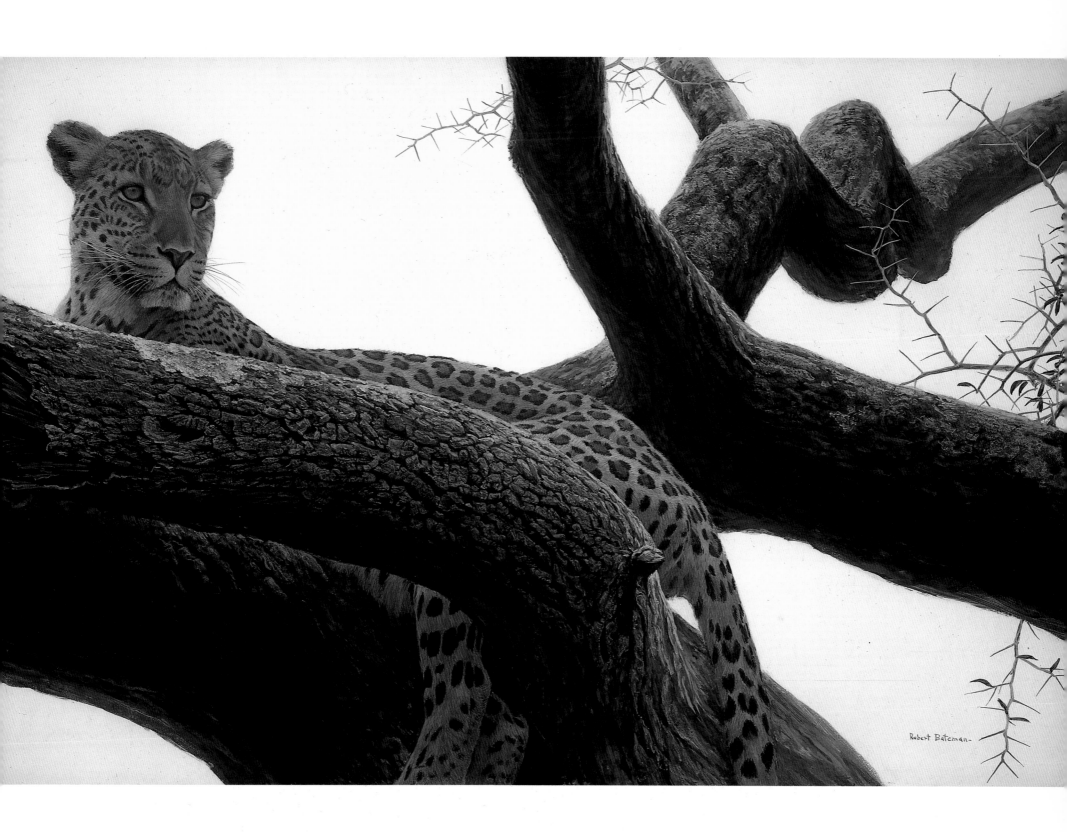

Robert Bateman

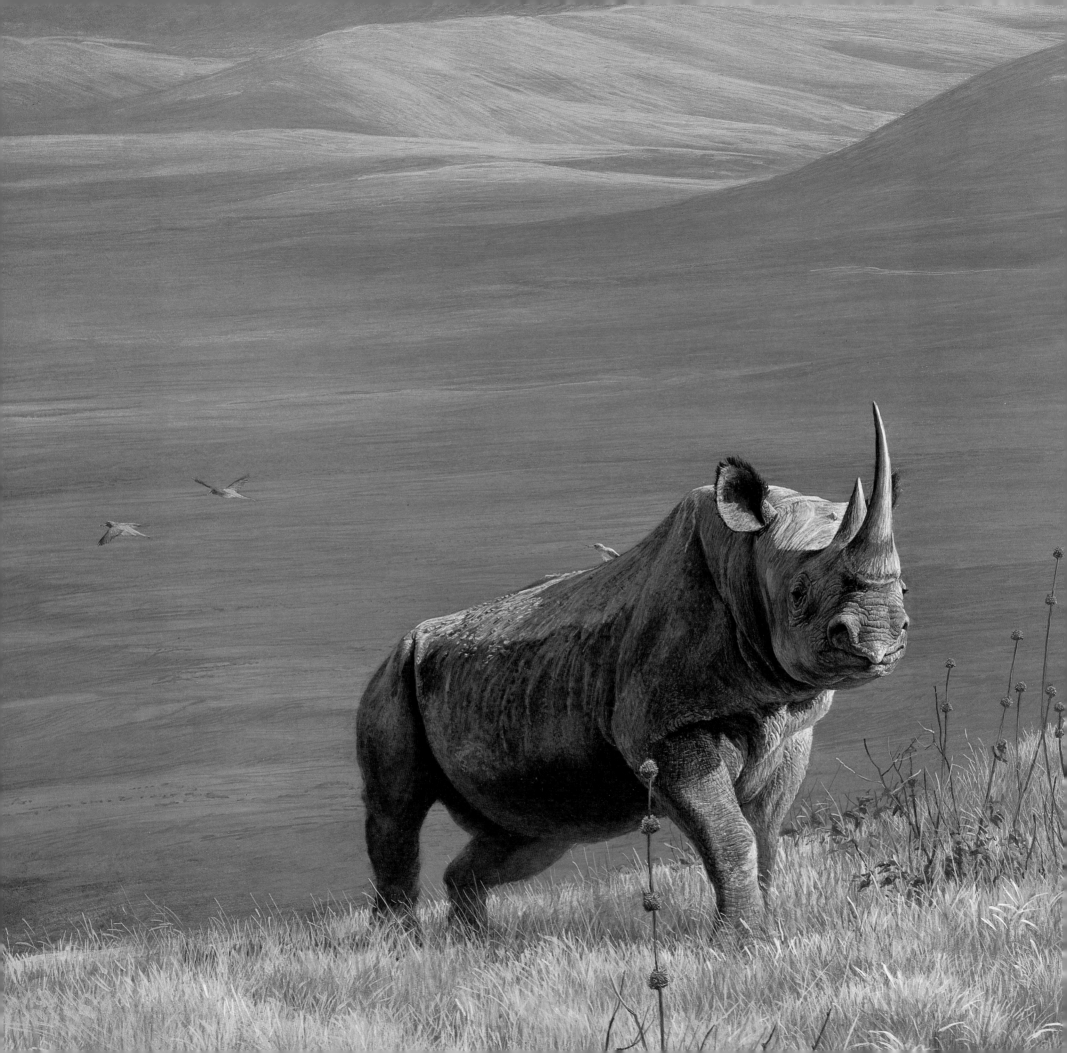

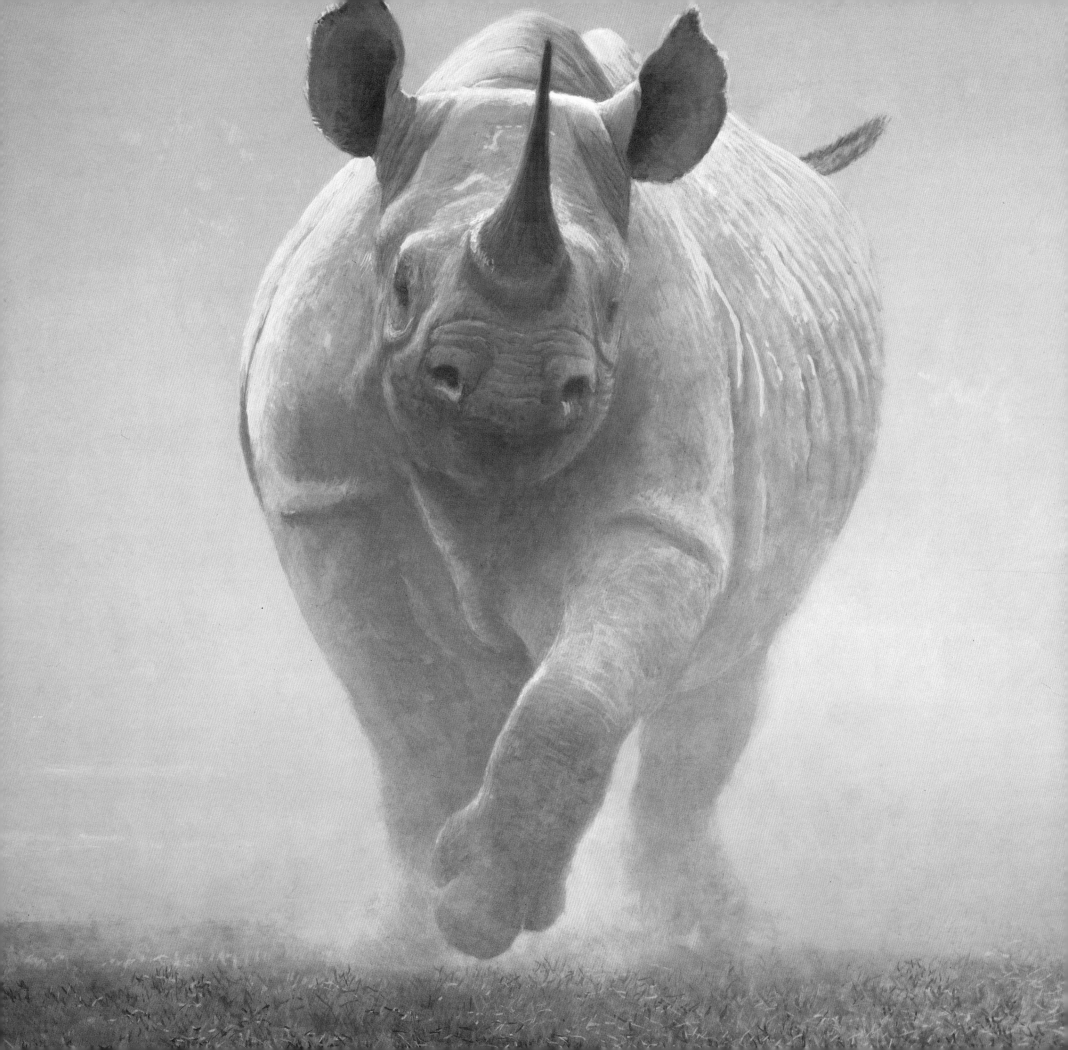

ONCE while on safari in East Africa we had a close call with a rhinoceros. We had stopped our Volkswagen bus to take pictures of him as he loped steadily toward us. He wasn't charging, but he kept getting closer and closer and showed no sign of swerving. Perhaps he simply hadn't seen us yet and would change course when he did. But I wasn't about to wait around and find out. Rhinos have been known to charge a vehicle, and they can make mincemeat out of one. Fortunately our engine turned over on the first try and we were soon safely out of the animal's path.

In *Power Play – Rhinoceros* I wanted to give the viewer the same feeling I had of this great beast coming inexorably toward me like some primordial creature out of the distant past. As I had learned firsthand, it certainly concentrates one's attention if a rhino is charging. I painted this for a fund-raising auction to help save the rhinoceros, which is a seriously endangered species wherever it still lives, and I was conscious of a kind of double-entendre in treating my subject in this way. The painting becomes something like a giant stop sign. It stops you cold, just as we've got to stop killing these magnificent animals that have been around for hundreds of thousands of years.

Power Play – Rhinoceros, 1987

Cattle Egret (sketch), 1989

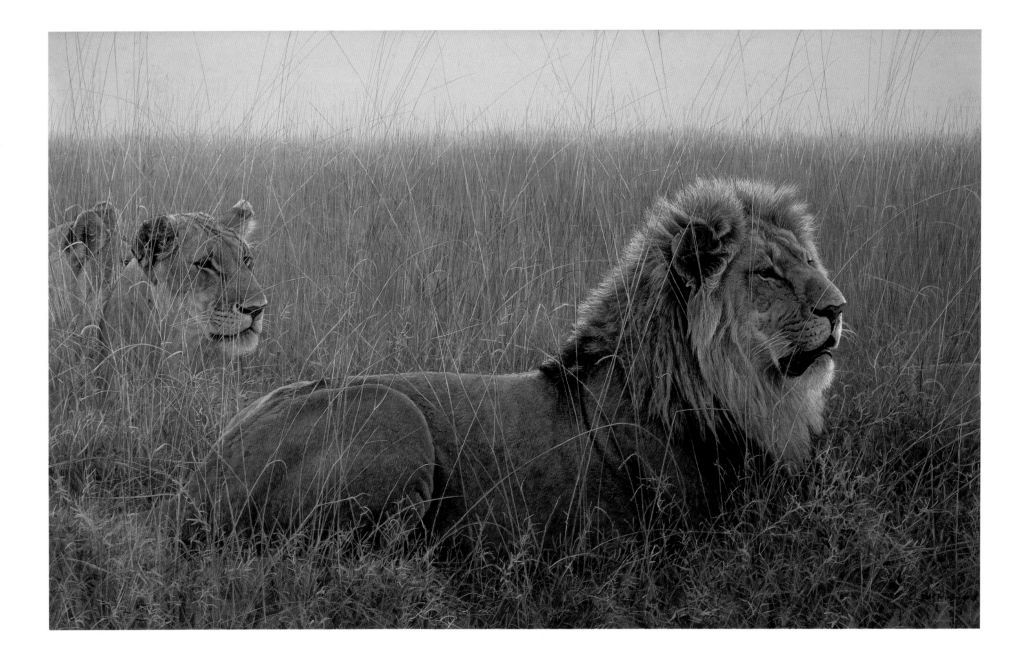

Lions in the Grass, 1985

Lioness and Wildebeest, 1990

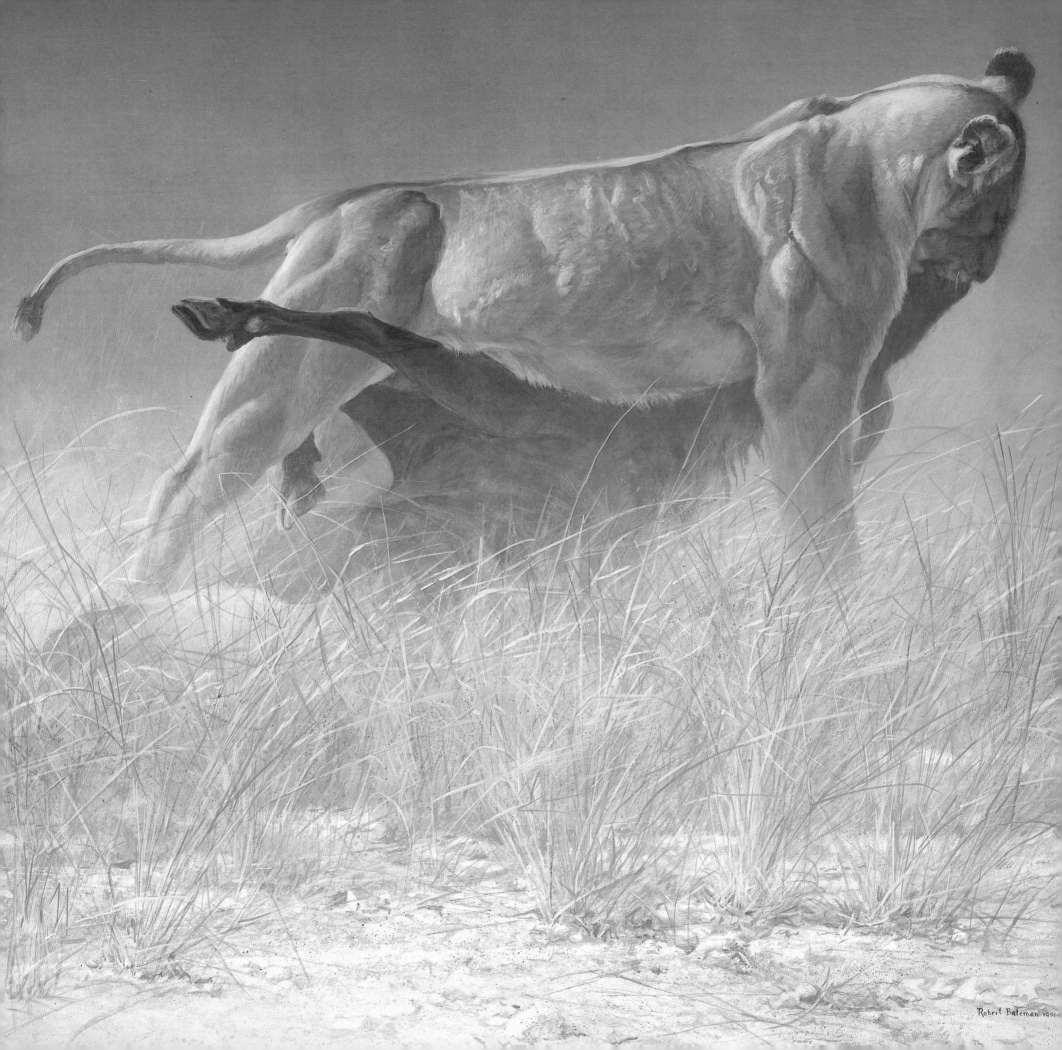

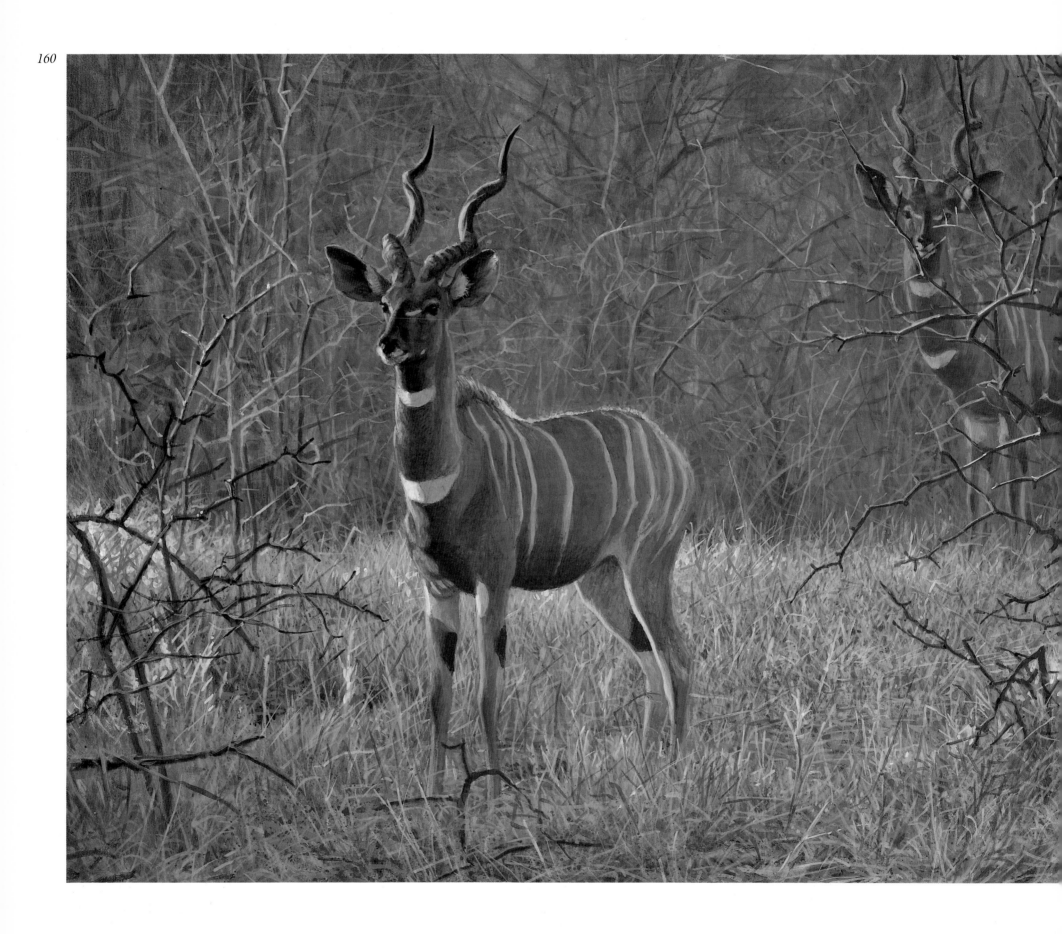

IN THE PAINTING below I have shown a greater kudu bull in a noble pose, emphasizing the masculine power of its thick neck and spiral horns. Both the greater and lesser kudu are magnificent antelopes. A greater kudu bull can stand over five feet high at the shoulder and weigh as much as seven hundred pounds. Despite its size it is swift and elusive, and because it inhabits dense bush country, it is usually quite difficult to see. In all my visits to Africa I have seen one only a few times.

The lesser kudus, on the left, are portraits taken from life. In 1988, while visiting Meru Park in Kenya, my family and I came upon this exact scene. The Land Rover we were in rounded a bend, and suddenly there was a male lesser kudu staring right at us. A few moments later, another male emerged from the bush. Lesser kudus are usually quite elusive. They are also skittish animals, and their preferred habitat of thickets and acacia scrub makes getting close to them a rare occurrence. In this painting, I've tried to recapture the moment when I first saw the kudus, including the soft browns and grays of the animals and the gentle slanting light that played over the whole scene.

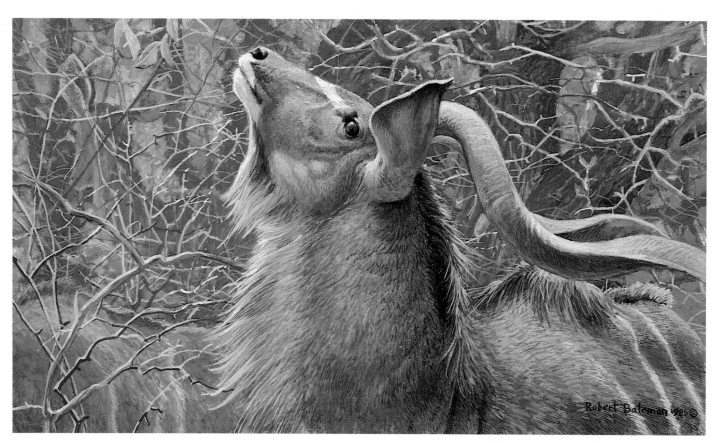

Lesser Kudus, 1989

Greater Kudu Bull, 1985

By the Stream – Cape Buffalo, 1971

A Resting Place – Cape Buffalo, 1986

I OFTEN TAKE an animal from one place and put it into another setting, but it is almost always a specific animal and a specific place, not a cooked-up landscape. In the case of *By the Stream – Cape Buffalo*, I didn't see the animal in this particular spot, although it could have been there. However, all the qualities of the stream area are very particular, and I've tried to capture the precise personality of that little spot on that particular day. I've sometimes been criticized for combining elements in this way, but the criticism seems pointless as long as the animal and its habitat are in harmony and the whole is artistically satisfying – which is up to the viewer to decide.

The African or cape buffalo is often mistakenly referred to as a water buffalo. But the cape buffalo is powerful and dangerous; the water buffalo is a slovenly domestic slave that plows the rice paddies of Asia. In *A Resting Place – Cape Buffalo* I have showed this animal in repose, but there is no mistaking his power. Something has startled him in the middle of chewing his cud and caused one of the cattle egrets to take flight. Wherever you see buffalo in Africa you also see these small white egrets, which feed on the insects stirred up by the hooves. Cattle egrets don't do that much flying, and they save a lot of energy by hitching rides on the backs of the wild or domestic cattle they coexist with so profitably. In the past hundred years their numbers have increased dramatically as they have extended their range. They probably arrived in South America sometime in the nineteenth century. Now they can be seen as far north as Canada, and some have even made it to Australia.

ELEPHANT HERD AND SANDGROUSE shows two cow elephants and their calves, who are timidly staying close to their mothers. The group is part of a larger herd that has just entered the water. As they squirt and splash themselves and each other their hides will soon be crisscrossed with dark patches. Perhaps one of them will lie down and roll. Since the elephant has such a large body mass and lives in mostly arid country, rivers are one of the few places it can cool down during the day. Its huge ears, which are primarily for getting rid of heat, are often inadequate to do the job.

Elephant Herd and Sandgrouse, 1985

THIS PAINTING, which is the largest I've ever done, is very much a study of textures. An elephant's face is an intricate topographical map. Every inch of it is different, and the older the elephant, the more complex the challenge that it presents to the would-be cartographer. Indeed, the sections in an old elephant's face can be read like a map. Its different neighborhoods are as distinct from each other as Montmartre is from the Left Bank or as Greenwich Village is from Harlem.

This is the face of a very old female, the acknowledged leader, or wise one, of the herd, who has worn off her tusks over many years and many skirmishes. It is a face you could look at for a very long time without ever getting tired of its variety.

Like her face, this old female's tusks bear evidence of a long, active life. Elephants use their tusks for prying the bark off baobab trees or digging for salt and other food in the ground. As a result they become damaged and worn down. A female's tusks aren't as long as those of a male, but shorter tusks can be an advantage. Even when this old elephant was young, her tusks would probably not have been a desirable trophy for a big-game hunter. Today, when ivory poachers are decimating Africa's elephant herds, few young elephants, male or female, will live as long as this one.

The Wise One, 1986

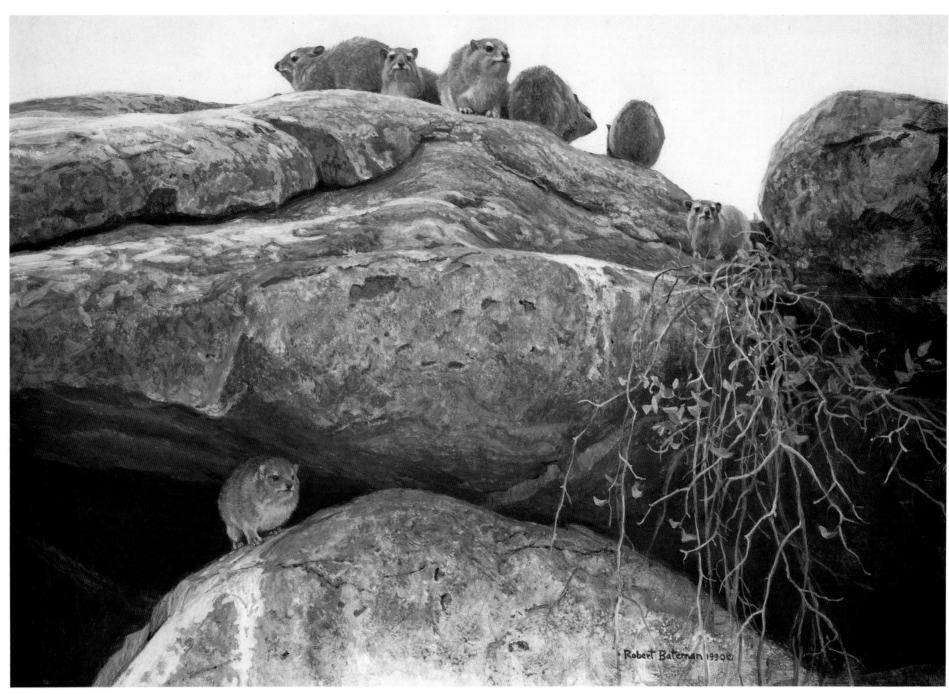

Hyrax, 1990

Black Eagle, 1984

WHEN MOST PEOPLE think of African wildlife, what usually comes to mind are the lions, elephants and antelopes – big inhabitants of the savannah or bush country that covers so much of the continent. But even within the savannah regions, there are very different habitats sheltering many other species. In these two paintings, I was interested in showing two animals that make their homes in the *kopjes* (stone outcroppings on the savannah), and in nearby canyons, escarpments and cliffs.

The hyrax is about the size of a groundhog, but despite its appearance it isn't a rodent. The hyrax's closest relatives are the rhino and the elephant. One clue to this kinship is the fact that it has hooves, not claws, and teeth that resemble small tusks. Another is that it is a gregarious animal. But quite unlike these much larger beasts, it is almost as agile as a mountain goat, scrambling deftly over the rocky areas in which it lives. Frequently preyed upon by cheetahs and other, smaller predators, the hyrax spends much of its time absolutely motionless, trying to blend in with its surroundings.

One of the predators the hyrax fears most is the African eagle, a magnificent black raptor. I've painted this one perched on an outcropping of granite, a reflection of the world in which it makes its home. Black eagles can spend their entire lives in the area around just two or three *kopjes*, nesting atop one and constantly circling others nearby on the lookout for food.

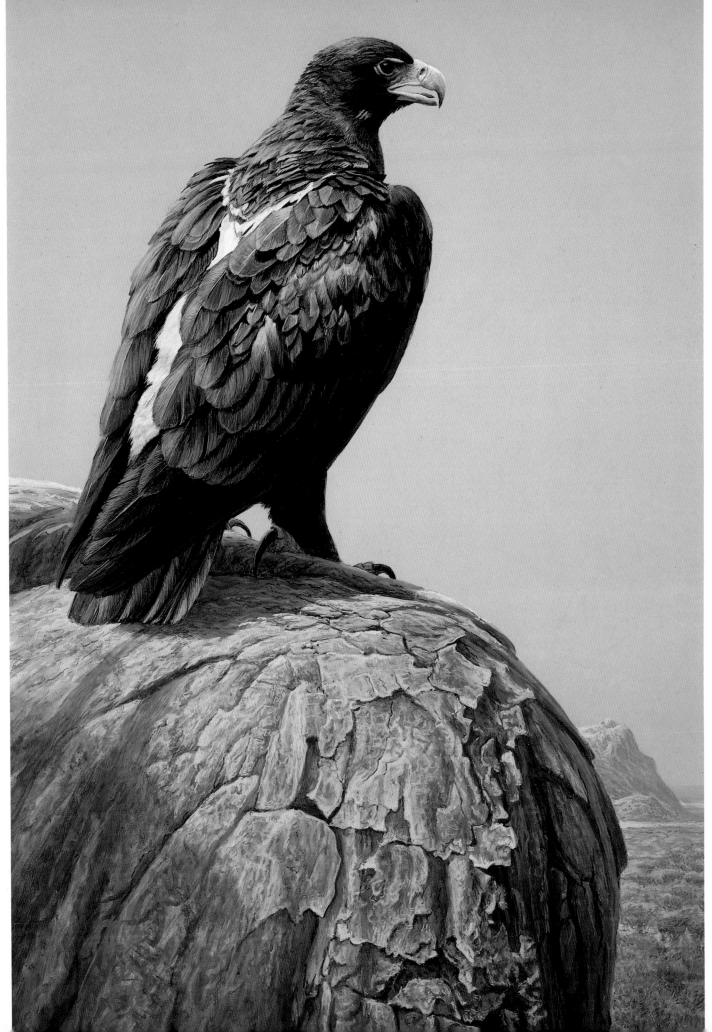

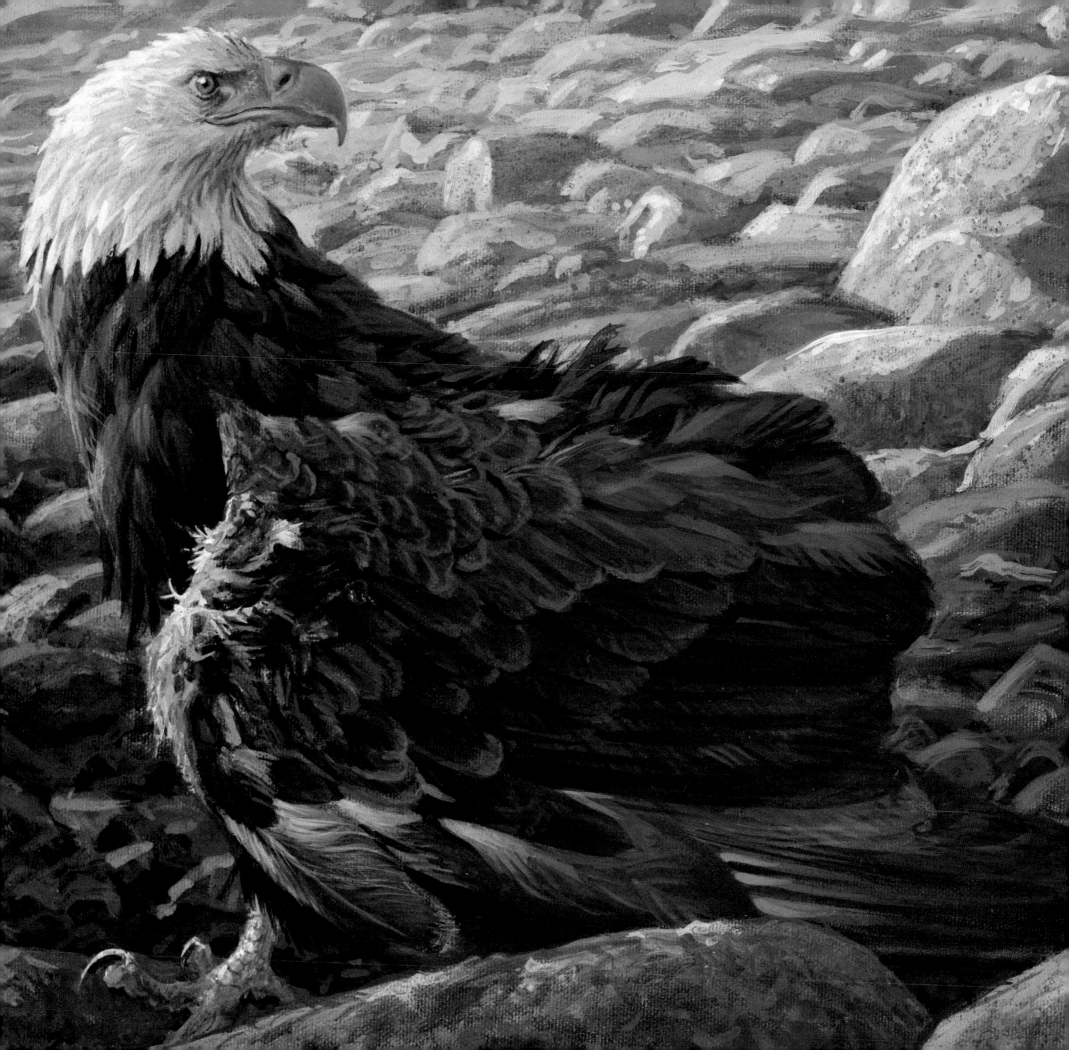

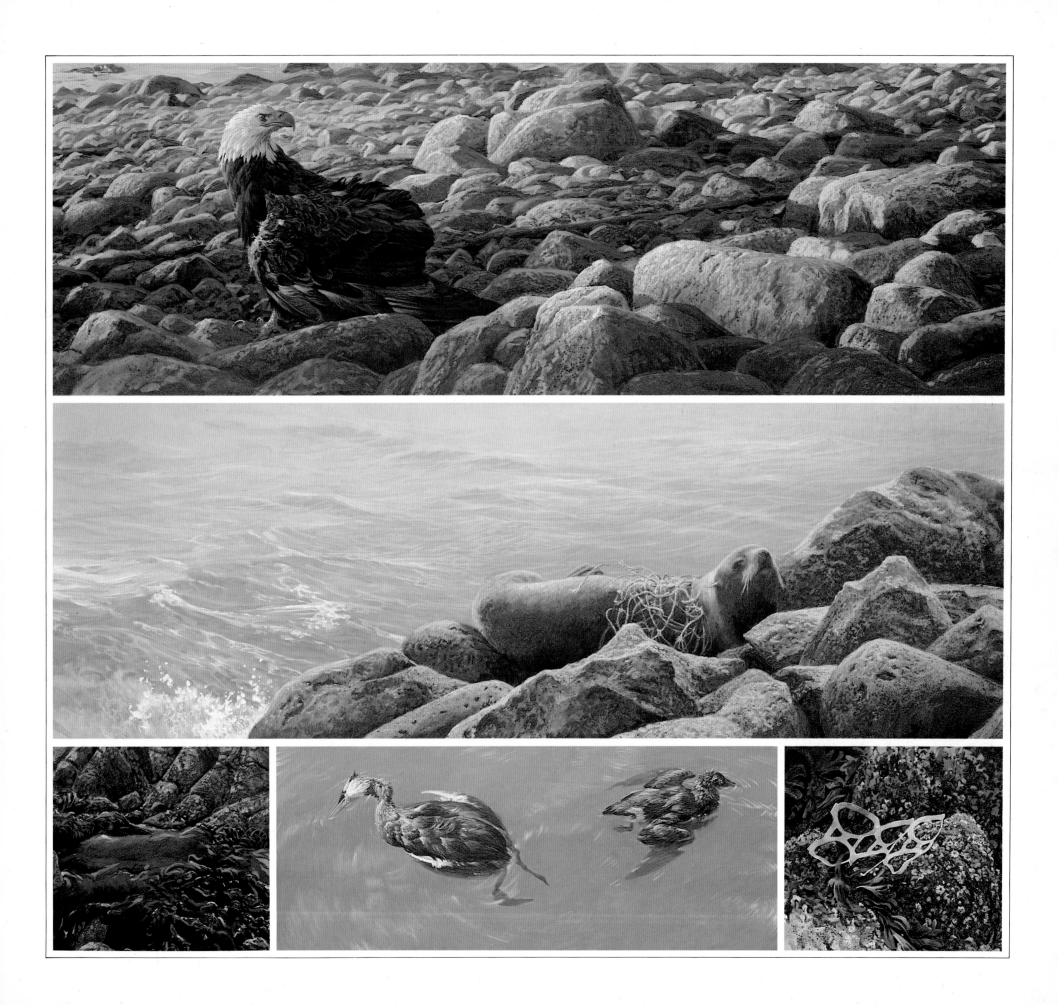

THIS PAINTING and those on the previous and following pages represent something of a departure in style for me. Each work consists of two or more separate images, which when taken together, make an explicit comment on the state of the planet. In *Wildlife Images* (previous page), I have tried through my choice of subjects to depict the harm that man, by design or through carelessness, does to the environment. The upper panel shows a bald eagle whose wing has been wounded by some guntoting yahoo hunter; it will never fly again.

The middle panel shows a seal tangled in a nylon drift net. Thousands of miles of such plastic drift net are set in the Pacific every day, and miles of it are lost. These "ghost" nets keep fishing for years, catching everything in their path. This seal is doomed either to starve or strangle as it grows.

In the center of the panel at the bottom are two dead birds, a red-necked grebe and an immature rhinoceros auklet. The bodies of these two, along with many others, were found recently off the coast of British Columbia. What killed them is unknown, but the area where they were recovered was the scene of a major oil spill a few years ago. Almost certainly their deaths are related to the effect of oil on the maritime food chain. The images at the bottom left and bottom right, appropriately enough, show two of the many menaces faced by sea creatures – oil spills and a prime example of the junk filling our seas, a plastic six-pack holder.

Vancouver Island Elegy is another cry of protest about the state of the environment, but it also focuses on my long-standing interest in different and time-honored ways of life, particularly those that unfolded in harmony with nature. The top image displays an old totem pole of the kind found all along the Pacific coast. It resembles the coffin of a dying culture, a culture which, at its height, produced art to rival anything of Rembrandt's or Picasso's.

In the middle, I have shown an Indian elder, a representative of the old way of life. I saw him on Vancouver Island at a gathering of natives and non-natives united in their opposition to clear-cut lumbering (the wholesale cutting down of forests when only the big old trees are wanted). The elder's face spoke powerfully to me of the vanishing of the old ways. This perception was heightened when one of the speakers, the tribal chief, told us the younger generation is not interested in their traditions – they are preoccupied watching sitcoms or rock videos on television. (I've made a reference to this by painting a TV aerial in the background.) In the bottom left-hand corner is an abandoned Indian fishing boat. Traditionally, the Indian tribes along the west coast depended upon fish for survival, but today, commercial fishing is so sophisticated that the Indians can't compete. Even if they could, industrial fishing methods have left their traditional fishing grounds depleted.

On the lower right is a logging truck representing an approach to nature very different from that of the native North Americans. The logs on this monster are uniform in species and size, part of a plantation put in after an old-growth forest has been cleared out.

The aftermath of clear-cutting is an ecological horror story. The Carmanah Valley, the subject of the painting overleaf, is one of the last areas of old-growth forest left on Vancouver Island and is home to a spectacular stand of Sitka spruce. But it is also threatened by big logging interests which have already clear-cut much of the surrounding rain forest. To help publicize this, the groups working to preserve the valley invited me and a number of other artists to go there and record our impressions of the forest. On our way to the valley we passed through areas that had already been cut down. Their appearance was shocking; nothing was left but stumps. In contrast to this scene of desolation is the lush, old-growth rain forest of the top panel. The human figure (me) is present to give some idea of the scale of the trees, but also to say that although humans do threaten these forests, there are many people working to preserve them.

Wildlife Images, 1989 (previous page)

Vancouver Island Elegy, 1989 (right)

Carmanah Contrasts, 1989 (overleaf)

Juvenile Spotted Owl, 1986 (page 176)

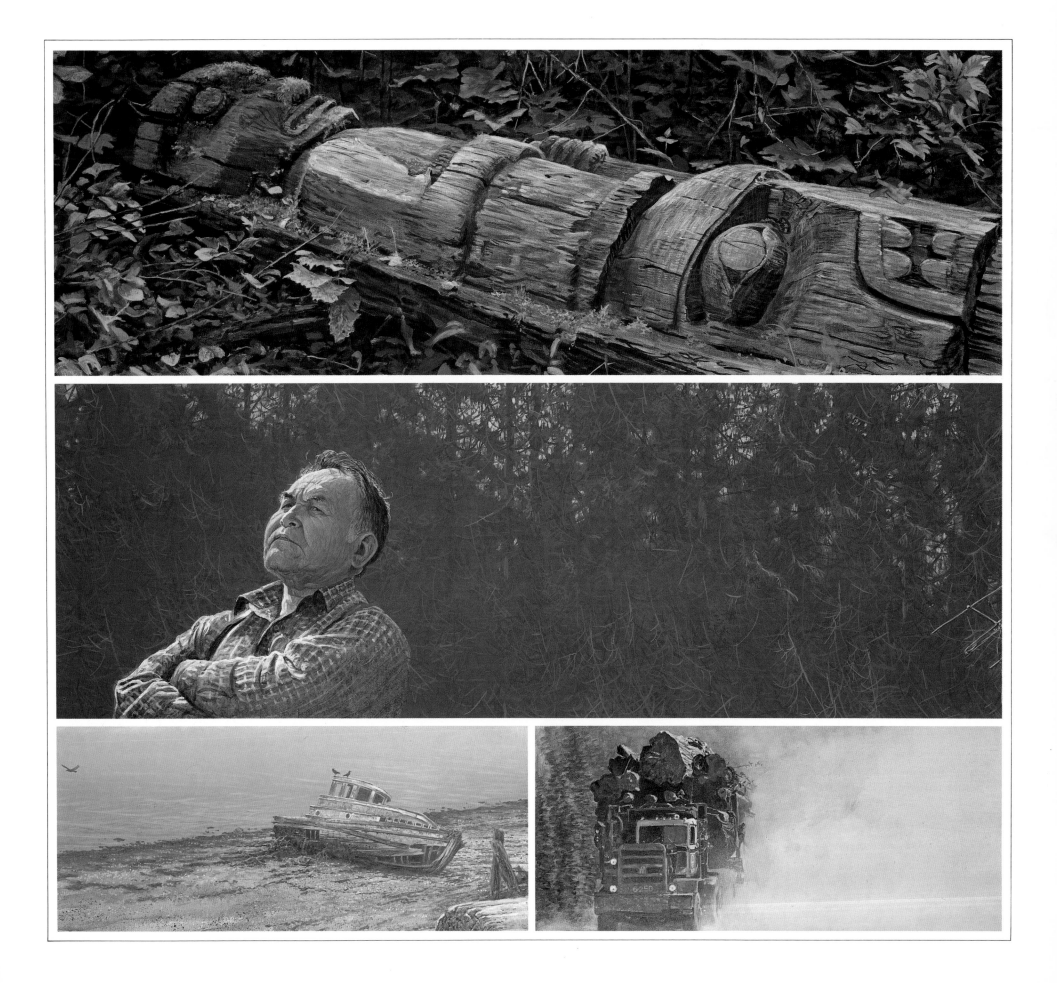

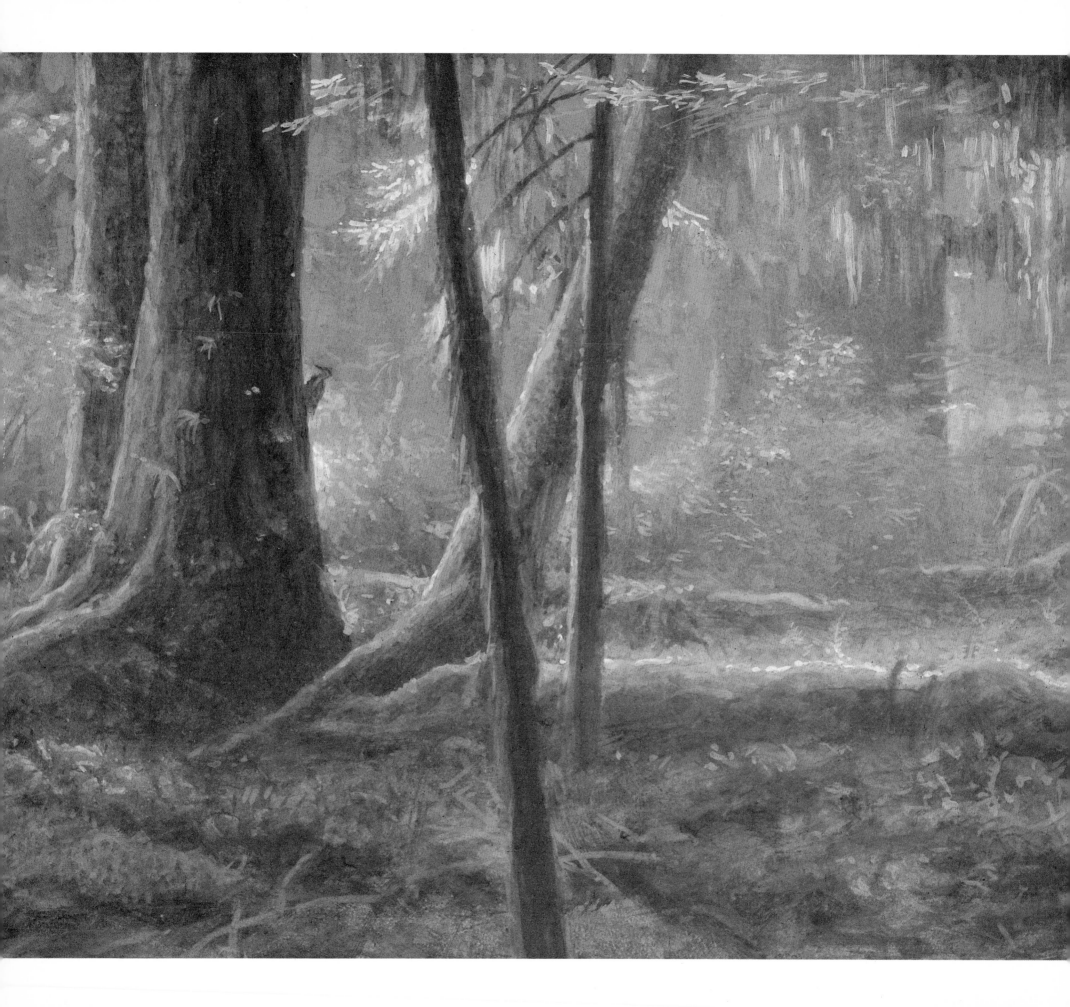

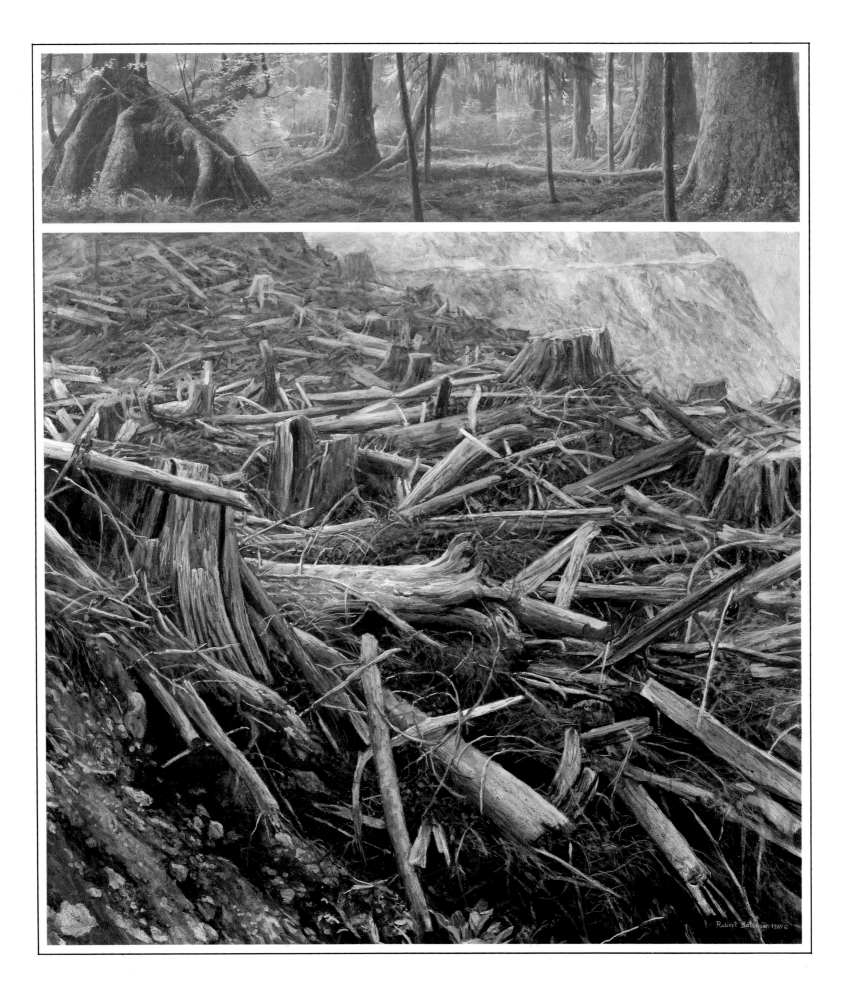

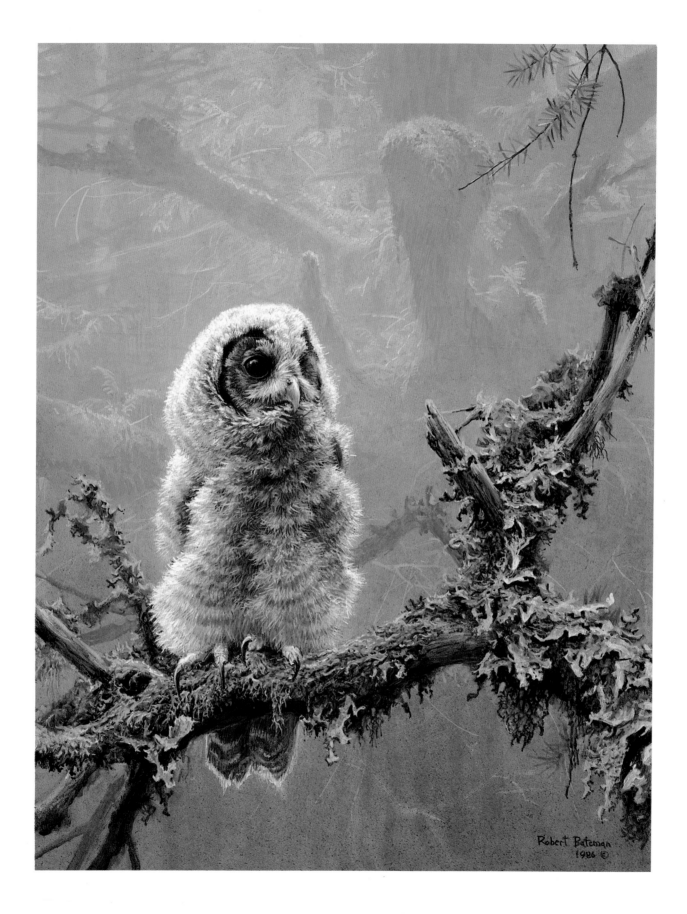

APPENDIX

INDEX TO THE PAINTINGS AND DRAWINGS

*These works, as well as other paintings by Robert Bateman, have been published as limited-edition prints by Mill Pond Press. For more information about their print publishing program please direct inquiries to the appropriate address.

In the United States

Mill Pond Press Inc.
310 Center Court
Venice, Florida 33595

In Canada

Nature's Scene
976 Meyerside Drive, Unit 1
Mississauga, Ontario
L5T 1R9

EXHIBITIONS

1959 – Hart House Gallery, University of Toronto, Toronto, Ontario, Canada

1967 – Alice Peck Gallery, Burlington, Ontario, Canada

1968 – York University, Toronto, Ontario, Canada (group exhibition)

1969 – Pollock Gallery, Toronto, Ontario, Canada

1971 – Beckett Gallery, Hamilton, Ontario, Canada

1972 – *Bird Artists of the World,* Tryon Gallery, London, England (group exhibition)

1974 – *The Acute Image in Canadian Art,* Mount Allison University, Sackville, New Brunswick, Canada (group exhibition)

1975 – *Endangered Species,* Tryon Gallery, London, England (group exhibition)
– *One Man's Africa,* Tryon Gallery, London, England
– *Animals in Art,* Royal Ontario Museum, Toronto, Ontario, Canada (group exhibition)
– *African Bird Art,* Peter Wenning Gallery, Johannesburg, South Africa (group exhibition)
– *Canadian Nature Art,* traveling exhibit sponsored by the Canadian Nature Federation (group exhibition)

1976 – Beckett Gallery, Hamilton, Ontario, Canada

1977 – *Birds of Prey,* Glenbow-Alberta Institute, Calgary, Alberta, Canada (group exhibition)
– *Queen Elizabeth Jubilee Exhibition,* Tryon Gallery, London, England (group exhibition)
– *Federation of Ontario Naturalists Exhibition,* University of Guelph, Guelph, Ontario, Canada (group exhibition)
– *1977 Bird Art Exhibition,* Leigh Yawkey Woodson Art Museum, Wausau, Wisconsin, U.S.A. (group exhibition)
– *A Wildlife Exhibition,* Tryon Gallery, London, England
– *Wolves: Fact versus Fiction,* The Gallery, First Canadian Place, Toronto, Ontario, Canada (group exhibition)

1978 – Art Gallery of Hamilton, Hamilton, Ontario, Canada
– Lynnwood Art Gallery, Simcoe, Ontario, Canada
– *Northwest Rendezvous Group Exhibition,* National Historical Society Building, Helena, Montana, U.S.A. (group exhibition)
– *1978 Bird Art Exhibition,* Leigh Yawkey Woodson Art Museum, Wausau, Wisconsin,

U.S.A. (group exhibition)
– Beckett Gallery, Hamilton, Ontario, Canada
– *The Artists and Nature,* traveling exhibit sponsored by the Canadian Wildlife Federation and the National Museum of Natural Sciences, Ottawa, Ontario, Canada (group exhibition)

1979 – *Society of Animal Artists Exhibition,* Sportsman's Edge Ltd., New York, U.S.A. (group exhibition)
– *Four Continents; Birds, Animals and their Environments,* Tryon Gallery, London, England
– *Wildlife Art,* Cowboy Hall of Fame, Oklahoma City, Oklahoma, U.S.A. (group exhibition)
– *Northwest Rendezvous Group Exhibition,* National Historical Society Building, Helena, Montana, U.S.A. (group exhibition)
– *1979 Bird Art Exhibition,* Leigh Yawkey Woodson Art Museum, Wausau, Wisconsin, U.S.A. (group exhibition)
– *The Dofasco Collection,* Art Gallery of Hamilton, Hamilton, Ontario, Canada (group exhibition)

1980 – St. Louis Museum of Science and Natural History, St. Louis, Missouri, U.S.A.
– *Selections from the Dofasco Collection,* Art Gallery of Brant, Brantford, Ontario, Canada (group exhibition)
– *Birds,* Smithsonian Institution, Washington, D.C., U.S.A. (group exhibition)
– *Northwest Rendezvous Group Exhibition,* National Historical Society Building, Helena, Montana, U.S.A. (group exhibition)
– *Trailside Group Exhibition,* Trailside Gallery, Jackson Hole, Wyoming, U.S.A. (group exhibition)
– *1980 Bird Art Exhibition,* Leigh Yawkey Woodson Art Museum, Wausau, Wisconsin, U.S.A. (group exhibition)
– *Society of Animal Artists Exhibition,* Four Seasons International, San Antonio, Texas, U.S.A. (group exhibition)
– Sportsman's Edge Ltd., New York, New York, U.S.A.
– Beckett Gallery, Hamilton, Ontario, Canada
– Trailside Gallery, Jackson Hole, Wyoming, U.S.A. (two-man exhibition)

1981 – *Images of the Wild,* traveling exhibit, sponsored by the National Museum of Natural Sciences, Ottawa, Ontario, Canada. The final appearance of this exhibit took place in 1983 at the Royal Ontario Museum in Toronto,

Ontario, Canada
– *Canadian Nature Art Exhibition,* University of Guelph, Guelph, Ontario, Canada, sponsored by the Canadian Nature Federation (group exhibition)
– *Trailside Gallery Miniature Show,* Jackson Hole, Wyoming, U.S.A. (group exhibition)
– *1981 Bird Art Exhibition,* Leigh Yawkey Woodson Art Museum, Wausau, Wisconsin, U.S.A. (group exhibition)
– *Northwest Rendezvous Group Exhibition,* National Historical Society Building, Helena, Montana, U.S.A.
– *Settler's West Miniature Show,* Tucson, Arizona, U.S.A. (group exhibition)

1982 – Mzuri Safari Foundation, Reno, Nevada, U.S.A. (group exhibition)
– *Trailside Gallery Miniature Show,* Jackson Hole, Wyoming, U.S.A. (group exhibition)
– *1982 Bird Art Exhibition,* Leigh Yawkey Woodson Art Museum, Wausau, Wisconsin, U.S.A. (group exhibition)
– *Northwest Rendezvous Group Exhibition,* National Historical Society Building, Helena, Montana, U.S.A. (group exhibition)
– *Settler's West Miniature Show,* Tucson, Arizona, U.S.A. (group exhibition)
– Musée du Québec, Quebec City, Quebec, Canada
– Museum of Man and Nature, Winnipeg, Manitoba, Canada
– Provincial Museum of Alberta, Edmonton, Alberta, Canada
– Centennial Museum, Vancouver, British Columbia, Canada
– *Le Conseil International de la Chasse et de la Conservation du Gibier* Annual Meeting, Monte Carlo, Monaco, sponsored by the Canadian Wildlife Federation. After the meeting, this one-man exhibit began an extensive European tour.

1983 – *Images of the Wild,* traveling exhibit, began at the California Academy of Sciences, San Francisco, California, U.S.A. The final appearance of this exhibit took place in 1985 at the Greenville County Museum of Art, Greenville, South Carolina.
– *Trailside Gallery Miniature Show,* Jackson Hole, Wyoming, U.S.A. (group exhibition)
– *1983 Bird Art Exhibition,* Leigh Yawkey Woodson Art Museum, Wausau, Wisconsin, U.S.A. (group exhibition)
– *Northwest Rendezvous Group Exhibition,*

National Historical Society Building, Helena, Montana, U.S.A.
– *Settler's West Miniature Show,* Tucson, Arizona, U.S.A. (group exhibition)
– Durham Art Gallery, Durham, Ontario, Canada
– *National Art Exhibition of Alaska,* Audubon Society of Alaska, Anchorage, Alaska, U.S.A. (Robert Bateman appeared as both featured artist and judge.)

1984 – *Robert Bateman – The Early Years,* Georgetown Art Gallery, Georgetown, Ontario, Canada
– *Science Museum of Virginia Print Exhibit,* Richmond, Virginia, U.S.A.
– *Bird Artists of the World,* Everard Read Gallery, Johannesburg, South Africa (group exhibition)
– *Northwest Rendezvous Group Exhibition,* National Historical Society Building, Helena, Montana, U.S.A.
– *1984 Bird Art Exhibition,* Leigh Yawkey Woodson Art Museum, Wausau, Wisconsin, U.S.A. (group exhibition)
– *Trailside Gallery Miniature Show,* Jackson Hole, Wyoming, U.S.A. (group exhibition)
– *Settler's West Miniature Show,* Tucson, Arizona, U.S.A. (group exhibition)
– *Mzuri,* Safari Foundation, Reno, Nevada, U.S.A. (group exhibition)

1985 – *The World of Robert Bateman,* Tryon Gallery, London, England

1986 – *The World of Robert Bateman,* Gilcrease Art Museum, Tulsa, Oklahoma, U.S.A. (one-man exhibition)
– *Robert Bateman: A Retrospective,* Leigh Yawkey Woodson Art Museum, Wausau, Wisconsin, U.S.A. (one-man exhibition)
– Beckett Gallery, Hamilton, Ontario, Canada (one-man exhibition)

– *An Artist's Celebration of Nature,* Joslyn Art Museum, Omaha, Nebraska, U.S.A. (one-man exhibition)
– *1986 Bird Art Exhibition,* Leigh Yawkey Woodson Art Museum, Wausau, Wisconsin, U.S.A. (group exhibition)

1987 – *Portraits of Nature,* Museum of Natural History, Smithsonian Institution, Washington, D.C., U.S.A. (one-man exhibition)
– *1987 Wildlife Art Exhibition,* Leigh Yawkey Woodson Wildlife Art Museum, Wausau, Wisconsin, U.S.A. (group exhibition)
– *1987 Bird Art Exhibition,* Leigh Yawkey Woodson Wildlife Art Museum, Wausau, Wisconsin, U.S.A. (group exhibition)

1988 – *Reflections of Nature,* Missouri Botanical Gardens, St. Louis, Missouri, U.S.A. (one-man exhibition)
– Tryon Gallery, London, England (group exhibition)
– Beckett Gallery, Hamilton, Ontario, Canada (group exhibition)
– *Images of the Wild – The Art of Robert Bateman,* Frye Art Museum, Seattle, Washington, U.S.A. (one-man exhibition)
– *1988 Bird Art Exhibition,* Leigh Yawkey Woodson Art Museum, Wausau, Wisconsin, U.S.A. (group exhibition)

1989 – *D'Après nature,* Musee d'Histoire Naturelle, Luxembourg (group exhibition)
– *1989 Bird Art Exhibition,* Leigh Yawkey Woodson Art Museum, Wausau, Wisconsin, U.S.A. (group exhibition)
– *1989 Wildlife Art Exhibition,* Leigh Yawkey Woodson Art Museum, Wausau, Wisconsin, U.S.A. (group exhibition)

1990 – *1990 Bird Art Exhibition,* Leigh Yawkey Woodson Art Museum, Wausau, Wisconsin, U.S.A. (group exhibition)

The Nature of Birds, edited by Stanley Fillmore, McClelland and Stewart; Toronto, Canada, 1974.

The Art of Robert Bateman, Ramsay Derry, Madison Press Books/Allen Lane, Penguin Books Canada Ltd./The Viking Press; Toronto, Canada, and New York, U.S.A. 1981.

Wildlife Artists at Work, Patricia Van Gelder, Watson-Guptill Publications; New York, U.S.A., 1982. Pages 18-33.

The World of Robert Bateman, Ramsay Derry, Madison Press Books/Penguin Books Canada Ltd./Random House Inc. U.S.A./Viking, Penguin Books U.K., 1985.

From the Wild, edited by Christopher Hume, Summerhill Press Ltd.; Toronto, Canada, 1986.

Robert Bateman, Marjorie E. White, Fitzhenry and Whiteside; Markham, Canada, 1989.

Carmanah, Western Canada Wilderness Committee; Vancouver, Canada, 1989.

FILMS

Robert Bateman. Canadian Broadcasting Corporation, produced by John Lacky for *This Land,* 1972.

Images of the Wild: A Portrait of Robert Bateman. National Film Board of Canada, directed by Norman Lightfoot, produced by Beryl Fox, 1978.

The Nature Art of Robert Bateman. Eco-Art Productions, produced by Norman Lightfoot, 1981.

Robert Bateman: A Celebration of Nature: Canadian Broadcasting Corporation, produced by Brigitte Berman for *Take 30,* 1983.

Robert Bateman: Artist and Naturalist: Canadian Broadcasting Corporation, produced by Donnalu Wigmore as a one-hour special, October 1984.

PUBLICATIONS

The Conservationist: Wayne Trimm, "Robert Bateman," pp. 22-26, vol. 36, no. 1, July/August 1981.

Maclean's: vol. 94, no. 47, November 1981.

Reader's Digest (Canadian): from the introduction by Roger Tory Peterson to *The Art of Robert Bateman,* "The Wild and Beautiful World of Robert Bateman," pp. 98-105, November 1981.

Equinox: Frank B. Edwards, "Unfettered Realism," pp. 50-61, vol. 1, no. 1, January 1982.

Forêt Conservation: Jean-Pierre Drapeau, "Reflects de la nature," pp. 31-34, vol. 48, no. 8, janvier 1982.

Reader's Digest (United States): from the introduction by Roger Tory Peterson to *The Art of Robert Bateman,* "The Wild and Beautiful World of Robert Bateman," pp. 98-105, February 1982.

Reader's Digest (World): from the introduction by Roger Tory Peterson to *The Art of Robert Bateman,* "The Wild and Beautiful World of Robert Bateman," pp. 98-105, February 1982.

Intrepid: Greg Stott, "Robert Bateman," pp. 8-17, vol. 7, no. 4, Summer 1982.

City & Country Home: Kay Kritzwiser, "The Artist," pp. 126-129; Elaine Sills, "A Visit with Robert Bateman at Home," pp. 130-135, vol. 1, no. 1, Fall 1982.

Art West: Diane Ciarloni Simmons, "Robert Bateman: A World of Surprises!" pp. 88-97, vol. 5, no. 6, October/November 1982.

Camera Canada: Greg Stott, "An Interview with Robert Bateman," pp. 8-16, 39-40, no. 54, November 1982.

Kosmos: "Mit den Augen Robert Batemans," pp. 42-47, Heft 10, Oktober 1983.

Cuesta: "The Escarpment Art of Robert Bateman," pp. 21-26, p. 29, Spring 1983.

Saturday Night: Mark Abley, "The Painted Bird," pp. 61-63, vol. 99, no. 6, June 1984.

Grasduinen: Margriet Winters, "Robert Bateman," pp. 12-18, no. 10, October 1984 (Holland).

Prints: "Robert Bateman," pp. 18-25, p. 65, vol. 6, no. 5, December 1984.

Nature Canada: Rick Archbold, "Sense of Place," pp. 32-38, Fall 1985.

Equinox: Robert Bateman, "Bateman on Bateman: Excerpt from Forthcoming Book *The World of Robert Bateman,* " pp. 44-53, vol. 4, no. 24, Nov-Dec 1985.

Canadian Business: Shona McKay, "Nature's Bounty," pp. 68-69, 71 ff., vol. 59, January 1986.

Maclean's: Brian D. Johnson, "Window on the World of Nature," pp. 81-83, vol. 98, Nov. 11, 1985.

BC Outdoors: "Mr. Bateman goes to Washington," p. 10, vol. 43, no. 1, Jan.-Feb. 1987.

Alberta (Western) Report: George Koch, "Art of the Wild: British Columbia's Robert Bateman opens at the Smithsonian," pp. 38-39, vol. 14, no. 8, February 9, 1987.

Financial Post: Arnold Edinborough, "Robert Bateman makes capital in Washington," p. 42, vol. 81, no. 20, May 18, 1987.

Nature Canada: Lyn Hancock, "Birds before Breakfast: how three wise men came to love nature and spread the word," pp. 37-41, 48, vol 16, no. 3, Summer 1987.

enRoute: Shona McKay, "Paradise found: three intrepid travellers reveal their personal Shangri-las," pp. 34-39, 55 ff., vol. 17, no. 2, February 1989.

COMMISSIONS

1976 – World Wildlife Fund: designed a relief sculpture of a polar bear for a limited edition silver bowl to raise funds for endangered species.

1977 – Canada Post: designed the annual stamp series depicting endangered species.
 – Board of Trade of Metropolitan Toronto, Ontario, Canada: painted "Window into Ontario."
 – Tryon Gallery, London, England: painted "King of the Realm" for the Queen Elizabeth Jubilee Exhibition.

1980 – *American Artist* magazine: painted "Kingfisher in Winter" for the *American Artist* Collection.

1981 – Government of Canada: painted "Northern Reflections – Loon Family" which was presented to H.R.H. Prince Charles, the Prince of Wales, as a wedding gift from the people of Canada.

1985 – Art Gallery of Hamilton, Hamilton, Ontario, Canada.

1988 – Wildlife Habitat Canada: Painted "Pintails in Spring" for use as a duck stamp.

1989 – State of New York: painted "Rolling Waves – Greater Scaup" for use as a duck stamp.
 – Painted "Charging Grizzly" as a birthday gift for Prince Bernhard of the Netherlands.

1990 – State of Texas: Painted "Peaceful Flock – American Widgeons" for use as a duck stamp.
 – United States National Fish and Wildlife Foundation: Painted "Tundra Swan" for use as a duck stamp.

HONORS

1977 – Queen Elizabeth's Silver Jubilee Medal (Canada).

1979 – Award of Merit, Society of Animal Artists.

1980 – Artist of the Year, *American Artist* magazine.
– Honorary Life Member, The Audubon Society.
– Honorary Life Member, The Canadian Wildlife Federation.
– Honorary Life Member, The Burlington (Ontario) Cultural Centre.
– Hamilton-Wentworth Regional Government Excellence in the Arts Award for contribution to the artistic community.
– Award of Merit, Society of Animal Artists

1981 – Honorary Life Member, The Federation of Ontario Naturalists.
– Award of Merit, *Northwest Rendezvous Group Exhibition,* Helena, Montana, U.S.A.
– Award of Merit, Society of Animal Artists.

1982 – Honorary Member, The Federation of Canadian Artists.
– Doctor of Science, *honoris causa,* Carleton University, Ottawa, Ontario, Canada.
– Doctor of Laws (for Fine Arts), *honoris causa,* Brock University, St. Catharines, Ontario, Canada.
– Master Artist, Leigh Yawkey Woodson Art Museum, Wausau, Wisconsin, U.S.A.

1983 – Doctor of Letters (for Fine Arts), *honoris causa,* McMaster University, Hamilton, Ontario, Canada.

1984 – Officer of the Order of Canada.
– The Bicentennial Medal for Ontario for service to the community.

1985 – Doctor of Laws, *honoris causa,* University of Guelph, Guelph, Ontario, Canada.
– Medal of Honor, World Wildlife Fund, Geneva (presented by HRH Prince Philip).

1986 – Doctor of Letters (for fine arts) *honoris causa,* Lakehead University, Thunder Bay, Ontario, Canada.

1987 – Doctor of Laws, Laurentian University, Thunder Bay, Ontario, Canada.
– Governor-General's Award for Conservation, Quebec City, Quebec, Canada.

1989 – Doctor of Fine Arts, *honoris causa,* Colby College, Waterville, Maine.

ROBERT BATEMAN: A CHRONOLOGY

1930 – Born May 24 in Toronto, Ontario, Canada to Joseph Wilberforce Bateman and Annie Maria Bateman (nee McLellan). He is the first of three children; brothers John (Jack) and Ross are born in 1933 and 1936.

1935-43 – Attends primary and elementary school.

1938 – Bateman family rents and eventually purchases a summer cottage in the Haliburton lakes region of Ontario. Time spent here is an important part of Bob's development as an artist and naturalist.

1942 – Joins the Junior Field Naturalist's Club at the Royal Ontario Museum. During his adolescent and teen years there he develops his birdwatching skills and ornithological knowledge under the influence of James L. Baillie and Terence Shortt. Shortt, an outstanding bird painter, is a major and long-lasting influence.

1943-48 – Attends high school at Forest Hill Collegiate in Toronto. During high school he is active in the Biology Club of the University of Toronto.

1947-49 – Spends three summers working at a government wildlife research camp in Algonquin Park in northern Ontario. Here his enthusiasm grows for the landscapes of the painters of the Canadian Group of Seven school.

1948 – Begins taking painting lessons from Gordon Payne, a well-respected Toronto artist, who teaches him the basic skills of representational painting.

1950 – Travels to Vancouver Island by bus, painting and sketching with his friend Erik Thorn.

1950-54 – Attends the University of Toronto in a four-year honors course in geography. Also takes evening courses in the Nikolaides method of drawing from Carl Schaefer. Summer jobs on geological field parties take him to Newfoundland, Ungava Bay, and Hudson Bay.

1954 – Graduates from university and takes a painting and sketching tour of Europe and Scandinavia.

1954-63 – Experiments with a range of painting styles. From the influence of impressionism and the Canadian Group of Seven, he moved into a cubist phase, and, finally, embraced an abstract-expressionist style.

1955 – Receives a teaching certificate from the Ontario College of Education and begins a career as a high school teacher of geography and art in Thornhill, Ontario.

1957-58 – A round-the-world trip in a Land Rover with friends Bristol Foster and Erik Thorn takes him to England, Africa, India, Sikkim, Burma, Thailand, Malaysia, and Australia.

1958 – Resumes his teaching career in Burlington, Ontario.

1960 – Marries Suzanne Bowerman, a sculpture student at the Ontario College of Art.

1962 – Attends a major Andrew Wyeth exhibition at the Albright-Knox Gallery in Buffalo, New York. This encourages him to return to a realist style of painting.

1963-65 – Spends two years teaching in Nigeria under the sponsorship of Canada's External Aid program. Here he begins painting African wildlife in a naturalist style and begins exhibiting at the Fonville Gallery in Nairobi.

1965 – A first child, Alan, is born in Nigeria. Later in the year, the family returns to Canada where Bateman resumes teaching in Burlington, Ontario. He continues to paint African wildlife pictures for the Fonville Gallery in Kenya and begins painting Ontario landscapes and rural settings in a realistic style.

1966 – A second child, Sarah, is born.

1967 – A series of historical scenes of Halton County, Ontario, are painted as the artist's own Canadian Centennial project and are shown at the Alice Peck Gallery in Burlington, Ontario.

1968 – John, the third Bateman child, is born.

1969 – A one-man show is held at the Pollock Gallery in Toronto.

1971 – A well-received show at the Beckett Gallery in Hamilton, Ontario, encourages him to concentrate on wildlife paintings.

1975 – A large show at the Tryon Gallery in London, England, one of the world's foremost galleries of wildlife art, is sold out. This convinces him that he should paint full time.
 – *Animals in Art*, a group exhibition at the Royal Ontario Museum in the same year, brings his work to Canadian attention.
 – Marries Birgit Freybe after his first marriage concludes in divorce.

1976 – A fourth child, Christopher, is born.

1978 – Shows are held at the Beckett Gallery, Hamilton, and the Art Gallery of Hamilton, Ontario.
 – Mill Pond Press begins distributing Bateman images as limited-edition, signed prints. Over 284 Bateman paintings have become prints since this program was launched, not including the many special projects.
 – Travels to the Falkland Islands and the Antarctic aboard the Lindblad *Explorer*.

1979 – Robbie Bateman, a fifth child, is born.

1980 – Drawing lots for paintings is required at sold-out shows at the Beckett Gallery and The Sportsman's Edge Gallery in New York City.
 – Bateman is named "Artist of the Year" by *American Artist* magazine.
 – Visits Ecuador and the Galapagos Islands.

1981 – *Images of the Wild*, a major Bateman show organized by the National Museum of Natural Sciences, opens in Ottawa, Canada, and travels to museums in Quebec City, Winnipeg, Vancouver, and Toronto over the next two years.
 – *Northern Reflections – Loon Family*, a painting commissioned by the Governor-General of Canada, is the official wedding gift of the people of Canada to Prince Charles.
 – *The Art of Robert Bateman* is published, a large-format art book featuring over eighty color reproductions of Bateman paintings, with an introduction by Roger Tory Peterson and a text by Ramsay Derry.
 – Visits New Zealand, Australia's Great Barrier Reef, and Melanesia.

1982 – Explores the Queen Charlotte Islands.
 – Bateman and three of his children visit the
 game parks of East Africa.

1983 – The *Images of the Wild* exhibit opens at the
 California Academy of Sciences in San
 Francisco, and eventually travels to St.
 Louis, Cleveland, Cincinnati, and
 Greenville, South Carolina.
 – He visits Alaska for the first time.

1984 – Bateman is named an Officer of the Order
 of Canada.
 – *Robert Bateman: Artist and Naturalist,* a
 one-hour television documentary, is
 shown on the Canadian Broadcasting
 network.

1985 – The Tryon Gallery in London exhibits a
 major Bateman show.
 – *The World of Robert Bateman,* a second book
 devoted to the work of Robert Bateman, is
 published.
 – Bateman is awarded the Medal of Honor,
 World Wildlife Fund, Geneva (presented
 by HRH Prince Philip).
 – The Batemans move to Fulford Harbour,
 Saltspring Island, British Columbia.

1986 – One-man shows are held at the Gilcrease
 Art Museum, Tulsa, Oklahoma, the Leigh
 Yawkey Woodson Art Museum, Wausau,
 Wisconsin, the Beckett Gallery, Hamilton,
 Ontario, and the Joslyn Art Museum,
 Omaha, Nebraska.

1987 – The *Portraits of Nature* exhibit opens at the
 Smithsonian Institution's Museum of
 Natural History in Washington, D.C.
 – Bateman is given the Governor-General's
 Award for Conservation, Quebec City,
 Quebec.
 – Spends the year in Bavaria.

1988 – The *Images of the Wild – The Art of Robert
 Bateman* exhibit opens at the Frye Art
 Museum, Seattle, Washington.
 – Visits Japan, China, Nepal and India.

1989 – Paints "Charging Grizzly" as the birthday
 present for Prince Bernhard of the
 Netherlands.
 – Visits Israel.

1990 – *Robert Bateman: An Artist in Nature,* a
 third book featuring Bateman as artist,
 naturalist and conservationist is published.

DESIGN AND ART DIRECTION	V. John Lee
EDITORIAL DIRECTOR	Hugh M. Brewster
EDITORIAL ASSISTANCE	Ian R. Coutts Nan Froman Shelley Tanaka
PRODUCTION DIRECTOR	Susan Barrable
PRODUCTION ASSISTANCE	Sandra L. Hall
ASSEMBLY	Universal Communications
PRODUCTION PHOTOGRAPHY	Mill Pond Press Thomas Moore Photography See Spot Run Inc.
TYPOGRAPHY	Cybergraphics Co., Inc.
COLOR SEPARATION, PRINTING AND BINDING	Arnoldo Mondadori S.p.A.

ROBERT BATEMAN: AN ARTIST IN NATURE
was produced by Madison Press Books
under the direction of Albert E. Cummings